Tim Hawkinson

Tim Hawkinson

Lawrence Rinder

with essays
by Howard N. Fox
Doug Harvey

Whitney Museum of American Art, New York
Los Angeles County Museum of Art

Distributed by Harry N. Abrams, Inc., New York

This catalogue was published on the occasion of the exhibition
Tim Hawkinson. The exhibition was organized by the Whitney Museum of
American Art, New York, and the Los Angeles County Museum of Art.

Whitney Museum of American Art
February 11 – May 29, 2005

Los Angeles County Museum of Art
June 26 – September 5, 2005

Major support for this exhibition was provided by Peter Norton and the
Peter Norton Family Foundation with additional significant support from
the National Committee of the Whitney Museum of American Art.

WHITNEY

Whitney Museum of American Art
945 Madison Avenue at 75th Street
New York, NY 10021
www.whitney.org

LACMA

Los Angeles County Museum of Art
5905 Wilshire Boulevard
Los Angeles, CA 90036
www.lacma.org

 Library of Congress Cataloging-in-Publication Data

Rinder, Lawrence.
 Tim Hawkinson / Lawrence Rinder ; with essays by Howard N. Fox and
Doug Harvey.
 p. cm.
 Catalog of an exhibition to be held early Feb.-May 29, 2005 at the
Whitney Museum of American Art, New York, and June 26-Sept. 25, 2005,
at the Los Angeles County Museum of Art.
 Includes bibliographical references and index.
 ISBN 0-87427-144-4 (hard cover : alk. paper)
 1. Hawkinson, Tim, 1960---Exhibitions. I. Fox, Howard N. II. Harvey,
Doug, 1961- III. Hawkinson, Tim, 1960- IV. Whitney Museum of American
Art. V. Los Angeles County Museum of Art. VI. Title.
 N6537.H377A4 2005
 709'.2--dc22
 2004022773

Distributed in 2005 by
 Harry N. Abrams, Inc.
 100 Fifth Avenue
 New York, NY 10011
 www.abramsbooks.com
Abrams is a subsidiary of

 LA MARTINIÈRE
 GROUPE

Printed in Germany

Contents

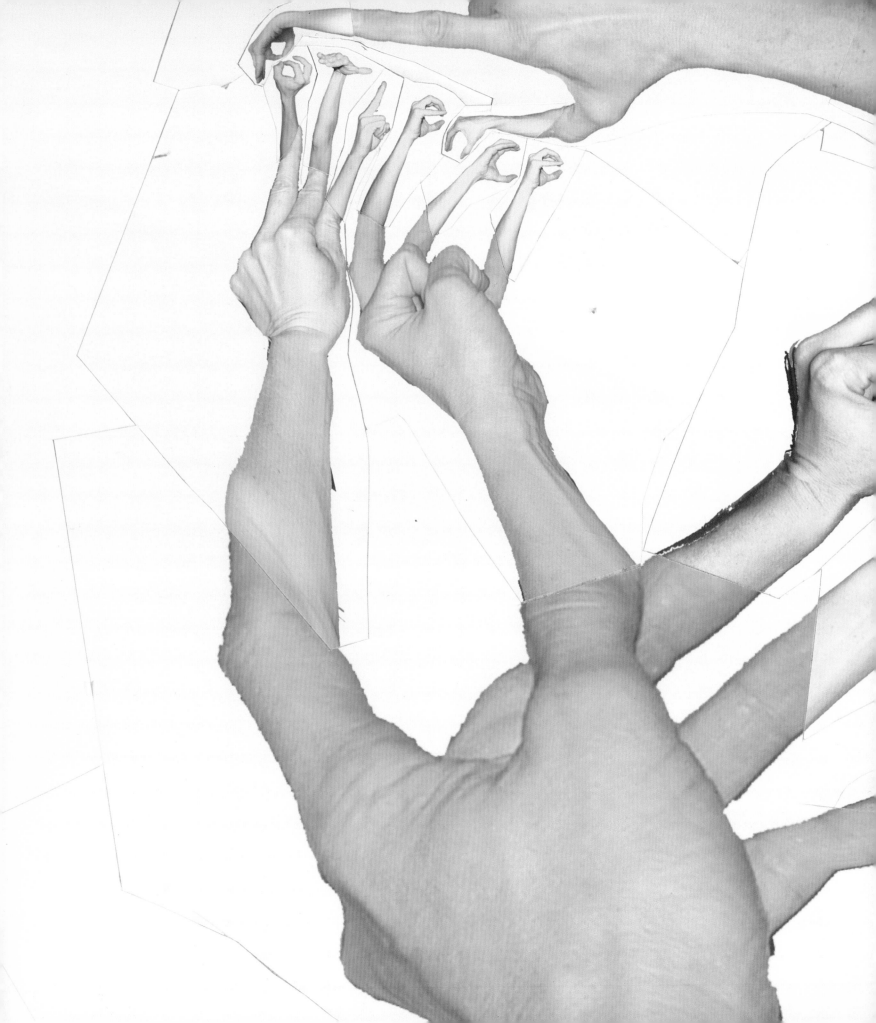

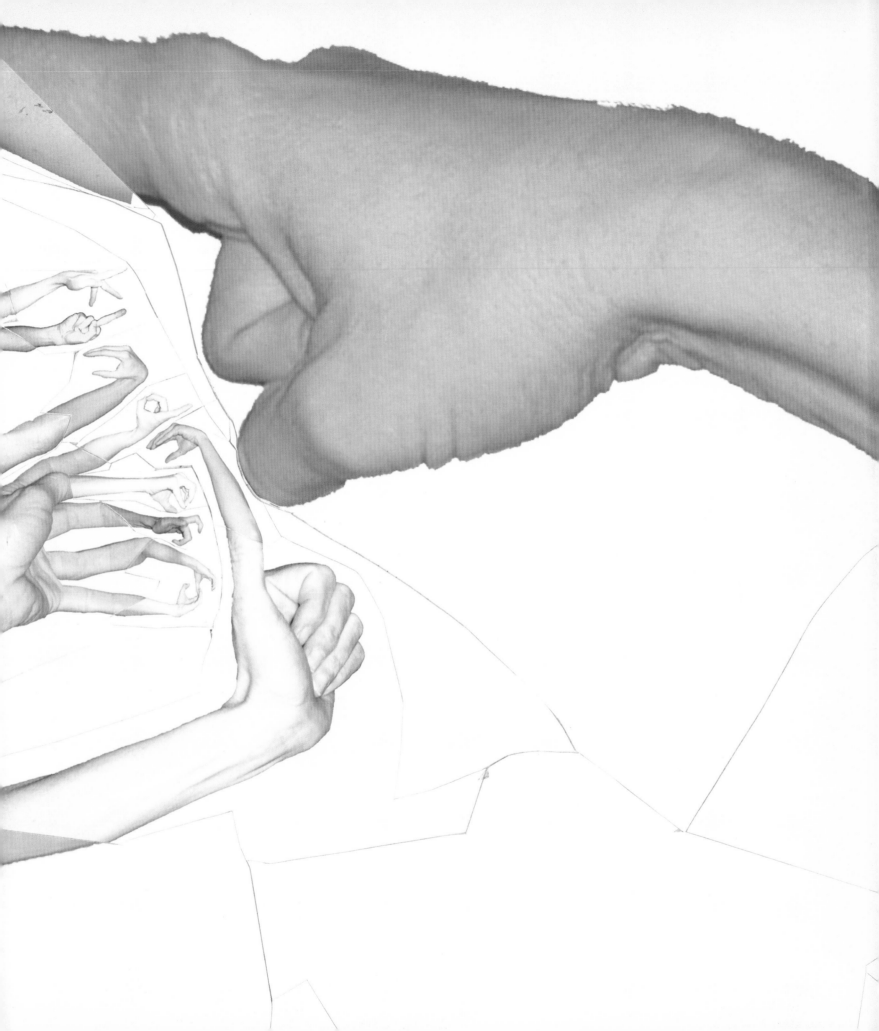

Foreword
Adam D. Weinberg

The Whitney Museum of American Art was founded in New York City nearly seventy-five years ago with the commitment to present the geographic breadth of American art, and that commitment remains critical even as the Museum reshapes its mission to exhibit American art in a global context. While, given the riches of New York, the representation was often heavily weighted toward art from this city and the northeastern United States, in recent years the Whitney has taken great effort to exhibit, and in particular collect, the work of artists from across the country. Accordingly, the Whitney has been the New York museum most responsive to recent art made on the West Coast and especially in Los Angeles. We have been pleased to organize major exhibitions of work by artists including Richard Diebenkorn, Ed Ruscha, Ed Kienholz, Jay DeFeo, Mike Kelley, and Bill Viola. We have also organized smaller, focused exhibitions of new work by Paul Sietsema and Jennifer Pastor. Thus, this extraordinary mid-career survey of work by Los Angeles–based artist Tim Hawkinson is part of a long and proud tradition.

We are especially pleased to exhibit such a substantial range of work by this artist who is well known within the art world but perhaps little recognized by the general public. Those who have followed his work have been astonished by each new piece and exhibition. His ingenuity is amazing and his creativity seemingly limitless. Hawkinson's art is accessible and occasionally humorous while touching on themes of tremendous vitality and urgency. In our high-tech digital age, it is remarkable to find an artist whose output is so devoutly engaged with physicality, both that of his materials and that of his own body. It is inspiring to observe how Hawkinson derives sublime effects from everyday materials and images as simple as a tree stump, a clock, or a pipe organ. This is the most comprehensive presentation of Hawkinson's work to date and will without doubt seal his reputation as one of the most innovative and significant artists working in America today.

Lawrence Rinder, adjunct curator at the Whitney and curator of this exhibition, is to be commended for his unswerving dedication to this complex project. He included work by Hawkinson in an exhibition as early as 1989 and has been a devoted follower of the artist ever since. His understanding

and appreciation of the work is evident in both the selection of works and in his nuanced and perceptive essay in this catalogue.

This exhibition has been co-organized with the Los Angeles County Museum of Art, and we are thrilled to collaborate on this timely survey exhibition. My thanks go to Andrea L. Rich, LACMA president and director, for her generous and collegial support. Stephanie Barron's commitment was critical to realizing our collaboration. Howard N. Fox, curator of modern and contemporary art at LACMA, has been a marvelous member of the team and contributed an insightful text to the catalogue.

This catalogue, published in association with Harry N. Abrams, Inc., New York, is the most exhaustive book on Hawkinson to date. In addition to the informative contributions of Rinder and Fox, Doug Harvey offers a cogent yet appropriately eccentric text. Hawkinson's own pithy descriptions of his works are another delightful and engaging facet of this book. Among those at the Whitney to whose talent and efforts the catalogue owes a great deal are Tina Kukielski, senior curatorial assistant, and Rachel de W. Wixom, head, publications and new media.

We are tremendously grateful to all of the individuals and institutions that so generously lent works to this exhibition. Hawkinson's creations are often particularly vulnerable, made of unusual materials with many moving parts, so we are especially indebted to those who parted with their much-beloved works.

This exhibition could not have been organized without the generous financial support of the Whitney National Committee, which has historically supported many of the Museum's most contemporary and cutting-edge exhibitions.

We are honored that Tim Hawkinson chose to work with the Whitney and LACMA on this monumental undertaking. The opportunity to spend time with him and his extraordinary art has enriched all of our lives.

ADAM D. WEINBERG is the Alice Pratt Brown Director of the Whitney Museum of American Art.

Acknowledgments
Lawrence Rinder

I am tremendously grateful to everyone who helped to make this exhibition possible. Most importantly, I would like to acknowledge the lenders who so generously made available their precious — and often very fragile—works. Everyone at Ace, Tim Hawkinson's gallery, has been tremendously helpful, most especially Douglas Chrismas as well as Cristin Donahue.

My colleagues both at the Whitney and the Los Angeles County Museum of Art have been supportive throughout. I am very grateful to Howard N. Fox, curator of the exhibition at LACMA and author of an incisive text in this catalogue, for his invaluable contributions. Also at LACMA, I would like to acknowledge the participation of Bruce Robertson, director, exhibitions and art programs, and Irene Martin, assistant director, exhibition programs. Stephanie Barron, senior curator of LACMA's Center for Modern and Contemporary Art, and Lynn Zelevansky, head of the modern and contemporary art department, lent their support at crucial moments to ensure that the Whitney-LACMA collaboration would take place. Thanks also to Christine Hansen, senior vice president and chief marketing officer; Jeff Haskin, manager of art preparation and installation; and Toby Tannenbaum, assistant chief, art museum education. I am of course grateful to Andrea L. Rich, president and director of LACMA, for her enthusiastic support of this project and for appreciating the great honor of co-organizing this landmark exhibition for presentation in Tim's hometown.

At the Whitney, my thanks go to Adam D. Weinberg, Alice Pratt Brown Director, as well as to Maxwell L. Anderson, former director, under whose tenure this project began. I would also like to thank Christy Putnam, associate director for exhibitions and collections management, for her steady guidance. Suzanne Quigley, head registrar, and Tara Eckert, associate registrar, have devoted their attention and care to this unusually complex project. Joshua Rosenblatt, head preparator, and the installation team have outdone themselves with their careful and concerned handling of these works. I am grateful to Mark Steigelman, manager, design and construction, for his elegant and economical installation design. Meg Calvert-Cason, exhibition coordinator, has proved invaluable as a coordinator and liaison throughout the development of this project. Scott Elkins, associate director and director for development, worked assiduously to obtain the necessary financial support for the exhibition. In the curatorial department, I want to thank most of all Tina Kukielski, senior curatorial assistant, for her unparalleled organizational skills. Without her insights and dedication, this exhibition would not have come to pass. Kenneth Fernandez, senior curatorial assistant, is to be thanked for his remarkable modeling skills. Interns Erin Scime and Catherine Krudy made important contributions to the research and organization of the exhibition. I would also like to thank Jan Rothschild, associate director for communications and marketing, as well as Stephen Soba, communications officer, and Meghan Bullock, communications coordinator, for their great work in generating publicity. Raina Lampkins-Fielder, associate director, Helena Rubinstein Chair for Education, led her fantastic team in developing education and public programs for a wide range of visitors.

This catalogue marks a significant milestone in Tim Hawkinson's career, including not only three substantial essays but also background information provided by the artist on many more works than are included in the exhibition itself. It will prove to be an important resource for years to come. I would like to express my gratitude to both Howard N. Fox and Doug Harvey for their insightful and penetrating essays. Rachel de W. Wixom, head, publications and new media, has been an exceptional midwife for this complex project. I would also like to thank Anita Duquette, manager, rights and reproductions, who obtained rights for many of the illustrated works; Kate Norment, our exceptional editor; Thea Hetzner, associate editor; and Makiko Ushiba, manager, graphic design, who has assisted throughout with issues pertaining to the design of the catalogue and other related materials. My thanks go especially to Omnivore, which has created a catalogue worthy of Tim Hawkinson's genius.

Of course none of this could have happened without Tim Hawkinson himself. He has been a wonderful partner in every facet of developing the exhibition. I am amazed by his artistry and grateful for his humility and patience.

LAWRENCE RINDER is an adjunct curator at the Whitney Museum of American Art.

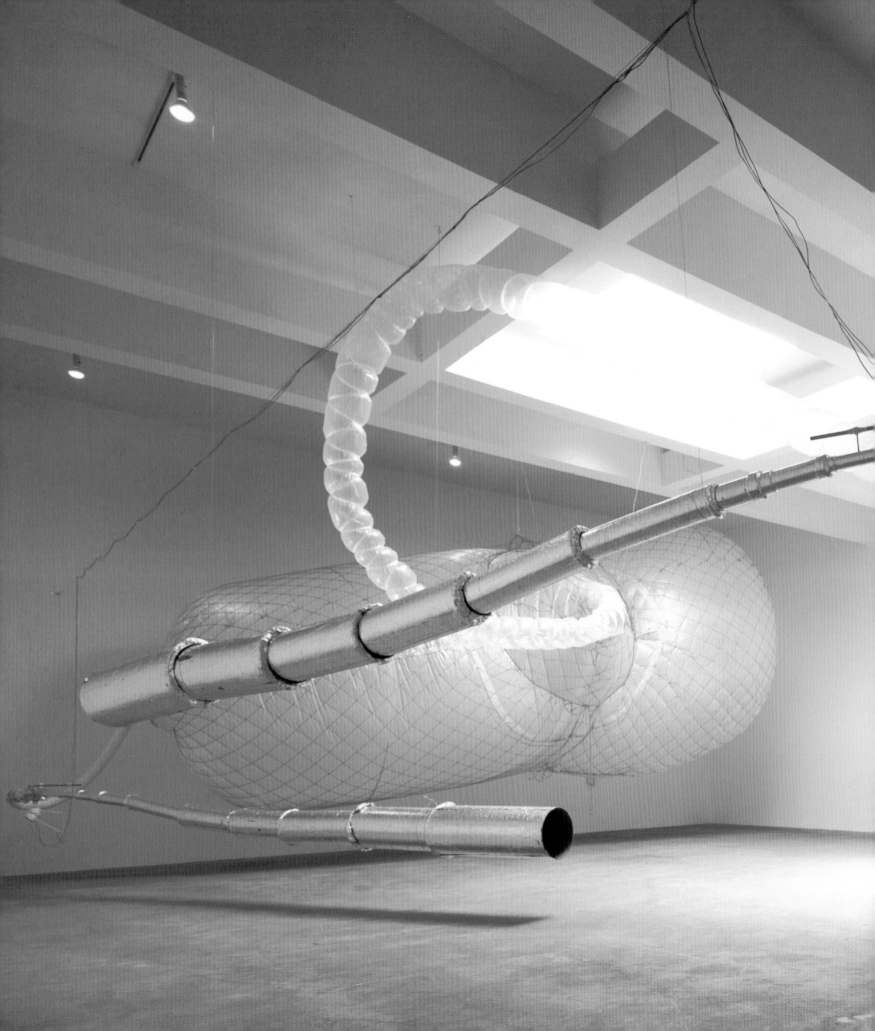

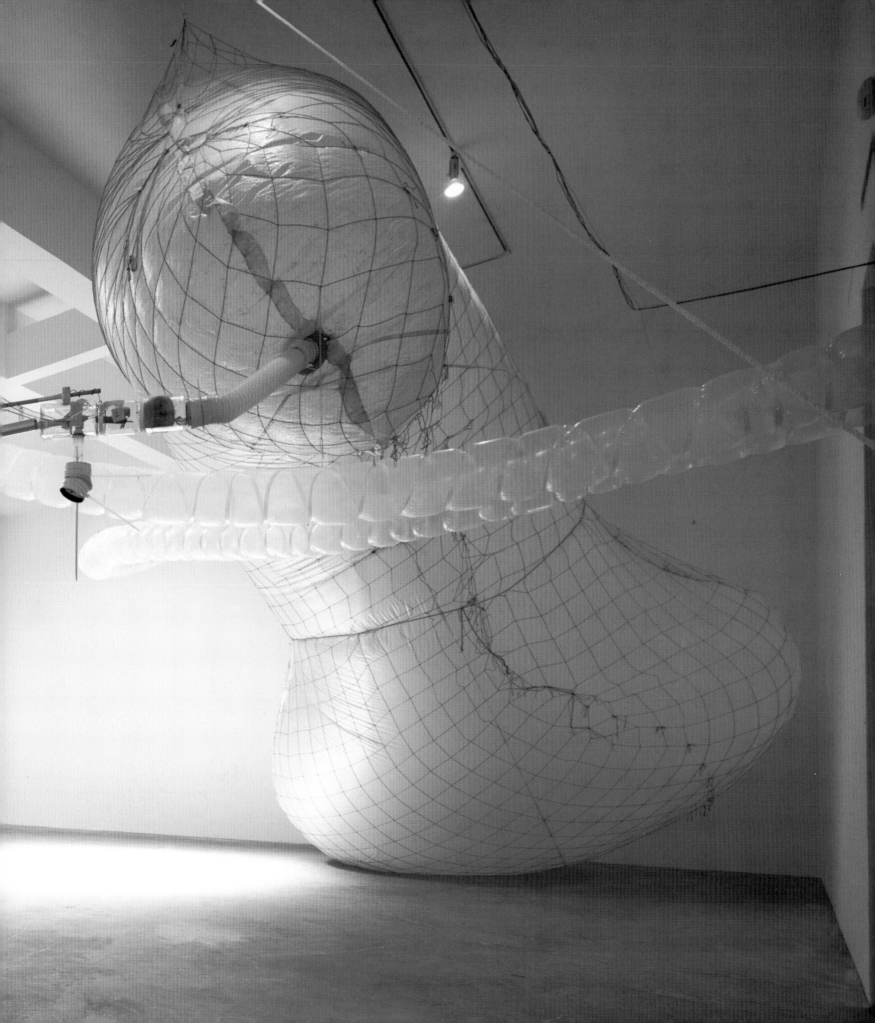

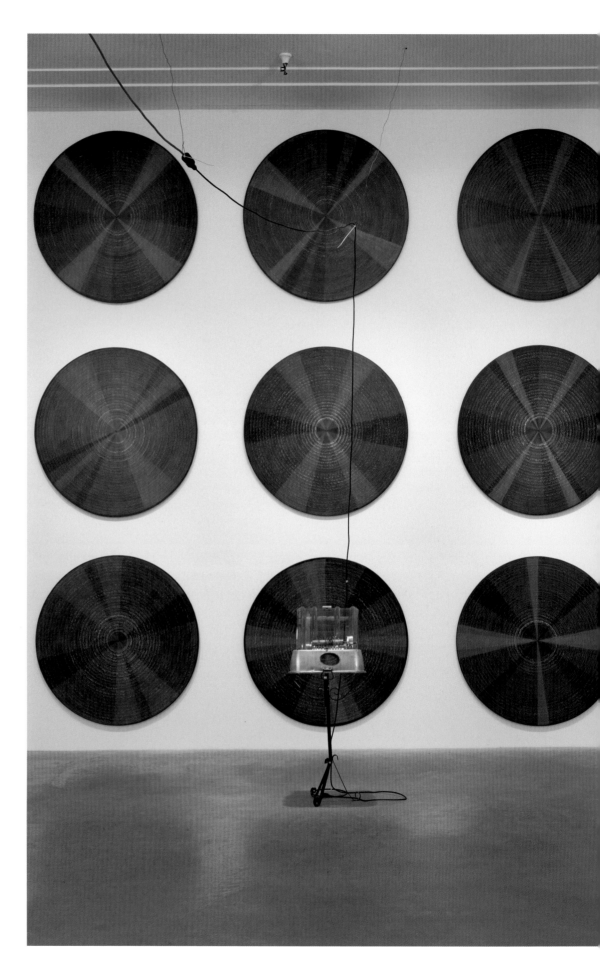

My Favorite Things, 1993

My Favorite Things
Lawrence Rinder

Tim Hawkinson's art is nothing if not idiosyncratic; the peculiarity and eccentricity of his art is legendary. His work does not rest comfortably within a single medium but skips erratically among drawing, painting, sculpture, photography, video, and sound. The creation of his astonishingly original works even at times necessitates the invention of entirely new tools and techniques. He has an ad hoc approach to materials, finding inspiration in the wealth of discarded objects found in the vicinity of his studio in an industrial area of Los Angeles. Stylistically, his work displays little continuity and cannot easily be broken down into categorizable periods. While his own body has been his most significant source of imagery, Hawkinson is equally at home working in abstract modes or transforming found images from a wide variety of sources. Hawkinson's unpredictability and inventiveness are a large part of what has delighted audiences of his work over the past two decades. Yet these characteristics have also made him hard to pin down and endowed him with an almost outsider status.

Unique as his art may be, Hawkinson clearly belongs to his age and his works are engaged with the most timely concerns of contemporary artistic practice. Between 1986 and 1989, Hawkinson attended UCLA, where he studied with Charles Ray, who was at the time creating sculptures that incorporated allusions to the body, mortality, and time. Ray's surrealistic approach to imagery was balanced by a belief in the importance of form, and he frequently cited the British sculptor Anthony Caro's abstract works as models of artistic excellence. Ray's own works often involved minimal forms created from unexpected materials or endowed with peculiar powers. One work, for example, which appeared to be a solid cube was actually filled with black ink, while another, a white disk embedded in the wall, spun so fast that it almost disappeared. There is something bizarre, almost punk-ish, in these strange twists on simple geometric forms. In Hawkinson's work, too, explorations of shape, composition, and texture are as significant as — and often intimately connected to — the thematic and psychologically expressive aspects of his art. Another seminal influence was Mike Kelley, a Los Angeles–based artist whose work touched on issues of the body, sexuality, and altered mental states. Especially important for Hawkinson were Kelley's psychological themes, his incorporation of found materials, and his use of repetition and accumulation as formal strategies. For both artists, the mundane materials and images of everyday American life contain the seeds of disturbing reflections on consciousness and the nature of being.

The distinctive balance between mind and body, conceptualism and viscerality that characterized much of the most important art being made in Los Angeles in the mid-1980s was indebted to the revolutionary early-twentieth-century work of Marcel Duchamp, who pioneered the use

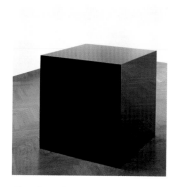

Charles Ray
Ink Box, 1986
Steel, ink, and automobile paint, 36 x 36 x 36 in. (91.4 x 91.4 x 91.4 cm)
Orange County Museum of Art, Newport Beach, California; museum purchase with additional funds provided by Edward R. Broida

Mike Kelley
More Love Hours Than Can Ever Be Repaid and The Wages of Sin, 1987 (detail)
Stuffed fabric toys and afghans on canvas with dried corn; wax candles on wood and metal base, 90 x 119 1/4 x 5 in. (228.6 x 302.9 x 12.7 cm)
Whitney Museum of American Art, New York; purchase, with funds from the Painting and Sculpture Committee 89.13a–e

Bruce Nauman
Eating My Words,
1966–67/1970, from the
series *Photograph Suite*
Chromogenic color print,
19 9/16 x 23 5/16 in.
(49.7 x 59.2 cm)
Whitney Museum of
American Art, New York;
purchase 70.50.5

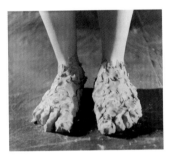

Bruce Nauman
Feet of Clay,
1966–67/1970, from the
series *Photograph Suite*
Chromogenic color print,
19 11/16 x 23 5/16 in.
(50 x 59.2 cm)
Whitney Museum of
American Art, New York;
purchase 70.50.8

of found objects and images in his so-called "readymades" and called for an end to "retinal" art. His works were not the result of painstaking struggles with paint on canvas but rather the outcome of methodical and reasoned activities, the results of which were known in advance. Yet, despite its conceptual basis, Duchamp's art is neither dry nor pedantic but pervaded by a compelling air of eroticism and mystery. Bruce Nauman, who lived in the Los Angeles area in the 1970s, provided an important link between Duchamp and the artists of Hawkinson's generation. Nauman, like Duchamp, was interested in the importance of language as the fundamental medium of human consciousness. However, his work possesses a relatively informal appearance, often engaging with the brute physicality and ephemerality of the human body. For Nauman, as for Hawkinson, body and thought are two sides of the same coin.

As important to Hawkinson as the California artists working in the Duchampian tradition were others whose work explored eccentricities of form. A trip to New York City in the mid-1980s exposed him to the vitality and exuberance of the graffiti art that was moving quickly from the streets to the galleries of the East Village. Other artists who captured his imagination were Judy Pfaff and Elizabeth Murray, both of whom were creating works that exploded the conventional boundaries of the pictorial frame. Challenging the distinction between painting and sculpture, these artists created unconventional grounds for paint, from Pfaff's chaotic linear tangles to Murray's bizarrely shaped canvases. Murray's paintings are especially relevant to Hawkinson's later work for their provocative mingling of figuration and abstraction and the grotesque distortion of the human form. Pfaff's and Murray's formal approach can be summarized by Frank Stella's statement in his much-debated book *Working Space*: "With abstraction the problem is more one of sustaining pictorial energy than of keeping an image intact."[1] In his own work of the mid-1980s, Stella attempted to express in a contemporary, abstract language the spatial complexity and formal dynamism that he celebrated in sixteenth-century Baroque painting, especially the work of Caravaggio.

One of the most distinctive features of Hawkinson's work is his fascination with mechanical devices. Many of his works are motorized, enabling them to move, play music, and even speak. A key precedent for this aspect of his art is to be found in the work of Jean Tinguely, a Swiss artist who created extraordinary contraptions from scraps of metal and improvised electronics. One of Tinguely's most famous works, *Homage to New York* (1960), was an enormous kinetic sculpture designed to self-destruct in a riot of steel, junk, and noise in the sculpture garden of New York's Museum of Modern Art. A more contemporary version of Tinguely's kinetic art was made by the collective known as Survival Research Laboratories, or SRL, which presented spectacles consisting of pitched battles among postapocalyptic-looking robots. SRL, which was based in San Francisco, was particularly active in the Bay Area in the early 1980s, when Hawkinson was a student at San Jose State University. Hawkinson's machines rarely display the overtly threatening posture of SRL's cyborgs, yet some of them do possess an undercurrent of morbidity and malevolence.

Like every artist, Hawkinson is defined in part by his influences. But his real significance lies in the unique ways that he expresses his own fundamental artistic concerns. Hawkinson himself is far more inclined to speak about his materials and techniques than to address the thematic aspects of his work. Ask him about a piece and he'll tell

you what he did to make it, sharing his pleasure in discovering a hidden nuance of texture, an unexpected resonance of forms, or a clever solution to a mechanical conundrum. His repertoire of ideas is seemingly limitless and his instinct for creating startling new images is rare. With a combination of imagination and ingenuity, Hawkinson creates works that make us feel that anything is possible. He ignores the difficulties of scale, elicits strange effects from common materials, and coaxes ethereal sounds out of rudimentary machines. He obstinately avoids high-tech shortcuts, preferring time-consuming but viscerally satisfying hand fabrication. The hint of the supernatural that hovers around many of his works is echoed in his oeuvre as a whole: "How could one person have thought of all this," one wonders, "let alone make it?" Yet wondrousness, appealing as it may be, is not the whole reason for the importance of Hawkinson's work. Rather, it is his ongoing and subtle exploration of themes of existence, free will, and the passage of time that gives his art the richness and complexity that rewards sustained contemplation.

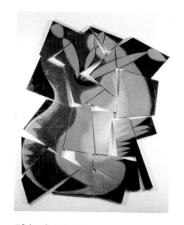

Elizabeth Murray
Painter's Progress,
1981
Oil on canvas, nineteen
parts, 116 x 93 in.
(294.5 x 236.2 cm)
The Museum of Modern Art,
New York; acquired
through the Bernhill Fund
and gift of Agnes Gund

Many of Hawkinson's works challenge and even transform our sense of the real. Time, space, and the integrity of forms all come under his withering scrutiny. His perspective is no doubt unusual, yet rarely is he so outrageous that we can calmly dismiss his peculiar visions as deriving from some world other than our own. His use of everyday materials, the incorporation of old-fashioned and even antique objects and images, and the clearly handmade quality of his works, including his cobbled-together machines, encourage this sense of familiarity and identification. So, too, does the methodical, quasi-scientific nature of his practice. His compulsively measured, timed, and detailed works possess a seductive technical authority. Hawkinson's approach to the question of being and the problem of existence is far from esoteric. He grounds his works in a variety of formal strategies through which the viewer is led to contemplate philosophical concerns. Among these strategies are contrasts of scale, the representation of negative space, repetition, and the creation of self-reflexive forms.

Contrasts of scale reflect on our experience of being in part because when faced with something radically larger or smaller than ourselves we are inclined to consider our place in the universe, our position relative to other objects and beings. Hawkinson is probably best known for his enormous sculpture *Überorgan* (2000), a mammoth music-machine that can extend to nearly the size of a football field. Essential to this work is the effect of its scale on the viewers' sense of their own size. Standing beneath *Überorgan*'s bellowing bladders and pipes, one feels not only dwarfed but also oddly displaced, as if swallowed by some gargantuan song-loving creature. In this work, Hawkinson plays on the double meaning of the word "organ" while alluding to the historical origin of the bagpipe instrument as an inflated stomach. The songs played by *Überorgan*, which runs on a player piano–like scrolling score, are a combination of traditional American songs and religious hymns. The all-encompassing, organic sounds that emanate from the looming bags and ducts suggest simultaneously the internal gurglings of a living body and the impossibly vast music of the so-called Harmony of the Spheres, a medieval notion that the planets in their orbits created a cosmic melody.

Frank Stella
Silverstone, 1981
Mixed media on aluminum
and fiberglass, 105 ½
x 122 x 22 in. (268 x
309.9 x 55.9 cm)
Whitney Museum of
American Art, New York;
purchase, with funds
from the Louis and
Bessie Adler Foundation,
Inc., Seymour M. Klein,
President, The Sondra
and Charles Gilman, Jr.
Foundation, Inc., Mr. and
Mrs. Robert M. Meltzer,
and the Painting and
Sculpture Committee
81.26

Hawkinson's large drawing *Humongolous* (1995) also depends on surprising contrasts of scale, although in this case they are contained within a single human body. The body is Hawkinson's own, a naked,

Frank Stella
Die Fahne hoch!, 1959
Enamel on canvas,
121 1/2 x 73 in. (308.6
x 185.4 cm)
Whitney Museum of
American Art, New York;
gift of Mr. and Mrs.
Eugene M. Schwartz and
purchase, with funds
from the John I.H. Baur
Purchase Fund; the
Charles and Anita Blatt
Fund; Peter M. Brant;
B.H. Friedman; the
Gilman Foundation, Inc.;
Susan Morse Hilles;
The Lauder Foundation;
Frances and Sydney Lewis;
the Albert A. List Fund;
Philip Morris Incorpora-
ted; Sandra Payson;
Mr. and Mrs. Albrecht
Saalfield; Mrs. Percy
Uris; Warner Communica-
tions Inc.; and the
National Endowment for
the Arts 75.22

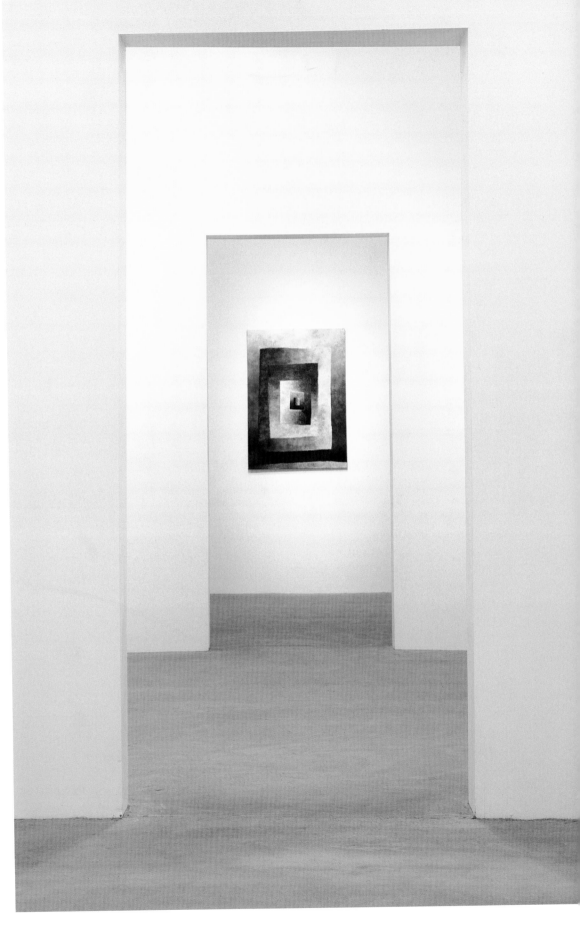

Untitled (Brown Rectangles), 1988 (installation view at Ace Gallery)

grossly distorted, and seemingly flayed pink skin. Despite its apparent oddity, the rendering was actually made with a straightforward logic. To create *Humongolous*, Hawkinson methodically marked a grid over his entire body. He then translated the information contained in each small square onto a large, flat surface. Because he could perceive more information in the areas of his body that he could clearly see, these areas became larger in the final piece. Certain distortions, specifically the flayed appearance of his arms, hands, and feet, are the result of the fact that he was able to see multiple sides of a specific limb or area. Areas that he could not see at all, such as his back or anything above his shoulders, are missing entirely from the drawing. *Humongolous*, however distorted it may appear, is an empirical record of the artist's physical self-perception mapped from three dimensions onto two. Here, Hawkinson reveals the degree to which the visual norms of the human form are the result of conventional ways of seeing. In an untitled 2003 work, Hawkinson substitutes for these quasi-scientific investigations a fantastically surreal though no less methodical procedure for exploring shifts of scale in the human form. This piece combines a large-scale photograph of the artist's body seen from above with smaller photos of his hands. Each finger of the figure in the larger photo seems to sprout a small hand from its tip, the fingers of which, in turn, sprout another hand and so on at exponentially tinier scales.

A more abstract version of this approach is found in the ink drawing *Jerusalem Cross* (1997), in which a central, equilateral cross is repeated ad infinitum at ever finer scales within its own quadrants. Combining the weighty symbolism of the cruciform—Hawkinson derived the pattern from Christian liturgy concerning the equal status of the four Gospels—with the informality of a doodle, the work can be read as a kind of fractal in which reality on one scale finds its mirror image on another. A related work, *Untitled (Brown Rectangles)* (1988), consists of a concentric series of brown and white rectangles that telescope into the center of the composition. In this painting, Hawkinson gave particular emphasis to the brushstrokes, an approach that is unusual for a work of pure geometric abstraction. The painterly aspect of the work is further amplified by the alternation of light and dark passages, which creates a suggestion of both solid form and ethereal atmosphere. Curiously, this work appears to combine two seemingly antithetical traditions, on the one hand an orderly classicism exemplified by Frank Stella's so-called Black paintings and on the other the pictorial dynamism of Caravaggio's Baroque compositions.

An important feature of these works is their quality of self-reflexive insularity, turning back on themselves in an echoing loop of signification. One of Hawkinson's most powerful images of this kind is the sculpture *H.M.S.O.* (1995). Like a tall-masted sailing ship that has succumbed to uncontrollable growth, this vessel curves in on itself, its hull forming a complete circle while its masts create a bristly central vortex. As the title indicates, this surreal, wheel-like vessel carries the name "O," an allusion both to its shape and to a feeling of terminality, a "zero-ness" of options and opportunities. Though it is an exquisite form and even a humorous image, *H.M.S.O.* exudes a profound sense of Sisyphean futility. A similar sense of pointless, self-reflexive replication is to be found as well in the sculpture *Shrink* (1998). In what is perhaps a subtle nod to Conceptual artist Joseph Kosuth's seminal conceptual art work '*One and Three Chairs [ety.]*' (1965) involving a chair, a photo of the chair, and the definition of the word "chair,"

Michelangelo Merisi da Caravaggio
Saint John the Baptist, 1597–98
Oil on canvas, 51 $^{15}/_{16}$ x 38 $^{3}/_{16}$ in. (132 x 97 cm)
Pinacoteca Capitolina, Musei Capitolini, Rome

Wall Chart of World History from Earliest Times to the Present, 1997 (detail)

Shrink juxtaposes an ordinary wooden chair and a smaller version of this same object. Using thin threads, Hawkinson leads the viewer's eye from each tiny piece of wood composing the small chair to the vacant hole on the larger chair that was its source. In contrast to Kosuth's piece, which shows an equivalence among the real thing and its representations, Hawkinson's work suggests a strange cannibalistic interdependence. Similarly, in the collage *Cyctor* (1997) tiny round fragments of a found poster showing a smiling young woman have been reassembled on the original to create the image of a doctor's forehead mirror reflecting the woman's own eye. The title is a composite of the words "cyclops" and "doctor." Reality, in these works, appears to be in the process of consuming itself.

Joseph Kosuth
'*One and Three Chairs [ety.],*' 1965
Mounted black-and-white photograph and chair, dimensions variable
Courtesy the artist and Sean Kelly Gallery, New York

In Hawkinson's universe, as in ours, matter is finite; to create one thing, another must be lost. *Wall Chart of World History from Earliest Times to the Present* (1997) is a 35-foot-long scroll abstractly representing a record of all human activity. The work was inspired by history charts produced for education and amusement in the nineteenth and early twentieth centuries. *Wall Chart* is intended by the artist to be seen with a companion piece, *(Index) Finger* (1997). Bundling together the dozens of red pens and pencils he used to draw *Wall Chart*, Hawkinson transforms them into the innards of a sliced-off fingertip. The contrast of these two works alludes not only to the artist's own painstaking labor in creating the enormous chart (he "worked his fingers to the bone") but also to the work of humanity in creating history itself. Yet, despite these allusions to his own and humanity's most basic means of production (the use of the color red may indeed symbolize socialist ideology), there is ultimately something hollow about these two works. The kind of "history" represented in *Wall Chart* is not conventionally linear or even dialectical. Rather, Hawkinson shows an incomprehensible pattern of squiggles and loops that appear to go everywhere and nowhere at once. There is no sense of progress or development, just a self-consuming tangle of pointless indirection. The inside of *(Index) Finger* reveals not the muscle and bone of organic viscera but an orderly stack of image-making tools.

Tim Hawkinson
(Index) Finger, 1997
Pens, pencils, and polyester resin
5 x 5 x 6 in. (12.7 x 12.7 x 15.2 cm)
Private collection; courtesy Ace Gallery

The hollowness of being and time is touched upon frequently in Hawkinson's work. His painting *Conception of Time* (1988) shows what appear to be antique clock hands in the process of "fertilizing" a white, oval, egglike form. Yet, if this is the beginning, i.e. the "conception," of time, where did the clock hands come from? Hawkinson hands us a philosophical chicken-and-egg proposition. The central void in *Conception of Time*, a relatively early piece, anticipates the subsequent formal importance of negative space in Hawkinson's work. For Hawkinson, negative space — which is, conventionally, the empty areas surrounding or enclosed within a figure or form — takes on its own potent, physical reality. *The Fin Within* (1995), for example, is a sculpture made from a plaster cast of the space between Hawkinson's legs. In contrast to the work of other artists, such as Duchamp and Nauman, who also made sculptures out of the shapes and hollows of their own bodies, Hawkinson does not simply leave the work as a mute record of space. Instead, he adds crosshatch marks and fans out the lower body to suggest an alternative figurative reading, specifically the fin of a mermaid or merman. Curiously, another work, *Blindspot* (1991), which deals with negative space in a very different way, also results in an oddly fishlike form. This piece is a photomontage composed of shots of all the parts of Hawkinson's own body that he is unable to see without

the aid of a mirror. They are, in effect, the perceptual "negative spaces" of his body. When assembled contiguously on a two-dimensional surface, these photos result in a form that resembles an enormous flounder. The religious connotations of this vaguely cruciform figure are accentuated by the addition of a brightly gilded frame.

Many of Hawkinson's works reveal imagery and compelling forms through processes of elimination. *Untitled (Bleached Football Game)* (1990), for example, was made by literally bleaching out all the figures in a photograph of a football game and leaving only the scattered numbers on the players' jerseys. Hawkinson also performs compelling acts of erasure on his own body. *Self-Portrait (Height Determined by Weight)* (1990) is a radically truncated figurative sculpture. From its bare feet, the figure extends only halfway up the calves before abruptly ending. The piece is made of solid lead that has been measured to correspond to Hawkinson's own weight. By determining his body's height by its weight in lead, Hawkinson expresses one quality of his physical form (his weight) at the expense of another (the visibility of his upper body). In his series of so-called "bathtub-generated" self-portraits, Hawkinson began by reclining in a bathtub as successive layers of black ink were poured in, slowly covering his entire body. Each successive layer was documented photographically. Using these photos, Hawkinson was able to create a complex topographical rendering of himself based on the superimposition of the successive ink outlines. *Bathtub-Generated Contour Lace* (1995), which belongs to this series, suggests the degree to which Hawkinson was able to conjure extraordinary imagery from what was essentially a methodical erasure of his own body. This work possesses an ethereal quality, as if it represented patterns of energy or spirit emanating from a now absent physical form.

Hawkinson's interest in negative space and erasure adds a metaphysical dimension to his concern with existential issues. While at times Hawkinson seems content to explore the purely physical aspect of unseen space, he admits, as well, hints of powerful unseen forces at play beyond our field of vision or scope of perception. *Untitled (Barn with Vortex)* (1991) was created by cutting an ordinary found landscape painting into strips and rearranging them to transform the bucolic scene into a field of vertiginous distortion. A later work, *Draw! Paint! Weave! Spin!* (1996), captures a similarly psychedelic merging of form and flow. This simple woven pattern, resembling a rudimentary doily, appears twisted and turned as if under the influence of some kind of cosmic wind. In his figurative sculptures, too, there is frequently the suggestion of an external force at play. Hawkinson's *Balloon Self-Portrait* (1993), for example, which consists of a latex cast of the artist's body that has been turned inside out, is inflated through a tube that extends from another piece, called *Reservoir* (1993), a wall-size latex pouch similarly inflated by means of forced air. The relationship between these two works is like the connection of a fetus to the placenta and suggests the dependency of living beings on a source of nurture and, literally in this case, inspiration.

Emoter (2002) shows the artist's image under the inexorable influence of random electronic signals. This piece is composed of a photograph of the artist's face that has been cut up into fragments and reassembled in a kinetic collage in which the various parts of the face are moved by hydraulic mechanisms. These mechanisms in turn are driven by light sensors attached to the screen of a television that is tuned to a broadcast program. The sensors capture the flickering of light

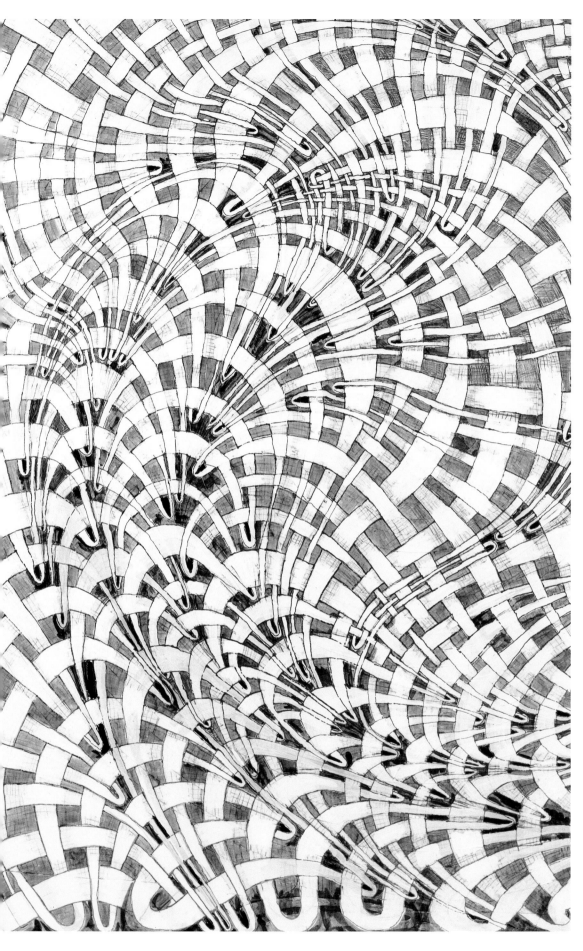

Draw! Paint! Weave! Spin!, 1996 (detail) TIM HAWKINSON 22/23

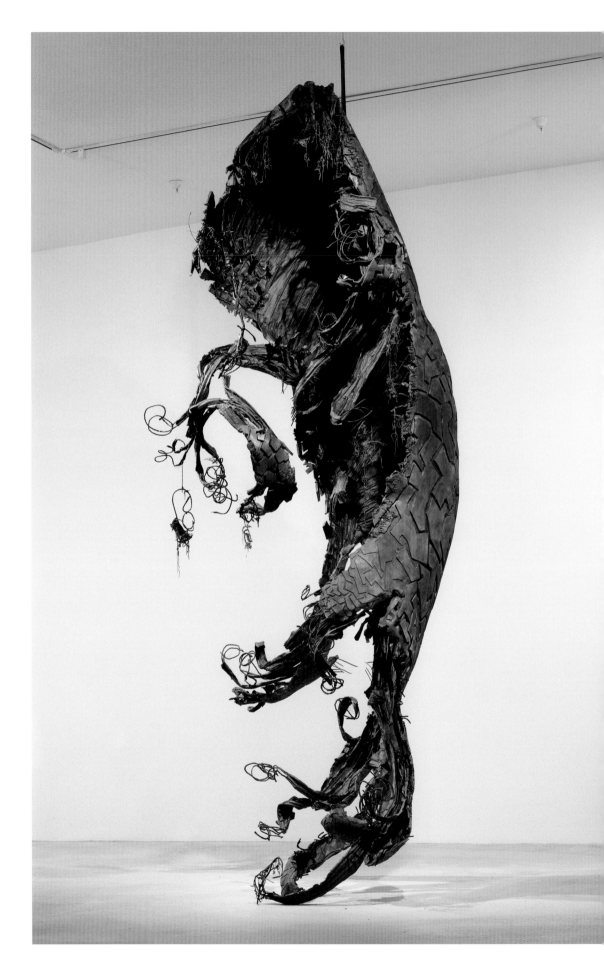

Magdalen, 2003

on the screen and transfer this information into signals that control the lips, eyes, and eyebrows of the collage. On a more abstract level, Hawkinson raises the issue of existential dependency by foregrounding the presence of the extension cords that bring power to his mechanical works. He has woven various forms into these cords, from a vessel to a pair of shorts, and hangs them from the ceiling in full view. Works such as these raise issues of free will and the autonomy of the human spirit.

A related concern, touched on in several works, is the notion that the human being is simply a soulless biological machine. In *Signature* (1993), for example, a contraption mounted to a school desk mechanically generates scraps of paper inscribed with Hawkinson's signature. These pile up at the base of the desk like endlessly generated clones. In several kinetic figurative and quasi-figurative works, Hawkinson prominently displays their activating machinery at a near distance from the figure itself. Indeed, the machinery is often as prominent as the figure, and sometimes more so. Like *Überorgan*, Hawkinson's *Ranting Mop Head (Synthesized Voice)* (1995) and *Drip* (2002) both run off of player piano-like scrolls that generate electronic signals controlling the art works' sound. *Ranting Mop Head* itself is almost pure machine, with only the hairlike strands of a mop and a nattering voice to signify a human presence. *Drip*, a fantastical, octopuslike form that hangs high above the floor, has even fewer vestiges of the human figure. However, the oddly precise staccato rhythm generated by the sound of water dripping from its many tentacles into metal buckets suggests the existence of some kind of intelligent control. So, too, does the fact that the piece begins to function only when a viewer enters the room. Like *Drip*, in Hawkinson's hands even inanimate objects take on lifelike characteristics.

The nature of life is one of Hawkinson's central concerns, so it is not surprising that one finds the theme of mortality widely evident in his work. In *Armor Ooze* (1996), what appears to be a recumbent knight in armor literally oozes a grotesque pusslike material. *Penitent* (1994), meanwhile, consists of a submissively kneeling skeleton made of rawhide chew toys that emits a "come here" whistle as if calling willfully for its own demise. An allusion to ancient Egypt's cult of the dead is found in *Butterflummies* (1993), a work made with ordinary aluminum foil mounted on wood and scored to create images of butterflies enclosed in cocoonlike wrappings. Despite the constriction of their bodies, the three insects, arrayed in a mystical triad, display marvelous outstretched wings.

Hawkinson, whose parents owned an antique shop, is especially interested in the evocative nature of time-worn, broken, and discarded materials. One of his earliest pieces, *Untitled (Sinking Ship)* (1987) incorporates an old wig encased in a thick varnish that is itself enclosed by an equally hoary wooden chair seat. The curving tendrils of brown hair are arranged in a manner that suggests a pattern of enormous waves or the tentacles of a giant octopus, forming a border that recalls the decorative elements of ancient Cretan art. On the wig's liner, Hawkinson has painted an image of a sinking ship. This work combines morbid themes of ancient myths — the perils of the *Odyssey* come to mind — with a more contemporary psychological symbolism that juxtaposes an "internal" mental state (the image of a sinking ship) with an external manifestation (hair, in the form of waves or tentacles). At times, Hawkinson goes to tremendous lengths to create from scratch pieces that seem at first glance to be found or abandoned items. His large sculpture

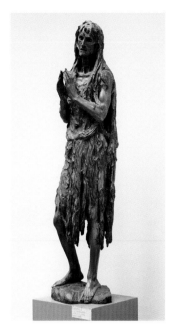

Donatello
Mary Magdalen, 1453
Wood
Museo dell'Opera del
Duomo, Florence

Tim Hawkinson
Untitled (Sinking Ship),
1987
Oil on wig on wooden
chair seat and varnish,
16 (diam.) x ³/₄ in.
(40.6 x 1.9 cm)
Private collection

Magdalen (2003), which appears to be a gargantuan blown-out truck tire, was meticulously fabricated by the artist from sundry materials. Like *Untitled (Sinking Ship)*, this work has latent figurative content; specifically, as the title suggests, the tangled "tire" shreds echo the appearance of Donatello's sorrowful sculpture of Mary Magdalen.

At times, Hawkinson's fastidiousness seems strangely at odds with the entropic themes of his work. *Shatter* (1998), for example, which appears to be a large broken sheet of glass, is in fact the intricate pattern of hand-assembled plastic fragments extending from what appears to be a central point of impact. Some of his most obsessively constructed pieces not only concern mortality but are also made from materials removed from his own body. *Bird* (1997), one of Hawkinson's most diminutive sculptures, takes the form of a tiny bird skeleton made up of the artist's own fingernail clippings. His nails as well as hair were crushed together with glue to form a related work, *Egg* (1997), which appears to be a tiny bird's egg that has cracked in two. The incorporation of bodily materials in images of death, dismemberment, and mortal entrapment conveys a visceral, personal connection to these morbid themes.

Hawkinson has referred to the works in his *Secret Sync* series, a group of highly unusual clocks, as *memento mori*, a term used to denote imagery intended as a reminder of mortality. Images of clocks have been used symbolically in this way for hundreds of years, appearing in still-life paintings alongside decaying flowers and spilled wine to suggest that the simple passage of time is the most certain cause of death. Yet Hawkinson's clocks do not initially seem to be tinged with morbidity. Fashioned out of the most unexpected materials — the clasps of a manila envelope, strands of hair caught in a brush, the stitches of a wound, a Coke can pull tab, the twist tie on a garbage bag, the petals of a daisy, the filaments of a bulb, and so on — these works possess a dry humor and a disarming charm. However, by surreptitiously embedding clocks in ordinary objects, Hawkinson suggests the inescapability of time and its consequences.

Hawkinson has created numerous clocks besides those in the *Secret Sync* series. Some of them, such as *Spin Sink (1 Rev./100 Years)* (1995), incorporate other key dimensions of his work such as repetition and the contrast of scales. *Spin Sink* consists of a linear sequence of twenty-four gears, arranged in order from smallest to largest. The interlocking gears turn at progressively slower rates as they grow in size and extend farther from the tiniest gear, which, driven by a toy car motor, spins at 1,400 rpm. The largest gear, by contrast, turns approximately once every hundred years. Silver, clock hand-like arrows painted on each gear, which were in alignment when the piece was first turned on, become progressively more out of synch as the gears turn. Like the strange sensation of being confronted with something vastly larger or minutely smaller than oneself, the contrast of speeds can elicit an awareness of one's own relative position in the scale of time. In *Spin Sink*, the notion that all time, whether measured fast or slow, exists on a single continuum is expressed by the mechanical interdependence of the series of gears. Hawkinson helps to make this abstract engagement with the subtleties of time more familiar and accessible by taking a decidedly informal approach to the work's construction: the gears are made from scraps of found wood and some of the gear teeth themselves are, ingeniously, composed of strips of the artist's corduroy pants.

Many of Hawkinson's works function through processes of translation, such as transposing a three-dimensional form onto a two-dimensional

surface, representing his own height measured by weight, or enabling an image of his face to register emotions according to random electronic signals. *My Favorite Things* (1993) translates the information contained in a time-based medium, music, into the static form of drawings on paper. To create this work, Hawkinson listened to fifteen albums, from Scarlatti to Gentle Giant, while making spontaneous impressionistic marks in tightly wound spiral patterns on large black circles of paper. His right hand responded to the melodies and his left to the rhythms of the songs. The resulting works appear from a distance to resemble old vinyl records. When more closely examined, they reveal their unique abstract hieroglyphic "texts." Accompanying the wall-mounted installation of these disks is a typically cobbled-together music box made from an old roasting pan and bits of scrap metal that plays a rudimentary but recognizable version of the song from *The Sound of Music* after which the piece is named.

 My Favorite Things encapsulates many of the key themes and techniques of Hawkinson's art. The allusion to vinyl records, as well as to a song that has become so much a part of the vernacular repertoire, endows the piece with a nostalgic allure. Like many of his works, this piece possesses an almost fossil-like stasis. The tropes of repetition and outsized scale, familiar from works such as *Wall Chart* and *Überorgan*, are expressed here with geometric clarity. And, much as these other works combined mechanical and "human" elements, *My Favorite Things* juxtaposes an electronic music device with markings that record the artist's own physical and emotional responses to various songs. Despite Hawkinson's handmade marks, the industrialized, mass-produced appearance of the disks resonates with other works, such as *Signature*, in which he gently questions the uniqueness of our individuality. By juxtaposing the disk drawings with a functioning music box, he demonstrates—as he does in the relationship of *Reservoir* to *Balloon Self-Portrait*—the logic and method of the work's creation and the underlying dependency of one aspect of the work (in this case, the drawn marks) on an external source or motive (in this case, the songs). Through these various strategies, Hawkinson presents us with a deceptively simple work in which are embedded serious musings on existence, free will, and the passage of time. Nevertheless, as the title of the work itself suggests, for Hawkinson there will always remain the wonder and allure of his "favorite things," the inexhaustible supply of images, objects, textures, sounds, and forms that capture his imagination and inspire him to create.

1. Frank Stella, *Working Space* (Cambridge: Harvard University Press, 1986), p. 164.

LAWRENCE RINDER is adjunct curator at the Whitney Museum of American Art and dean of graduate studies at the California College of the Arts, San Francisco. He has curated and authored the catalogues of, among other important exhibitions, the Whitney's *2002 Biennial Exhibition* and *The American Effect: Global Perspectives on the United States, 1990–2003* (2003). He was a contributing editor of *Nest* magazine, and is currently a contributing writer to *Artforum* and *The Village Voice*.

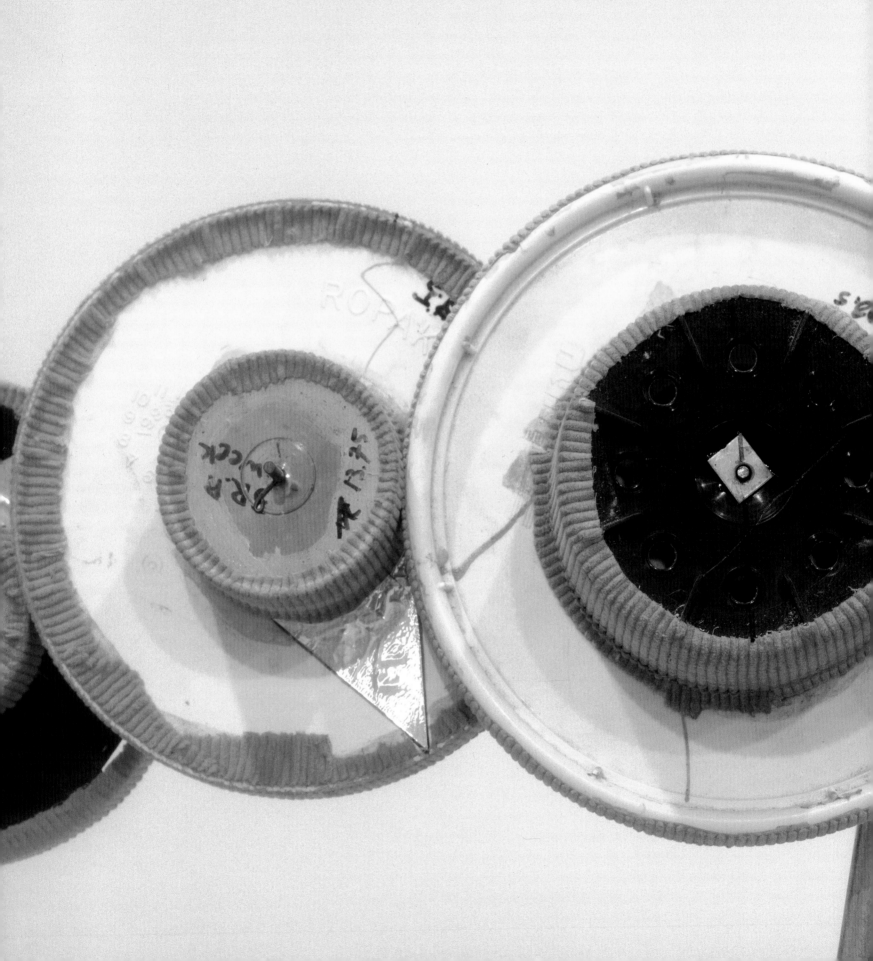

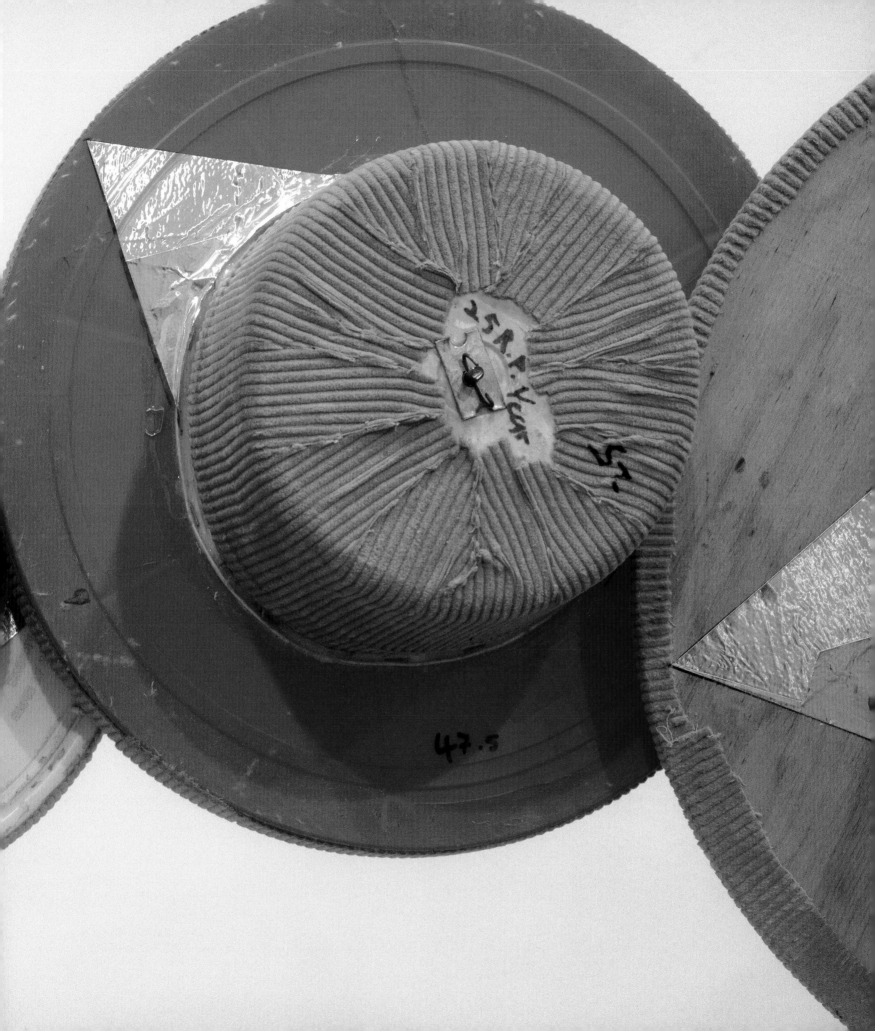

Speaking in Tongues: The Art of Tim Hawkinson

Howard N. Fox

Los Angeles–based Tim Hawkinson is a phenomenon within the art world and beyond. His 1995 solo exhibition in New York was heralded by critics as "astounding," "larger-than-life," and an "extravaganza... [that] must be seen to be believed."[1] Popular response was equally wowing, with eager viewers queuing up in lines that snaked around the block awaiting entry into Ace Gallery, where the vast rooms were jam-packed with spectators wondering at a breathing human skeleton, a giant inflated bagpipe, a flotilla of mechanized contraptions, obsessively intricate drawings, and an inflated latex balloon in the shape of a nude male floating overhead.

Such dazzling display, the daunting workmanship that goes into it, and the profusion of it all — Hawkinson is a remarkably prolific worker — tend to provoke critical superlatives. Virtually all the commentary describes him as some variation on the theme of a "mad scientist" who appeals to our "hankering for medicine shows, roadside attractions, and other quasi-scientific spectacles" — "a showman, in the all-American mode typified by [P.T.] Barnum."[2] The tone in much of the literature on Hawkinson, while universally laudatory in assessment, could leave the impression that his art is dominated by spectacle and showmanship, when in fact his nonstop studio production counts as some of the most formally and conceptually ambitious art of its day. Hawkinson's art has a great deal on its mind, with deep intellectual and philosophical — even religious — currents running throughout.

His oeuvre is a meditation on the body in all its physical manifestations and on human consciousness in all its metaphysical aspects. Imagery and themes of corporeality and spirituality abound in his work, as do contemplations of time and eternity. Christian iconography, such as cruciforms and auras, recur often, as do intimations of transubstantiation and transcendence. Mandalas appear, as do images that seem cosmological, like galaxies sprawled over unfathomable expanses of time and space. There are many references to the Bible. And hymns and liturgical melodies are there too, in numerous works that make sound, rhythm, and music.

With so many works that start with the physical body and launch persistently into meta-physical considerations, Hawkinson addresses the mind-body schism that has dominated Western thought since ancient times. If he does not precisely reconcile that split in an analytical, philosophical way, he does consistently probe and grapple with it in a visceral and deeply intuitive manner that inspires wonderment. In a time of our cultural history when so many artists critically dismantle and deconstruct our presumptions and appercep-tions of the world, Hawkinson synthesizes objects, systems, and notions of realities beyond the mundane. He conjectures and conjures and constructs a world he envisions. Though he frequently makes reference to Christian themes, his art is not sectarian or denominational. It is a secular expression of spirituality.

Hawkinson is highly articulate and forthcoming in discussing the form and technique of his art and the genesis of individual works. Yet when it comes to interpreting his art, the artist generally refrains from commenting: he both trusts his works to speak for themselves and avoids delimiting their content through the imprimatur of an "authorized" meaning. Hawkinson's reserve notwithstanding, his art openly and consistently courts a considera-tion of metaphysical and spiritual issues that might apply to almost any system of beliefs, and that especially resonate with basic tenets of Christianity.

The equipoise between the physical and the metaphysical issues in his art — as well as the tension and contradiction between the two — did not develop gradually, but were there from the outset. His earliest surviving work, *Untitled (Chicken)* (1986) is a complete chicken skin, its wings outspread like arms, stretched over a wire armature and preserved in some painter's medium that surely was not devised to fulfill that function. What remains of the bird looks like a winged football in a sickly translucent yellow-brown, a dead thing enclosing a hollow interior and posed as if attempting flight. It is impossible not to read the idea of the living creature into the form of its preserved, dead envelope. Though it is decidedly inanimate, like a puppet or a plush toy, the image speaks of a living thing and compels thoughts of life, however vestigial, in the viewer's imagination.

Another early work, *St. Francis Reliquary* (1987), is a small boxlike construction that opens to reveal a rudimentary human figure made of dried chicken flesh. The hands, feet, and heart of the figure are connected, like a marionette, by strings to a painted cruci-form hovering overhead. Hawkinson explains, however, that the strings are meant not so much to connote a puppet as to represent the rays that were traditionally used to illus-trate St. Francis's stigmata. St. Francis, the patron saint of animals, is known to have preached to sparrows and, it is widely believed, to other animals as well. If he was saintly for having spread the gospel to creatures other than humankind, it raises the question of whether the animals understood; and if they did, in what tongue was he speak-ing? How did the creatures comprehend? Speaking in tongues and in nonverbal languages, and perceiving content in nonverbal modes, is a theme that recurs regularly in Hawkinson's oeuvre, and is an aspect of faith in the incomprehensible that is shared by many religions.

Untitled (Hand of God) (1988) was created by sandwiching many match heads between two panes of glass and then igniting the matches, causing the burn to leave a shadowy, sulfurous residue on the internal surfaces of the glass. The filmy imprint of the combustion notice-ably resembles the iconic image from Michelangelo's ceiling fresco in the Sistine Chapel

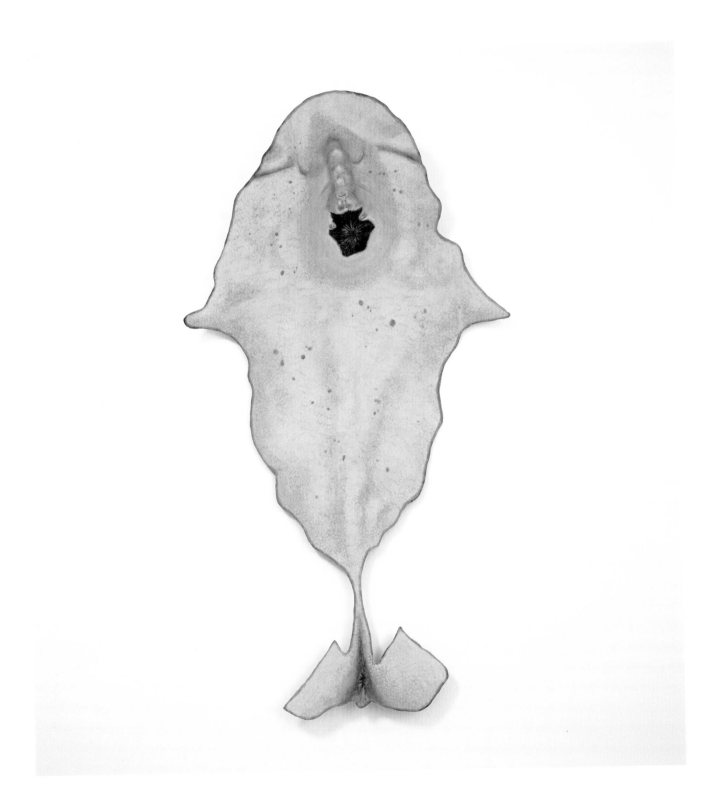

Blindspot (Fat Head), 1993

where God's fingertip touches Adam's, miraculously infusing Adam with life. In Hawkinson's deliberately crude effort, the residue is the actual material manifestation of fire and light—pure protean energy—and a metaphoric image of the generative force of creation.

Often, especially in his early works, Hawkinson goes out of his way to depict or evoke worlds beyond the here and now. *Spaceship* (1987) is a sci-fi painting he found in a thrift store depicting a spacecraft cruising through empty space, to which the artist added planets and a cosmos. In *Sculpture of a Mirror* (1988) he presented an arrangement of odd little trinkets—a teapot whistle in the form of a bird, a miniature hand bell, a petite ceramic swan, a charm-size silver cowboy boot—scattered across the surface of a mirror on which they sit, reflecting their undersides back up to us; suddenly, we realize that the surface is not a mirror at all but a pane of transparent glass, with a second set of identical trinkets affixed to the bottom side of the glass, almost like a parallel universe. For Hawkinson there is always a universe beyond what we already perceive, a reality "supra-" to what we already know.

If in his juvenilia Hawkinson would work with dead chickens or match heads to explore an interest in corporeality, animating forces, and intimations of spirituality, he would soon turn to himself as subject, object, and material for his art, examining his body objectively and reflecting on it philosophically. In the late 1980s and early '90s, he made numerous works that involved casting body parts or using his body contours to make prints, impressions, and drawings, often with haunting meditative overtones. For example, to make *Alter* of 1993, Hawkinson applied swaths of adhesive-backed fabric to his head, arms, legs, and torso, all but mummifying himself. Then, in a process similar to making a gravestone rubbing, he vigorously rubbed pastel all over the cloth, causing the uncanny effect of revealing the image of his bone structure on the surface of the fabric. With stunning inventiveness, he created a hybrid that posits itself somewhere between an X-ray and the Shroud of Turin. Visually everting himself to reveal his skeleton, Hawkinson turned the likeness of his living body into a *memento mori*.

Even the most corporeal and "fleshly" of his works are invested with deep metaphysical resonance. Approaching *Blindspot (Fat Head)* (1993), viewers encounter what at first glance seems to be an image of some form of marine life—a manta ray, perhaps, or a skate. An elongated mottled body is flanked at the top by two protruding winglike appendages.[3] Closer scrutiny reveals that the image is not an aquatic creature at all, but a highly distorted overview of the head, face, and back of a human being. This work is in fact a self-portrait of the artist, but instead of showing the usual frontal view or profile, Hawkinson pictures every part of his body that he cannot see by simply looking at himself: his face, his crown, his shoulders, his back, his buttocks, his anus.

Blindspot, like the many other Hawkinson works that focus on the body, is not fundamentally "about" the body per se—that is, its form, the things it does naturally, the things it can be made to do, the things that can be done to it. Rather, in Hawkinson's art the body is a means to another end. Depicting what he cannot know directly and empirically by simply observing himself, Hawkinson is exploring a kind of terra incognita. In the broadest sense, in the most essential sense, *Blindspot* is an allegory of the development of human consciousness over a lifetime. It reflects a process of ever-increasing awareness that begins in self-discovery and progresses inevitably to the discovery and consideration of realities

beyond the self. It is about the invisible made visible and the unknown made known. Hawkinson, by imaging the top of his head, or the bottom of his trunk, wonders aloud about what exists beyond what he already knows. The discovery catalyzes a steady progression from knowing one's body to conceptualizing about the creation of the universe and humankind's place in it. In Hawkinson's metaphysical mindset, the body begins life as a network of organs and systems, but it becomes a body of knowledge. It educes a soul.

Hawkinson has repeatedly made inflated sculptures of his body. For *Balloon Self-Portrait* (1993) he produced a latex casting of his naked body that he then hooked up to an air compressor and suspended from above. *Fat Head Balloon Self-Portrait* (1993) is a similar inflated latex cast, clothed in the artist's studio garb—black shirt, blue jeans, and loafers—and inflated to nearly the bursting point, the effigy of a human life trapped in and striving to surpass, or to transcend, its merely physical form. *Pneuman* (1994) is a transparent vinyl construction, inflated and suspended. Like his early chicken-skin piece, these objects are void internally but plainly lifelike in their form. They play on a tension between animate fullness and hollow emptiness, between being and nothingness.

But perhaps the appearance of emptiness or an existential void is deceptive and erroneous for Hawkinson. The title of *Pneuman* (1994) may suggest how the artist conceptualizes these strange, ghostlike forms. The word *pneumatic* denotes something filled with air or gasses (a pneumatic tire) or a device driven by compressed air (a pneumatic drill). But in theological terminology, the word, which derives from the Greek *pneuma*, or breath, connotes the soul or spirit. In Christian doctrine specifically, *pneuma* indicates the Holy Spirit, the third person of the Trinity. Hawkinson's title—pronounced "new man"—thus assumes intimations of the immanence of God in humankind and of Christian salvation. In Hawkinson's art, there is no existential void.

Bathtub-Generated Contour Lace (1995), another self-portrait, is revelatory of some ineffable metaphysical reality beyond the body that is also incarnate within it. The production of this work has a highly complex genesis. Hawkinson lay in a bathtub as it filled slowly with black paint from a delivery system he fashioned. He rigged up an overhead camera that photographed him every few minutes, recording the progress of the paint as it gradually rose in the bathtub to submerge more and more of his body. Subsequently, he superimposed the resulting images of the incremental photographs over one another so that they formed a kind of topographical map of his body, which image he then reproduced as a life-size drawing. But rather than merely trace the outlines of the successive strata of irregular contours, Hawkinson elaborately embellished the contours with a delirious filigree infinitely and intricately curling around each stratum they map.

Even the empty spaces between the contours, and the space between his body and the interior of the bathtub where there is nothing to depict, are engorged with rhythmic curlicues, zigzags, and arabesques that read as a force field suffused with relentless animating energy, refuting the very concept of the void. And the bodily figure appears composed from a single line curling, curling forever—a line that if unraveled and straightened to its full extent would seem to stretch to the moon and back. Thus Hawkinson launches our subliminal awareness of a body in the confines of a bathtub to the vast infinitude of time and space in which the body partakes, an imaginative catapult from the physical to the metaphysical.

The desire to know what fills or animates the apparent cosmological void, and what, if anything, exists beyond life and after death have been the central questions of human existence for virtually all civilizations. Philosophy attempts to answer these questions through logic and speculation; science through experimentation and analysis; religion through contemplation and revelation. Hawkinson frequently conflates these three pursuits in his art, producing works that share their attributes in unseemly combination.

Throughout his oeuvre, Hawkinson couches empirical realities in larger contexts, and transposes relatively simple systems of organization into more complex systems. For example, in many works from the mid-1980s well into the '90s, he was preoccupied with transposing one set of known facts into another, almost as if converting numbers from a decimal-based system into, say, a binary system such as computers use or, more implausibly, into a seven-based system or a nineteen-based system for which there is probably no practical application whatever. But the impracticability and complexity of such scramblings is an enticement for Hawkinson, for whom they are a formal, conceptual, and strategic equivalent of speaking in tongues.

Alphabetized Soup (1992), for instance, is essentially vivisection on a can of soup: Hawkinson removed all the pasta letters from a can of alphabet soup and arranged them, alphabetically, in vertical rows. It might seem moot to impose a process of taxonomy — sorting by kind and concept — on so mundane a subject; but it is Hawkinson's nature to forever rearrange the world, or whatever he turns his attention to, calling our attention to the seemingly endless convertibility of the workaday world into things of perplexity and fascination.

Self-Portrait (Height Determined by Weight) (1990) is a lead casting of the artist's feet and shins, the weight of the lead equivalent to the weight of his full body. Height and weight (along with sex and the color of the skin, eyes, and hair) are generally considered to be fixed aspects of personal identity; in Hawkinson's art, the determinants are always variable and convertible. Perhaps the most elaborate of his systemic transpositions is a series of fifteen untitled "record drawings" (1992–93) that resemble vast (43-inch-diameter) long-playing vinyl records. He listened to recorded music selected from his shelf at carefully measured 6-inch intervals; the musical samples were thus random, in terms of content, yet they were systematically chosen. As the music played, Hawkinson was suspended, his arms outstretched in a cruciform, before slowly revolving disks that were prepared with gesso and wax, as he used his right hand to inscribe his impressions of the melody onto the disk, and his left to record his response to the rhythm. A set of inwardly spiraling drawings — visual transcriptions of aural analogue recordings — was the result. Hawkinson in effect turned himself into a recording device first to decode and then to (impressionistically) reencode the music visually.

These operations of reordering and transposing appear to be nonsensical, yet they all have their own rules and logic. By reencoding very ordinary facts of life, Hawkinson represents the things of the world. More importantly, he underscores the limits of empirical knowledge and the banality of merely looking at and seeing the world as we already know it; he causes the viewer to see anew. An essential and recurring attribute of his oeuvre is Hawkinson's converting and reconstituting commonplace things into objects of wonderment. In this sense, Hawkinson's art is a metaphor, an artistic analogue to the Christian concept

of transubstantiation, the mystical transformation whereby the body and blood of Christ become the consecrated bread and wine of the Eucharist. In a leap of faith, and with almost naive audacity, Hawkinson reconsecrates the world again and again in his art.

Hawkinson engages the intellect with a ticklish anti-intellectualism. Habitually, he dances with both science and pseudo-science and uncannily subverts rationality while drawing upon its very attributes. Outgrowths of Hawkinson's systemic transpositions are his playful, hysterical machines, which share something of the antic spirit of Dada. As early as 1988, Hawkinson began making mechanized sculptures, but *Signature* (1993) was his first work to evoke something akin to artificial intelligence. Mechanically programmed like a player piano, it continuously cranks out intelligible information, in this case a facsimile of the artist's signature. A signature is the merest physical incarnation of that most ineffable and altogether immaterial concept, the self. An autograph is almost *nothing*, really: a scribble of ink on paper that alludes to something else — a complete mental picture of a human life — that cannot possibly be contained anywhere. Yet an autograph can carry enormous emotional, intellectual, and monetary value as the rarest physical evidence of a person's existence in time and space. But Hawkinson's mechanically produced signature is as devalued as a signature can be, cranked out endlessly, pointlessly, absurdly. The vaunted "rationality" of machines is reduced to a vain conceit, and the signature becomes a kind of *vanitas*, a tragicomic reminder of death.

Signature was the opening chapter in a continuing saga. If it seems to nurture a kernel of Dadaistic nihilism, subsequent machine works pointed to a desire to embrace something beyond physical death. As if he were Dr. Frankenstein attempting to create self-conscious life out of inanimate material, Hawkinson went on to make a still-evolving multigenerational family of automatons, all of whom try to give utterance to themselves as living, thinking organisms in a matter-of-fact world. *Penitent* (1994) is an effigy of a kneeling human skeleton formed largely out of rawhide ties that dogs like to gnaw on. But this skeleton is motorized and outfitted with a vocal mechanism that operates pneumatically on an air pump and valves, so that it continually aspirates, wheezy and labored, whistling and seeming to intone the artist's name. *Ranting Mop Head (Synthesized Voice)* (1995) is an elaborate gizmo pieced together from a swabbing mop, lots of vinyl tubing, air pumps, valves, and a crude makeshift unit that operates similarly to the mechanism of a player piano. It emits all manner of pops, clicks, buzzes, and warbles, and, speaking in an unnatural tongue, even has the ability to utter brief sentences: "Are you my mama?" The mop wishes to know its genesis, its creator.

Bagpipe (1995) is a giant vinyl balloon, 8 feet tall and 10 feet wide, inflated by an air compressor and fitted with long cardboard tubes. Equipped with motion detectors, it eagerly performs whenever it senses a visitor, playing such tunes as "A Bicycle Built for Two" — a wistful desire for the confluence of man and machine. And *Tuva* (1995) attempts to replicate the Central Asian style of polyphonic religious chanting in which an individual voice produces multiple sounds at once. There is something quite funny, and also quite poignant, about these machines yearning to become something more than they are — something with a spirit.

Überorgan (2000), a massive pipe organ, is by far Hawkinson's most ambitious machine, titanic in scale, Olympian in conception. It is a hulking leviathan interposed between the vast interior space it consumes — a whopping 16,000 square feet — and the dwarfed, awed

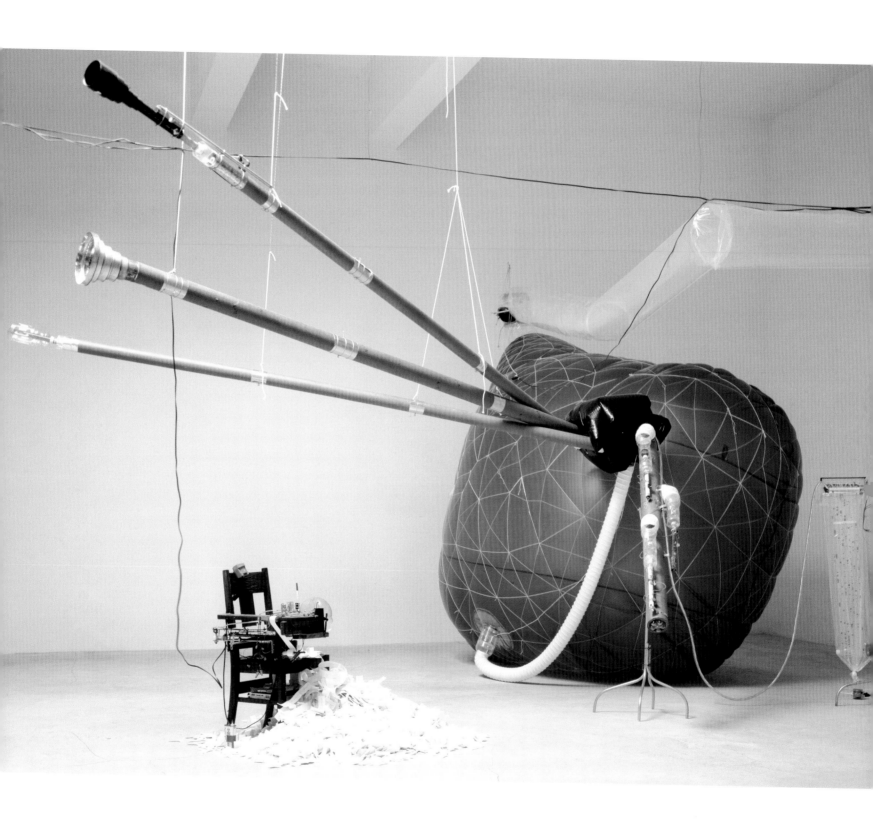

Signature, 1993 (foreground); *Bagpipe*, 1995 (background)
(installation view at Ace Gallery)

spectator. Its mechanical energy permeates the place, as the sound of forced air rushes through its endless inflated plastic skin. Snaking through its site and never completely visible, *Überorgan* sidewinds through so much space and into and out of so many rooms that it is virtually paranormal, beyond true comprehension. Formally it is inassimilable; rationally it is indefinable; and in its totality it is unknowable.

But it also seems to have a vital force of its own as it breathes, heaves, groans, and vocalizes. The air courses through its extremities, animating its whole sprawling, respiring mass, so that it registers somewhere in the imagination as not only a magnificent musical organ but as a nearly fearsome living organism, like a captive whale, or a crated elephant. Its larger-than-life life force suffuses it with an aura of superiority, dominion, domination. *Über* is the German word for "over" or "above," but it is not merely a preposition. It often connotes a sense of "beyond-ness," or "mega-ness," as in the Nietzschean concept of the *Übermensch*, literally meaning "over man" but generally translated as "superman," an idealized conception of an individual whose vision, creativity, and will enable him (and entitle him) to live beyond conventional moral standards. Hawkinson's *Überorgan* evokes this daunting exaltation, not only in its deliberately chosen title, but in its refusal to abide by the norms and the "rules" of common sense and practicability. *Überorgan* is Hawkinson's magnum opus, his supreme runaway machine. It is so ungainly, so unwieldy, so downright preposterous, that if the spectator's initial response is amusement and amazement, it soon comes to embrace something of the experience of the sublime — a response to the unfathomable, the unknowable, the infinite.

Hawkinson also grapples with the unknowable in his works that deal with time. While duration, the passage of time, exists in nature, its division into measurable units is a human invention. We cannot stop time, we cannot possess it, we cannot even know it except through the quaint artifice of mincing eternal amorphous flux into discrete, imaginary units that exist as abstract concepts quite independent of the passage of time. Hawkinson has made many works that attempt to incarnate and make physical this most intangible and immaterial attribute of nature and human perception.

He first introduced time as an overt thematic element in his art in 1988 with an oil painting, *Conception of Time*, that depicts a circular arrangement of images of ornate hour hands and second hands (as from antique clocks) all pointing inward to an egglike shape in the center of the canvas. The piece suggests his early (and abiding) preoccupation with concepts of time and life, and with life's philosophical rhyme with death.

Spin Sink (1 Rev./100 Years) (1995) is the *Überorgan* of Hawkinson's clock works. A sequence of gears formed of cams made variously of insulation board, plywood, or metal and gear teeth made of intermeshing ribs of corduroy fabric, it is a Hawkinsonian appropriation of materials *par excellence*. The system stretches nearly 24 feet across, with the largest gear — about 6 feet in diameter — interlocking with the next largest, and so on, down to the smallest, which is less than half an inch wide. Viewers are surprised to discover that the tiniest gear is propelled by a wee motor, the size of a wrist watch, and that the motor is driving the entire system. A wall label explains that the system completes one revolution approximately every one hundred years.

Presuming that *Spin Sink* is actually functional and that its makeshift components could really last for the duration of even a single hundred-year cycle, it nonetheless moves so

slowly that it might as well mark geological time: the compelling image of all those gears moving so profoundly slowly nonplusses the imagination. *Spin Sink* is about *long* time, and impossibly slow progress. Its very image—the lateral expanse of comically disproportionate gears moving so slowly as to essentially not be moving—connotes the utter stasis, the virtual eternity, of this clock. That such an ambitious clock, brought into existence by an almost haphazard collection of unlikely materials, should be driven by so diminutive a motor, like the little engine that could, confers both a pathos and a Promethean heroism on the work. As befits the poetry of Hawkinson's art, it reminds us of our own corporeality and mortality. The human body is the ultimate Hawkinsonian clock, a jumbled contraption of genes, chemicals, tissues, and organs never meant to report the hour yet, like *Spin Sink*, inevitably doing just that.

The mechanical logic of Hawkinson's works is always hobbled and inefficient, and the way they solve problems or fulfill tasks is forever on the verge of mechanical breakdown or dissolution. Only (our) faith and (Hawkinson's) dogged maintenance keep them going. They are chronically on life support. And *that* is their reason for existence: to churn and drone endlessly, to toil chronically on the threshold of giving out, or giving in, or giving way, but to keep on giving nevertheless. Hawkinson attempts to achieve perpetual motion. His works push at being inextinguishable, immortal.

Pentecost (1999) is in a state of perpetual ecstasy and perpetual motion. A gangling sprawl of cardboard tubes branches off everywhere like a rhizome or tree gone berserk. Perched in the tangle are twelve life-size cardboard humanoids instantly recognizable to anyone who has ever seen *Bathtub-Generated Contour Lace* as three-dimensional clones of that infinitely energized figure, here built up into multistratified shapes. The end of each tubular branch has a membrane stretched over it serving as a drum head, on which the figures tap, tap, tap rhythmically—though each in a different rhythm, and each using a different body part—causing an unintelligible nonstop commotion of beating and thunks. A text accompanying the installation explains that the rhythms are derived from the melodies of popular Christmas carols and that the title of the work refers to the feast day commemorating the descent of the Holy Spirit upon the twelve apostles, who miraculously, in a state of grace, began to speak in tongues. Hawkinson's apostles, all transmogrified visions of himself, are speaking through body language and musical (rhythmic) language, both nonverbal but consisting of meaning endlessly coded and recoded. Within his oeuvre, *Pentecost* distills all of Hawkinson's modes, methods, and meanings into a potent, pulsating, stupefying ecstasy. As with all of Hawkinson's art, it is speaking of transcendent knowledge, through the body, in strange tongues.

With his metaphysical machines, Hawkinson recalls Robert Fludd (1574–1637), the British natural philosopher, occultist, physician, and cosmologist. Fludd conflated "old" science—alchemy, Ptolemaic astronomy, pharmacology—with the "new" science and the incipient foundation of the scientific method. He is best known for his cosmological charts and graphs of the universe—not star maps and sky atlases, but schematic drawings that explained the "moral architecture" and harmony of the creation that he depicted variously as musical instruments and machines, often with an interpolated image of the human body. Like Fludd, Hawkinson explores a zone in which physics and metaphysics remain compatible pursuits.

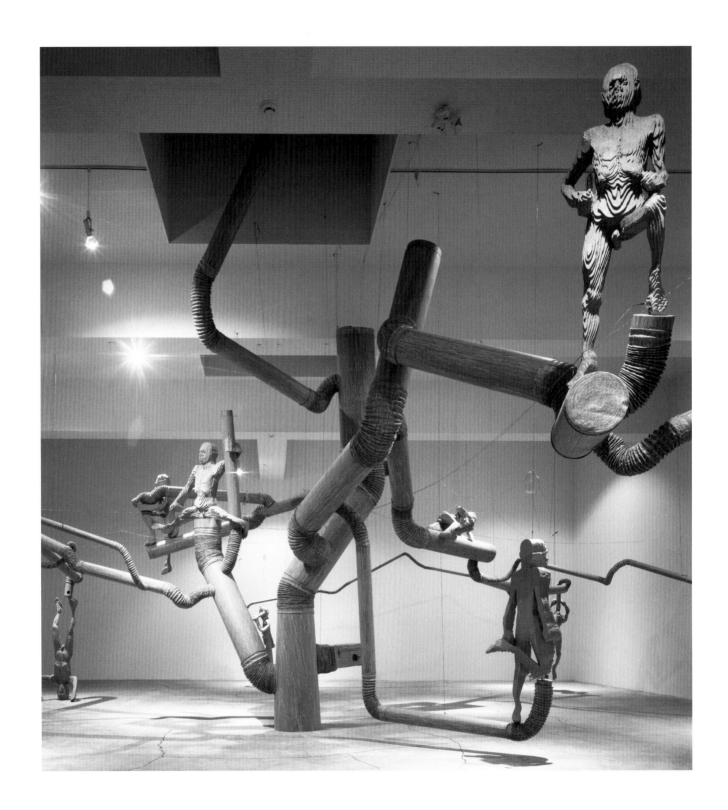

Pentecost, 1999

Tim Hawkinson, the artist-practitioner, the individual working hands-on in the studio, plainly commits himself to his work with the ardor and engrossment of a votary—one bound by vow, as a monk, in devotion to a cause or belief or pursuit. Perhaps the same could be said of many, if not nearly all, artists. But Hawkinson applies himself *in extremis* to his work, and that nearly sacramental energy is everywhere evident in his art. His pursuit may be a kind of madness—that of the "mad scientist"—or it may be a means to a state of grace. Most likely it is both.

1. "astounding": Lilly Wei, "Tim Hawkinson at Ace," *Art in America*, 83 (November 1995), p. 110; "larger-than-life": Terri Friedman, "Reviews: Tim Hawkinson: Ace," *Zingmagazine,* 2 (November 1995), pp. 215–16; "extravaganza... [that] must be seen to be believed": Roberta Smith, "Art in Review: Tim Hawkinson," *The New York Times*, November 3, 1995, p. C21.
2. "mad scientist": Michael Duncan, "Recycling the Self," *Art in America*, 85 (May 1997), p. 112; "hankering for medicine shows, roadside attractions, and other quasi-scientific spectacles": Kristina Newhouse, "Tim Hawkinson: Mechanical Follies," *Sculpture*, 19 (December 2000), pp. 10–11; "a showman, in the all-American mode typified by [P.T.] Barnum": Christopher Knight, "Inventing an Edgy Carnival of the Human Condition," *Los Angeles Times*, July 24, 1996, p. F5.
3. Hawkinson has made six versions of this work. The first, *Blindspot* (1991), is a photocollage; *Blind Spots (Panel)* (1993) is a similar work mounted on a rectangular surface; *Blindspot (Fat Head)* (1993), in the collection of the Los Angeles County Museum of Art, is the largest version, and is an encaustic painting on paper mounted on a shaped steel backing that bows out concavely from the wall; *Blindspot Elizabethan Collar* (1994) is lace on metal; *Blindspot Lace Drawing* (1995) is ink and resin on steel; and *Blindspot Contour Relief* (1995) is photomontage on foam core.

HOWARD N. FOX is curator of modern and contemporary art at the Los Angeles County Museum of Art. He has organized numerous major exhibitions and authored their catalogues, including *Avant-Garde in the Eighties* (1987), *A Primal Spirit: Ten Contemporary Japanese Sculptors* (1990), *Lari Pittman* (1996), and *Eleanor Antin* (1999), and has published and lectured widely. He is a member of the history/theory/humanities faculty of the Southern California Institute of Architecture.

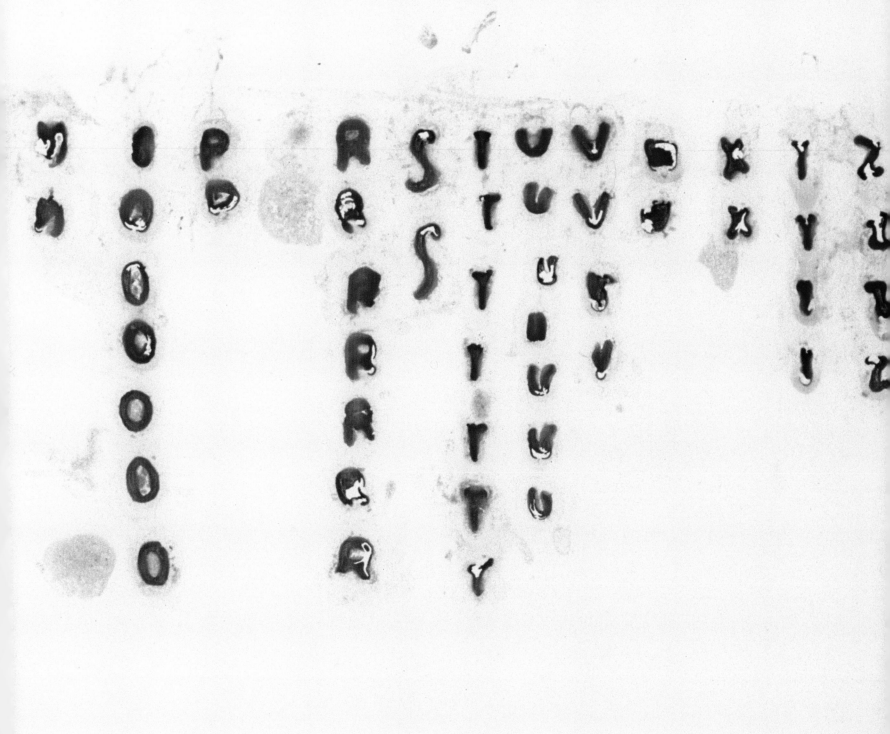

Encyclopedia Hawkinsoniae
Doug Harvey

AS-IS AESTHETIC, THE

A '90s mecca for the downtown L.A. art crowd (just across the river from Chinatown), the St. Vincent de Paul Thrift Store's chaotic as-is yard was like a simmering primeval soup of art ideas and materials, and one of several trawling grounds favored by Tim Hawkinson, whose elaborate kinetic, multisensory concoctions are often painstakingly constructed from salvaged components. After eyeing a particular vastly overpriced home electric organ in the main store for several months hoping for a price reduction, he finally caved in — only to find that the keyboard was no longer in the showroom. The dejected artist shuffled out to the as-is yard, where, lo and behold, the pre-dissection *Organ* (1997) was waiting, at a twentieth the price. *As is*, stripped of its pejorative implication, takes on an almost Zen-like connotation and opens the door for such serendipitous connections. The commitment to work with whatever is put in your path is the mark of an artist secure in his or her own — and the world's — creative potential.

BECK

In 1998, following the multiplatinum success of his sample-delic *Odelay*, Los Angeles techno-bohemian Beck released the much-anticipated *Mutations*. A collection of beautifully arranged, quickly recorded, minimally produced low-key folk ballads, *Mutations* was hailed by some as unvarnished proof of Beck's songwriting prowess, but more frequently it provoked bewilderment at his abandonment of a successful formula. A conscious abdication, the recording was even marketed with a self-defeating "This is not the real follow-up to *Odelay*" campaign. So why did Beck choose the art of Tim Hawkinson to adorn the booklet of this statement? Beyond the cyborg grafting of high and low technologies and cultures that both artists display, there are other affinities: both formed their artistic vision under the influence of an adolescent obsession with neglected American roots music. Beck is the grandson of the late Fluxus artist Al Hansen, who himself dived

in a dumpster or two for the sake of art. These calls to the preservation of cultural detritus are close to the heart of both artists' variegated oeuvres. My guess is that Beck recognized the principle of restless novelty around a still center at work in Hawkinson's diverse output, his use of a continual mutating flux of creative strategies and aesthetic vocabulary to define a primordial negative space and prevent the people from confusing style and substance.

CARNIVALESQUE

Hawkinson's penchant for diverse spectacles of an edifying and entertaining nature invites comparisons of his solo exhibitions to carnival sideshows and other vernacular museological exercises. Though the term is sometimes used in a dismissive sense, the sideshow has a rich and enduring symbolic significance in Western culture, with a unique rural American strain emerging in works such as Charles G. Finney's novel *The Circus of Dr. Lao* as a variation on Mikhail Bakhtin's revolutionary notion of the medieval carnival's liberating disordering of social conventions. Hawkinson's work, so inextricably rooted in the carnal, with its relentless testing of boundaries and inversions of just about everything, dovetails neatly with Bakhtin's sense of a constantly mutating semiotic plurality he called *dialogism*. It comes as no surprise that Hawkinson's work as a whole carries this reading to a more organically complex social level.

DELEUZEAN REVERSAL

In *Balloon Self-Portrait* (1993), by inverting a literal materialization of Deleuze and Guattari's *body without organs*, Hawkinson organ-izes almost the entire universe within his skin; the only thing that remains "outside" is the space occupied by the inflating air. Like *The Base of the World* (1961) by fellow inflatables enthusiast Piero Manzoni, Hawkinson's *Balloon Self-Portrait* is a breathtaking display of schizophrenically simultaneous humility and hubris, and a declaration of almost transcendent territoriality. Osiris-like, Hawkinson effectively re-members the drawn and quartered corpus of the world, with only the single pneumatic blind spot (as the optic nerve passes through the retina) where the mechanics of perception are translated into phenomenal events. Offering his Self as an absence whose impermeability restores the continuum of phenomenal reality — hocus pocus — the artist's martyred creative ego is splintered and dispersed throughout all creation in rhizomic immortality.

EXPERIENTIAL RECIPES

In considering the winning do-it-yourself philosophy permeating Hawkinson's practice (apart from the obvious, his materials and technical skills are cheaply and readily available in most industrialized societies and, unlike most contemporary sculptors, he generally eschews subcontracted fabricators), it occurred to me that there's a subtle variation on the conceptualist undermining of the art-object-as-commodity built into his work. I imagine an art collector who, rather than

purchasing Hawkinson's jetsam, re-creates the work on his or her own. Take pictures of yourself at intervals as black paint gradually submerges your body in a bathtub. Sculpt a bird skeleton from your fingernails. That collector would learn more about art in six months than most critics learn in a lifetime.

FIGURATION
I'm not exactly clear on when figuration was supposed to have disappeared from art history, but apparently it's back! Unfortunately, much of today's successful figurative art panders to the same nostalgia that makes people want to believe the government has their best interest at heart: a longing for a golden age of blissful naiveté that never actually existed. Hawkinson is one of a handful of artists whose depictions of the human body embrace the challenges posed by modernism and the information age, subjecting its rhythms and dimensions to measurement, fragmentation, transformation, and ultimately rebirth. No more or less than the Lascaux painters to Vito Acconci have done, but in a new form that is coincidentally discrete and continuous, binary and holistic, deconstructive and generative, sexy and clinical, sublime and ridiculous.

GENDER
Hawkinson's work, obsessed with the dualistic and the symmetrical, is profoundly androgynous. His embrace of contemplative homecraft and use of domestic materials, his employment of wombs and cocoon forms, and his relative lack of alienation from his body are balanced by his lab-tech geek-ishness and priapic novelty. It is not an ambivalent but a bivalve sexuality: two-shelled. The giant clam produces a trillion eggs in a single spawning.

HURDY-GURDY
Thanks to Donovan, we've all heard of the hurdy-gurdy. However, what the hell is a hurdy-gurdy? It turns out that the hurdy-gurdy is an awesome musical instrument, a zitherlike box with a cranked wheel that bows the strings (one of which is a drone), plus push-button frets. Although Hawkinson would deny it, there isn't much of a division between his art and his life. His home and studio abound with examples of idiosyncratic and labor-intensive domestic solutions. Where do you draw the line between the crafting of his musical pieces such as *Tuva* (1995) or *Barber* (1997) and the painstaking reconstruction of the broken hurdy-gurdy he bought on eBay a couple of years ago? Design authorship and the fact that the sculptures are closed systems while the hurdy-gurdy demands to be played are not sufficient distinctions.

ISSEY MIYAKE
In 1996 Hawkinson was invited as the first Westerner to participate in the guest artist series of Pleats Please Issey Miyake, the Japanese fashion designer's limited-edition clothing line. The two

collaborators decided to translate images of Hawkinson's preexisting work into fabric designs, which were made into tightly pleated jumpsuits. The remapping of body imagery like the *Bathtub-Generated Contour Lace* (1995) onto the rigid accordion contours of the crisply pleated fabric added yet another layer of topological complexity, but perhaps more interesting was the reinscription of Hawkinson's art work, largely intended for reception within the specific parameters of the art world, onto its equally hermetic but thinner mutant twin, the fashion industry.

JESUS

What Jesus was about was paying attention and withholding judgment — essential tools for making art. Tim Hawkinson is sort of like Jesus, the way he insists that the castoffs of society contain everything that we value or consider meaningful, the catalyst being attention. See *Magdalen* (2003).

KNITTING

As I have noted elsewhere,[1] the phrase "How Man Is Knit" is a cunning anagram of the artist's name. Knitting — a process by which a single, unbroken string is convoluted into a wide variety of autonomous three-dimensional forms (mostly pertaining to the cocooning of the human body) — has obvious parallels with Hawkinson's creative strategies. In a number of cases, as with his knotted extension cords and *Blindspot Elizabethan Collar* (1994), the connection is made explicit. Hawkinson is certainly not unaware of the political gender issues entangled in this most meditative form of socially valorized domestic busywork for genteel ladies, nor of feminist artists' ongoing attempts to recontextualize this handicraft. By giving equal weight to these ways of translating reality as he does to more macho approaches like digital sampling, his work effortlessly bears a feminist — within an encompassing humanist — interpretation.

LIMN

Attention is a light we cast upon the world to illuminate the limits of our perceptual mechanisms.

MOIRÉ

A moiré is an optical effect that results when two identical or close geometric patterns — typically grids — are overlaid. Moiré patterns are most commonly known for their problematic appearance in computer-scanned news photos, but they also have a history in decorative and fine arts, ranging from watered-silk endpapers in old books to the early paintings of Sigmar Polke and Larry Poons. In almost all of Hawkinson's work, but particularly pieces like *Self-Portrait (Height Determined by Weight)* (1990), *Stamträd (Family Tree)* (1997), and *Cyctor* (1997), we encounter what might be called a conceptual moiré, where content from one system is superimposed on a different system. After the initial, bracing conceptual dislocation, and the formal and conceptual elegance

of foregrounding structures by their difference, there is a more fugitive charge — the emergence of a third system that seems to be a product of aesthetics and intelligence, but eludes all authorial attribution and attempts at rational analysis. Does this phenomenon describe the function of the human brain seeking meaning, or an underlying intelligence to the world? Is there a difference?

NARRATIVE

The use or subversion of narrative is evident in many of Hawkinson's individual pieces: the description of the history of transportation in *Trajectory* (1995), the durational poetry of *Spin Sink* (1995), the subtle mockery of linear historicism in *Wall Chart* (1997), or the plotless repetition of *Signature* (1993) each address the problems of art and storytelling in novel and liberating ways. Many other works derive their depth of meaning (and punch lines) from the story of how they came into being. Built into each of these ontological cliffhangers is an interactive social narrative between artist and viewer, mediated by the object, where the viewer is taken on a scripted cognitive ride from puzzled curiosity through the looking glass to a sense of conspiratorial, co-creative complicity.

OPTICAL ILLUSIONS

The son of a lens crafter, Hawkinson often synthesizes optical effects — the "false" iridescence of *Volume Control* (1992) and *Pearl Vision* (1994), the "meaningless" complexity of *Wall Chart* (1997) and *My Favorite Things* (1993), the "hallucinatory" Op Art translations of *Winer* (1993) or *Draw! Paint! Weave! Spin!* (1996) — into another subtly scripted experience: choreographing the whole body of the viewer, leading with the eye.

PUNS

The pens and pencils used to make *Wall Chart* (1997) are bundled together as blood vessels in an oversized severed fingertip, entitled *(Index) Finger* (1997). Puns are a much-despised backwater of literary invention, but notoriously irresistible to mathematicians and other highly evolved types. In fact, this bad reputation is something of a bum rap — seminal modernist literature from *Finnegans Wake* to the writings of Raymond Roussel (which were epiphanous for Marcel Duchamp) are deeply, inherently punny, as is Hawkinson's art. The pun's disgrace, and its iconoclastic power, derive from its breaking of the fourth wall at a fundamental semiotic level, rupturing the invisibility of the authorial voice by violating the basic contract between word and meaning, calling into question the reliability of any text, including this one.

QUIDDITY

[As this essay was partly inspired by Hawkinson's *Alphabetized Soup* (1992), which contains no Q, I am leaving this entry empty, as a blind spot.]

RIGGING

Nautical themes crop up recurrently in Hawkinson's oeuvre, from early works like *Untitled (Sinking Ship)* (1987) to *Aerial Mobile* (1998). Given the artist's concern with amniotic environments and corporeal fluidity, an argument could be made that this branch of his work derives from our species' — indeed all land-based life's — slight removal from our briny mom. An inordinate amount of Hawkinson's attention in this area has been devoted to the intricate miniature rigging found in *Aerial Mobile*, *Das Tannenboot* (1994), and *H.M.S.O.* (1995). The nostalgia of these pieces is once-removed; for most of Hawkinson's audience the first association to spring to mind would be the pop media meme (and anachronistic surrealist fetish object) of the model ship built inside a bottle by a slightly pixilated recluse or a blustery college dean. Models are Hawkinson's first point of reference. Rigging — the patiently evolved, physically intricate webbing that both keeps the mast rigid and wraps the sails around the shifting winds — becomes interpolated into cast-off fragments of contemporary culture, by way of an unmentioned, impossible uterine architectural folly.

SWADDLING

In conversation, Hawkinson and his painter spouse Patty Wickman, who had recently become parents, brought up the subject of swaddling, an ancient infant-care technique they had employed with little Clare for her first several months. It was only in skimming a previous essay on Hawkinson's work that I realized I had raised a comparison some years before between this practice — wrapping babies in strips of cloth to restrain their movements — and the artist's exploration of body boundaries.[2] Although the motivation to "return to the womb" is generally disparaged as regressive and irresponsible, these criticisms evaporate if one considers time as cyclic and human evolution as a progression of incrementally more encompassing womb-states, each of which — needless to say — may be mimicked in the medium of swaddle.

TWINNING

What is with these twins who grow up separate, never knowing each other, and wind up using the same brand of exfoliant cream and marry people with identical social security numbers except for one digit? I mean, come on! And yet, if they grew up together, I'll bet they'd use different exfoliant creams! How many individuals are actually present? Hawkinson for one. Or two. Or none. His work betrays an acute awareness of the bipolar nature of identity, not to mention its nonexistence.

UNKNOWABLE, THE

People always forget how funny Samuel Beckett is. I think it's some kind of defense mechanism: if depictions of such wretched frustration can be so, well, life-affirming, why pay the rent? One of Beckett's (and Buster Keaton's) last great works was *Film* (1965), a treatise on opticality and existence that remains unparalleled as a synecdoche of unrequited creative reflexivity: to be is

to be perceived, but how can you be in two places at once? Yet while Duchamp languorously siphoned the retinality out of modern art, safe in his Manhattan bunker, Beckett was fighting Nazis with the French Resistance. How was he able to overcome the solipsism upon which his finest works hinge? Like Hawkinson, Beckett's cornucopic wit boils from the margins of a lacuna—an absence, a blind spot, a Not-I—that places the ego in overwhelming perspective.

VARIETY
If variety is the spice of life, what is the spice of death? That's poetry, man. Variety *is* death as long as it only keeps the viewer entertained. Entertainment is like refined sugar or crack— highly addictive distillations of relatively benign and complex organic substances that lose their essence in the process of sublimation. And yet, variety is life. Evolution tries everything before whatever is advantageous sticks. Hawkinson's art works are evolutionary probes, adaptive radiation in search of forms that will allow art to survive.

WORM
A creature whose inside is continuous with its outside; a tube through which every bit of the world must eventually pass. This may be Hawkinson's goal—to act as a transformational conduit, working the world like a compost heap, grinding the inert lumps of twentieth-century art into fertilizer.

X-RAY
X-rays are employed as a tool for revealing what lies beneath surfaces, those of the human body in particular. A mysterious, invisible force that makes visible the hidden workings of our very being, X-rays are the kind of bravura magic that make people such passionately religious true believers in Big Science. With lo-tech radiographic substitutes like *Alter* (1993) and *Penitent* (1994), Hawkinson comes across as a believer in small science, or at least in a magic less fixed in one end of the rational/spiritual spectrum.

YGGDRASIL
The tree at the center of the world; the arboreal *axis mundi* where Deity is fixed. In spite of repeated intimations of Christianity, Hawkinson's work exudes a distinctly pagan aroma. Pine-scented: incidences of conifers abound. And like all good pagans, Hawkinson is possessed by a visceral need to uncover the sacred within the mundane.

ZIRCONIUM, CUBIC
What's so funny about cubic zirconium? Why are precious stones valued in the first place? For their optical effects of cubist kaleidoscopy and dazzling internal reflection. Not only are we hardwired to respond to the beauty of colorful, faceted translucent pebbles, but, like flames and

crystal balls, they are useful light-mediating visual tools for accessing altered states of consciousness of the numinous variety. Oddly, consciousness of this experiential psycho-spiritual functionality has been superseded by The Diamond as the ultimate symbolic condensation of commercial materialism. Next door in that spectrum is the objet d'art, a conventionally useless thing around which an entire subculture labors to generate a consensus of meaning and value. Like the gemstone, the art work's pragmatic, ahistorical ability to entrance us—to open new ways of understanding the world and show us things we can't otherwise see—gets the short end of the stick compared to its confabulated scarcity and capacity to induce consumer frenzy. Yet, like the Soviet-perfected skull crucible system used to produce cubic zirconium, Hawkinson's stripped-down, materially anti-elitist object lessons in physics, spirituality, and phenomenology are saturated with alchemical juju. They embrace their zirconiumism by transubstantiating potent and surprising aesthetic experiences from whatever means and materials are readily available: cheap and plentiful technological miracles. In spite of its homeliness, Hawkinson's work stands out like a star sapphire in a display case full of paste costume jewelry. Surrounded by placeholder art predicated on the denial of the senses in favor of hierarchically mandated verbal consensus, the radical autonomy of Hawkinson's oeuvre testifies to the transcultural, transtemporal, transpersonal usefulness of art. So shine on, you crazy cubic zirconium. Shine on.

1. "Tim Hawkinson: Man with No Skin," in *Tim Hawkinson* (Toronto: The Power Plant/MASS MoCA, 2000), p. 24.
2. Ibid., p. 22.

DOUG HARVEY has written extensively about the Los Angeles and international art scenes and other aspects of popular culture, primarily as the art critic for *L.A. Weekly*. His writing has also appeared in *Art Issues*, *Art in America*, *The New York Times*, and numerous other publications. He has written museum and gallery catalogue essays for Georgeanne Deene, Margaret Keane, Thomas Kinkade, Big Daddy Roth, Jim Shaw, Jeffrey Vallance, and others.

Plates

Untitled (Chicken), 1986
Chicken skin and wire
6 x 13 x 10 in.
(15.2 x 33 x 25.4 cm)

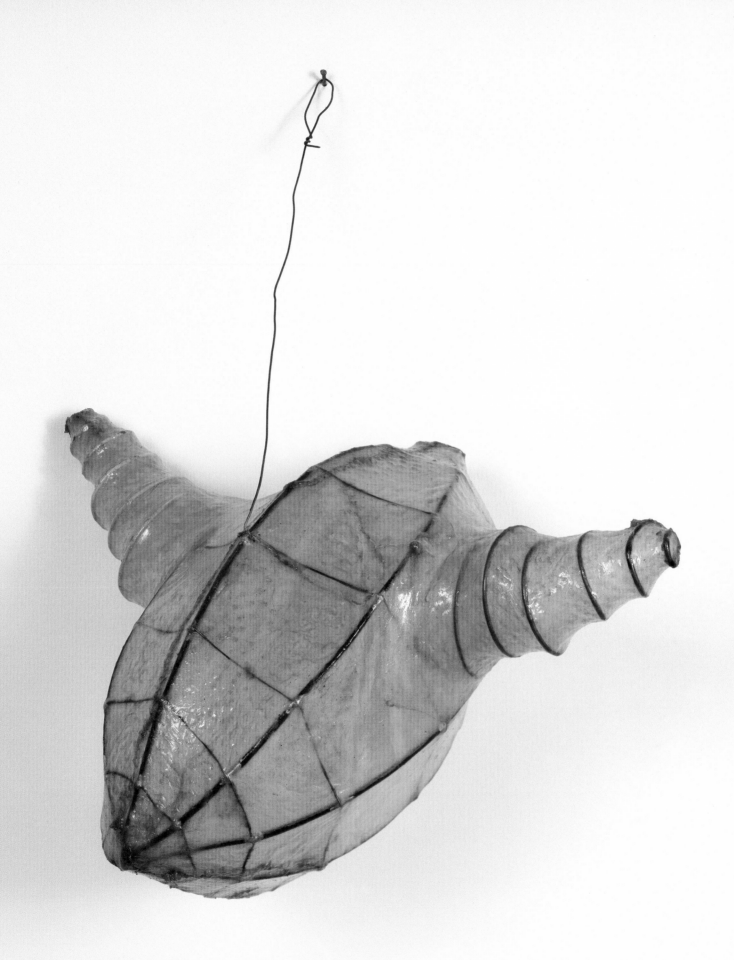

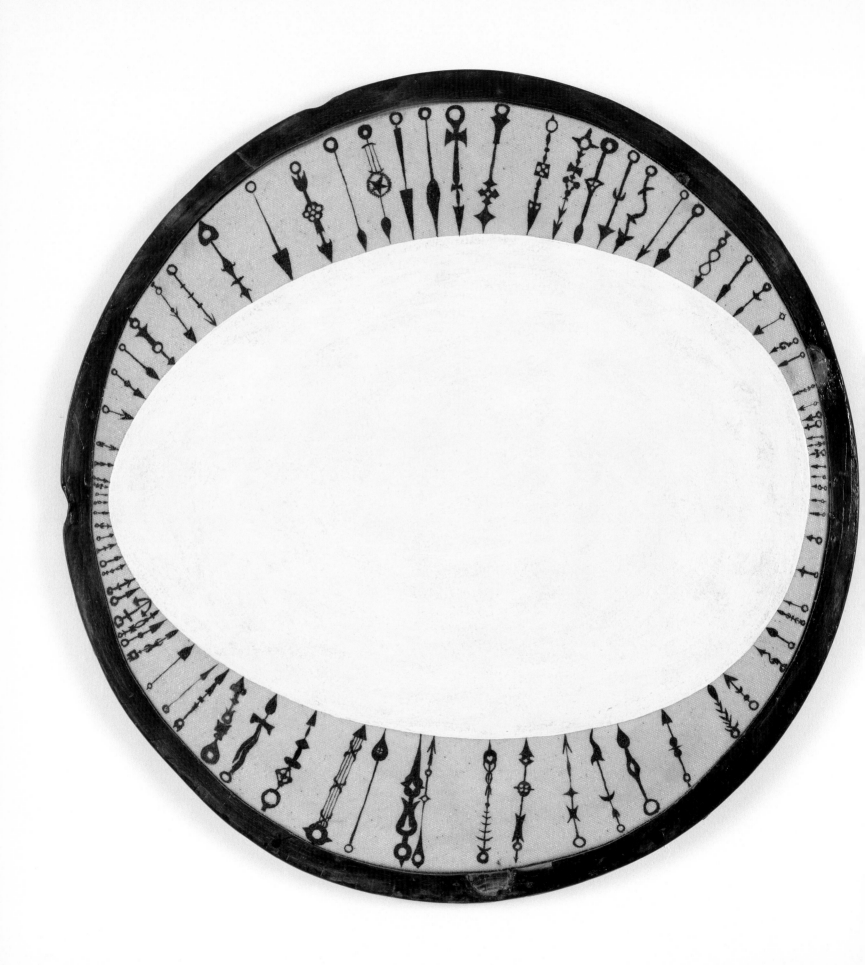

Conception of Time, 1988
Oil on canvas on wooden chair seat
16 $\frac{1}{2}$ (diam.) x $\frac{3}{4}$ in.
(41.9 x 1.9 cm)

Untitled (Brown Rectangles), 1988
Oil on canvas
52 x 38 x 2 in.
(132.1 x 96.5 x 5.1 cm)

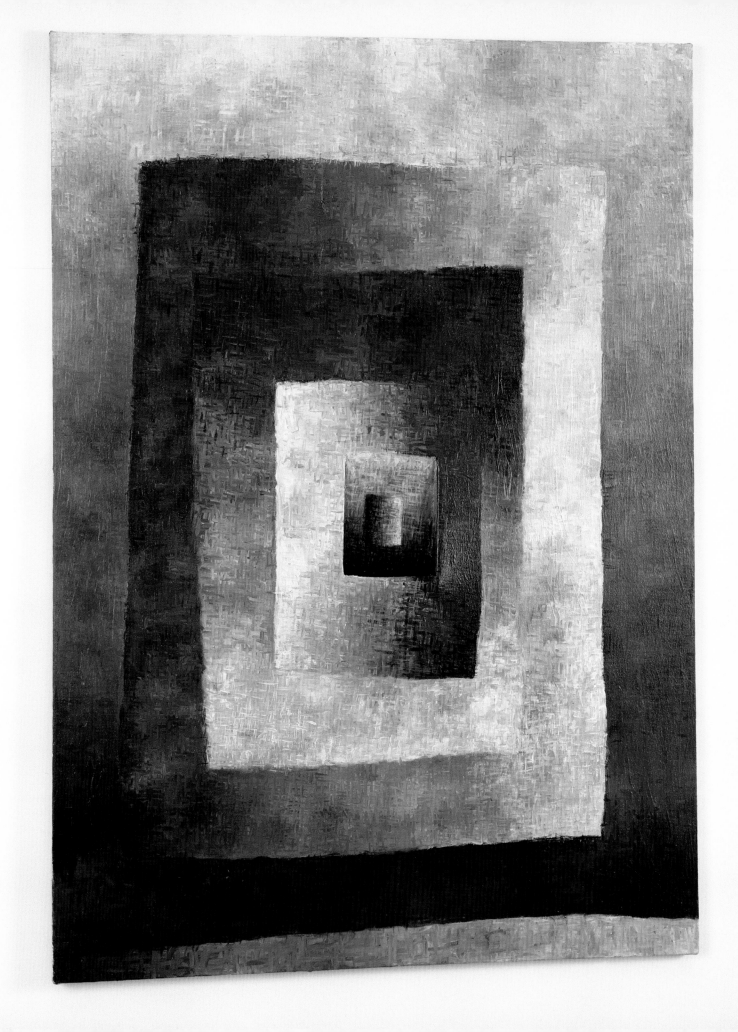

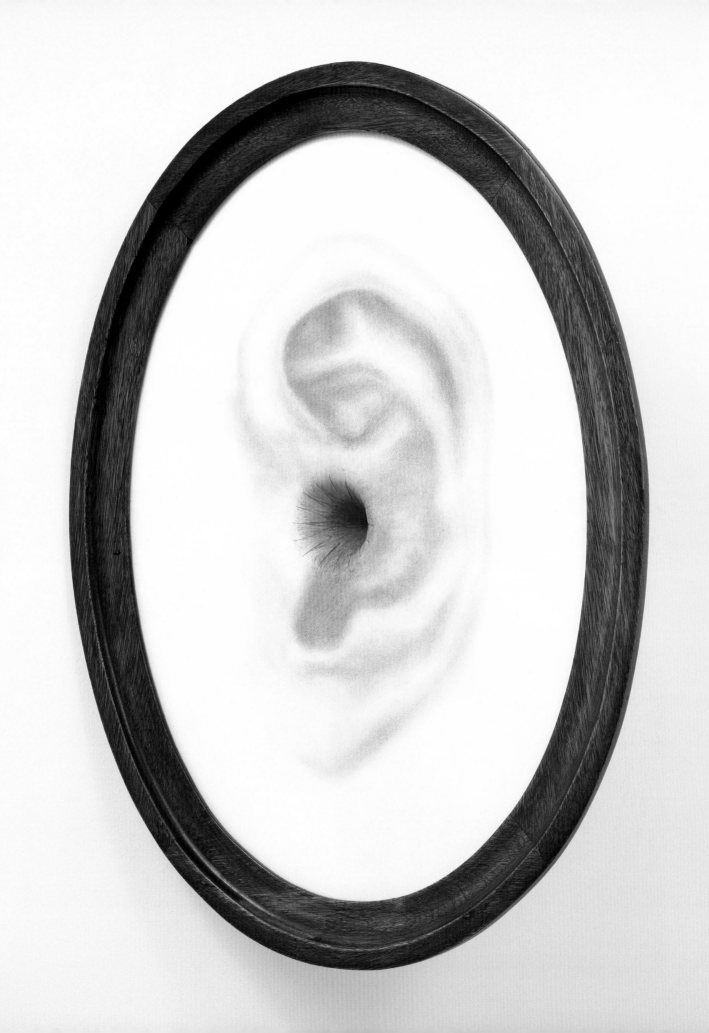

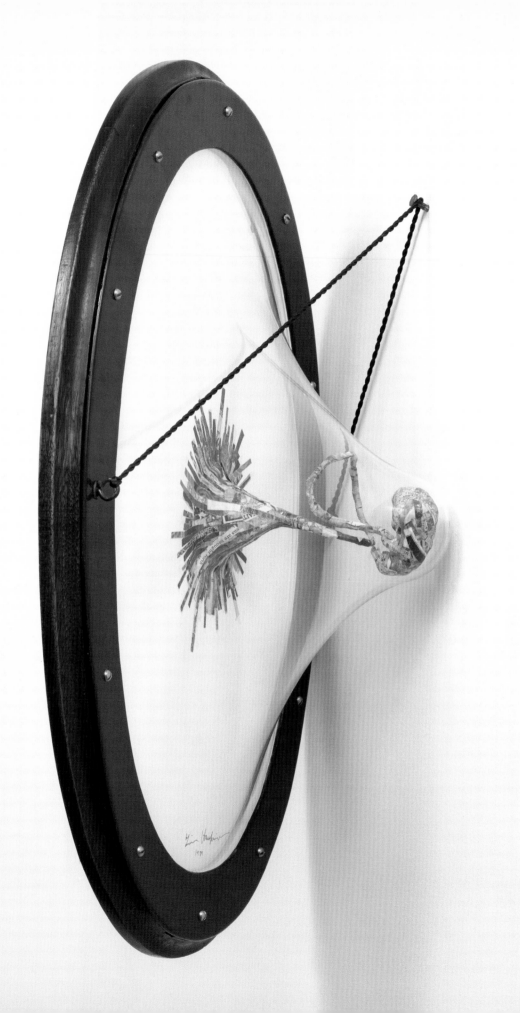

Untitled (Ear/Baby), 1989
Mixed media
20 1/2 x 15 1/2 x 6 1/2 in.
(52.1 x 39.4 x 16.5 cm)

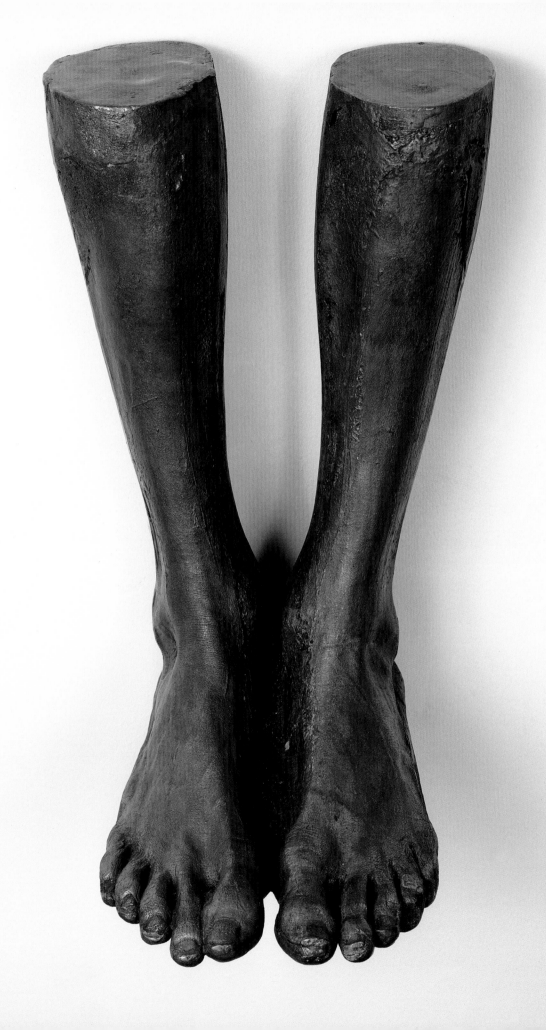

*Self-Portrait (Height Determined
by Weight)*, 1990
Lead
15 $^1/_2$ x 9 $^1/_4$ x 11 in.
(39.4 x 23.5 x 27.9 cm)

Untitled (Bleached Football Game),
1990
Altered found photograph
7 $\frac{1}{2}$ x 19 $\frac{1}{2}$ x $\frac{3}{4}$ in.
(19.1 x 49.5 x 1.9 cm)

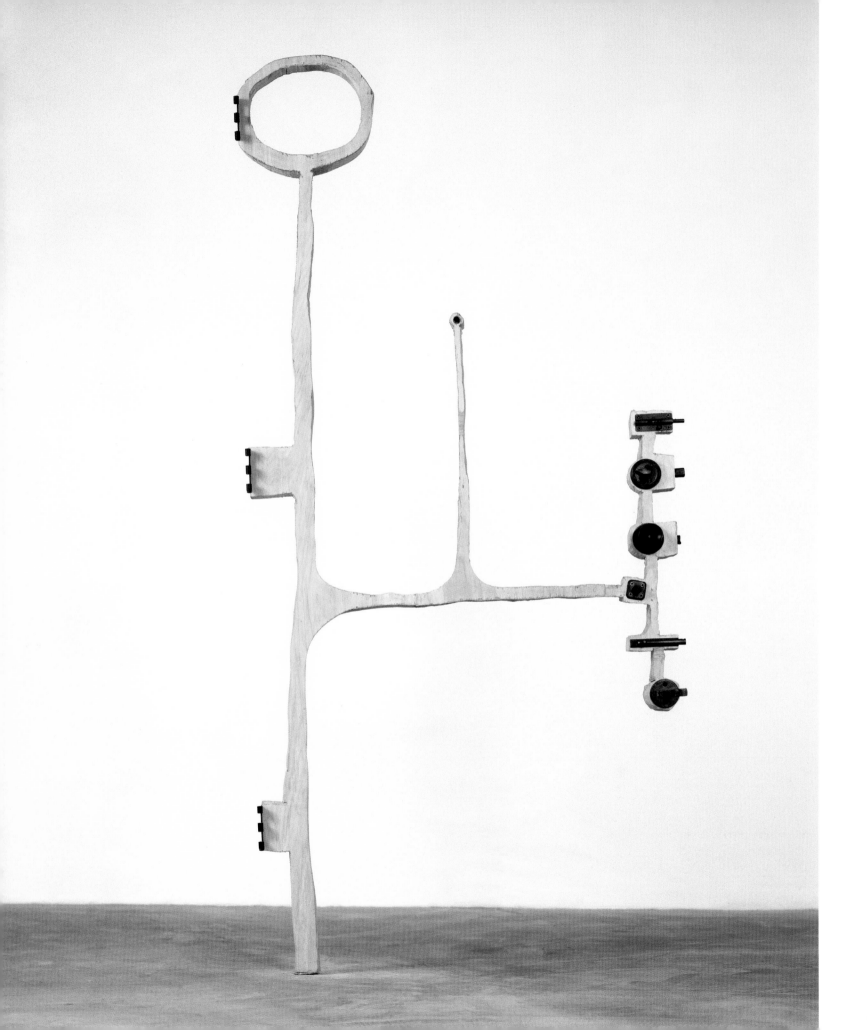

Untitled (Key II), 1990
Altered wooden door, doorknob,
hinges, and handle
78 $\frac{1}{2}$ x 36 $\frac{1}{2}$ x 6 $\frac{1}{2}$ in.
(199.4 x 92.7 x 16.5 cm)

Blindspot, 1991
Photomontage
22 x 16 x ³/₄ in.
(55.9 x 40.6 x 1.9 cm)

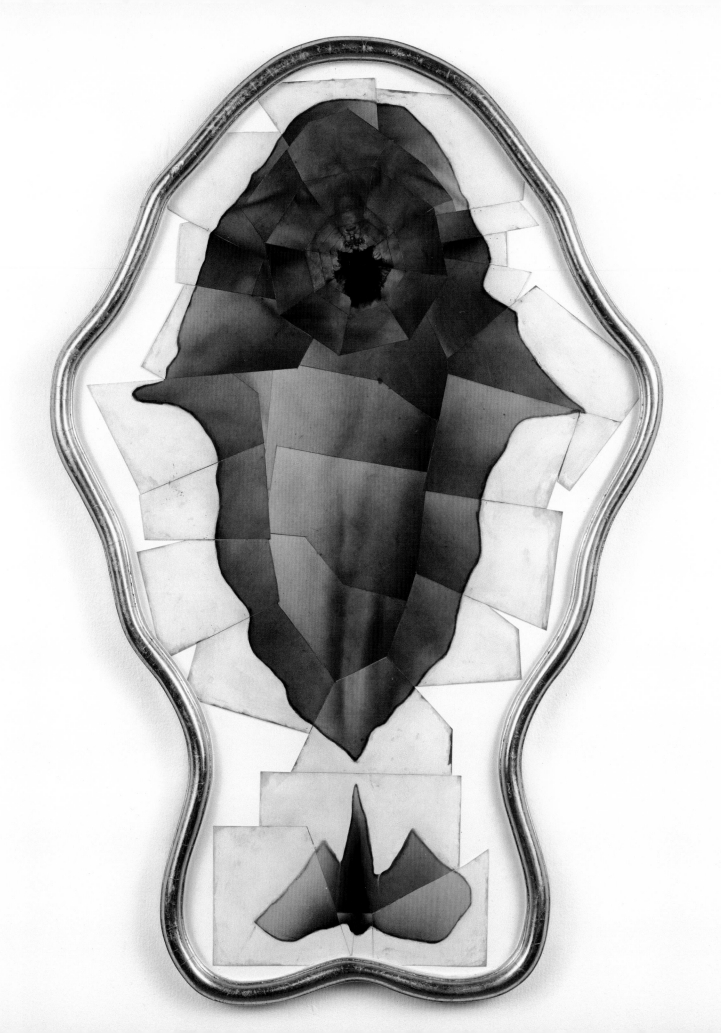

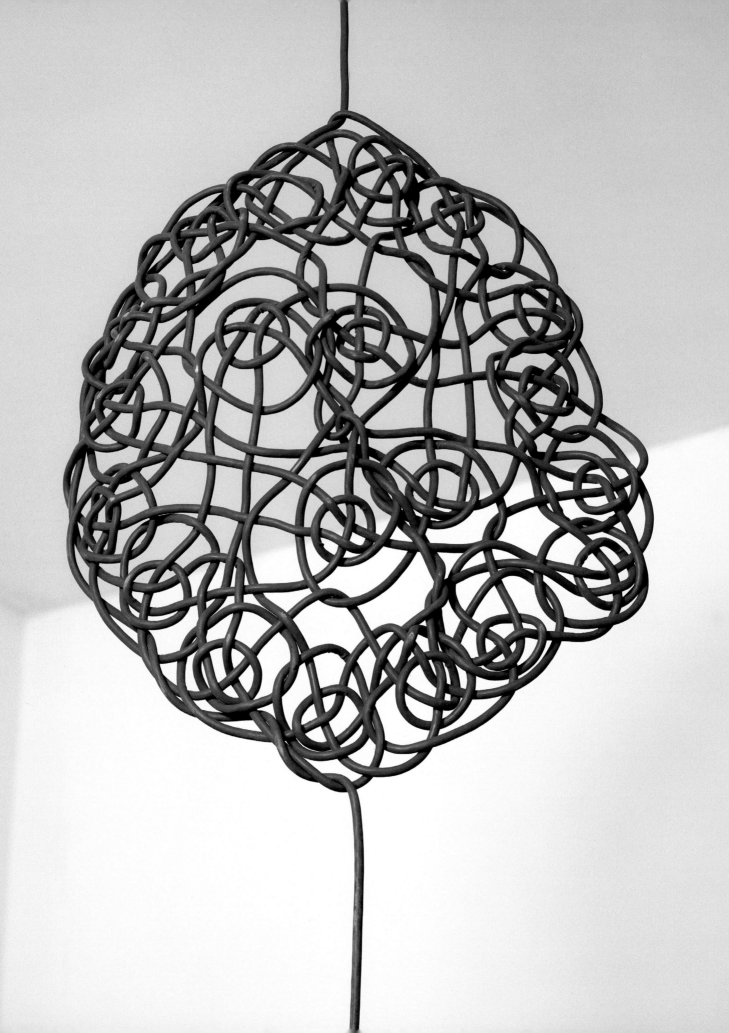

Knot, 1991
Extension cord
30 x 30 in. (76.2 x 76.2 cm)

Shorts, 1993
Extension cord
14 x 14 x 10 in.
(35.6 x 35.6 x 25.4 cm)

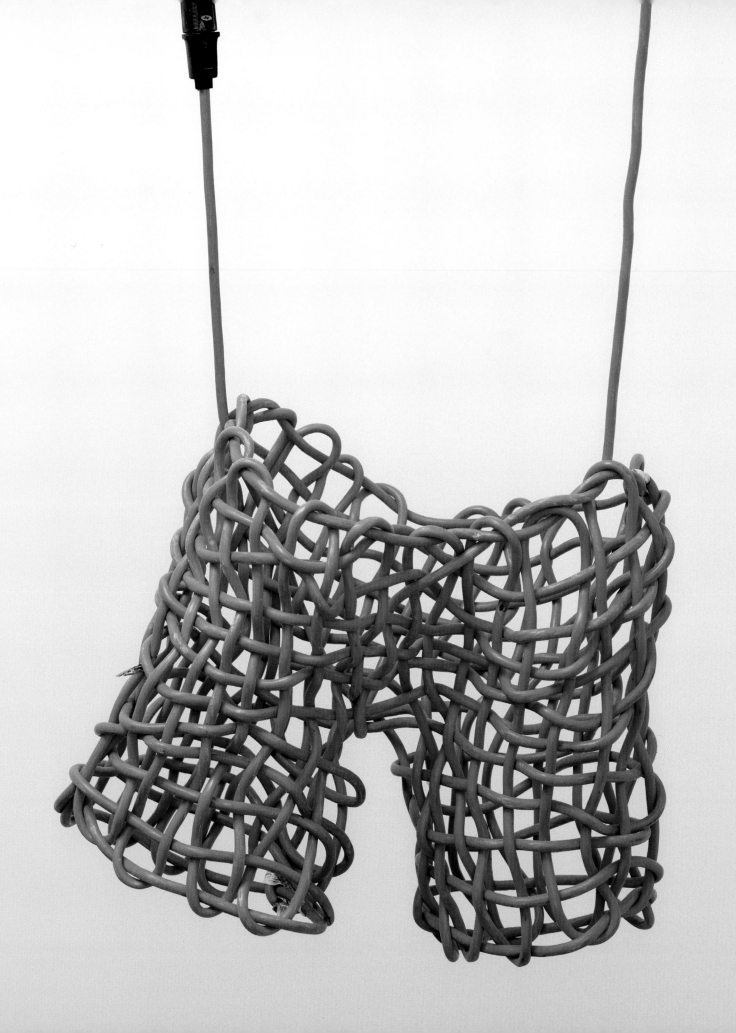

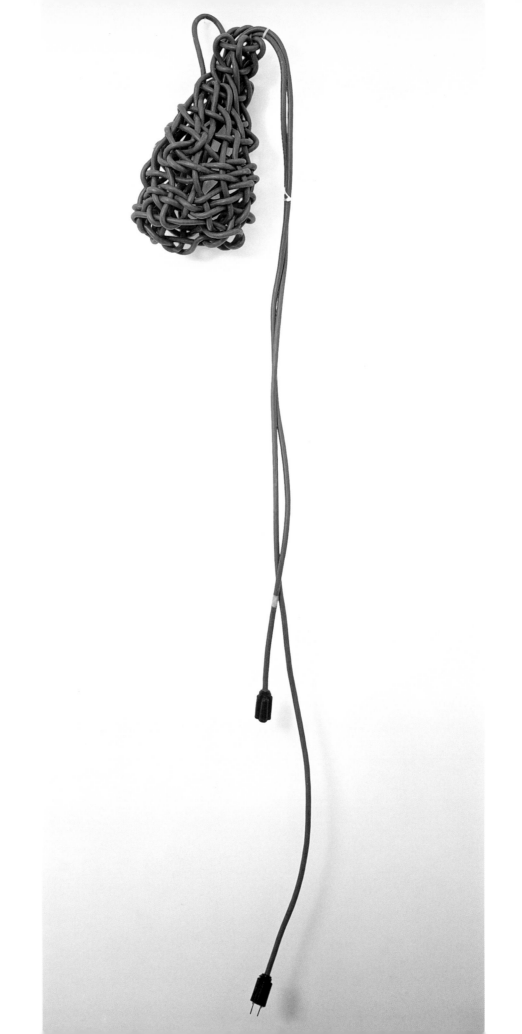

Vessel, 1994
Extension cord
12 x 5 x 5 in.
(30.5 x 12.7 x 12.7 cm)

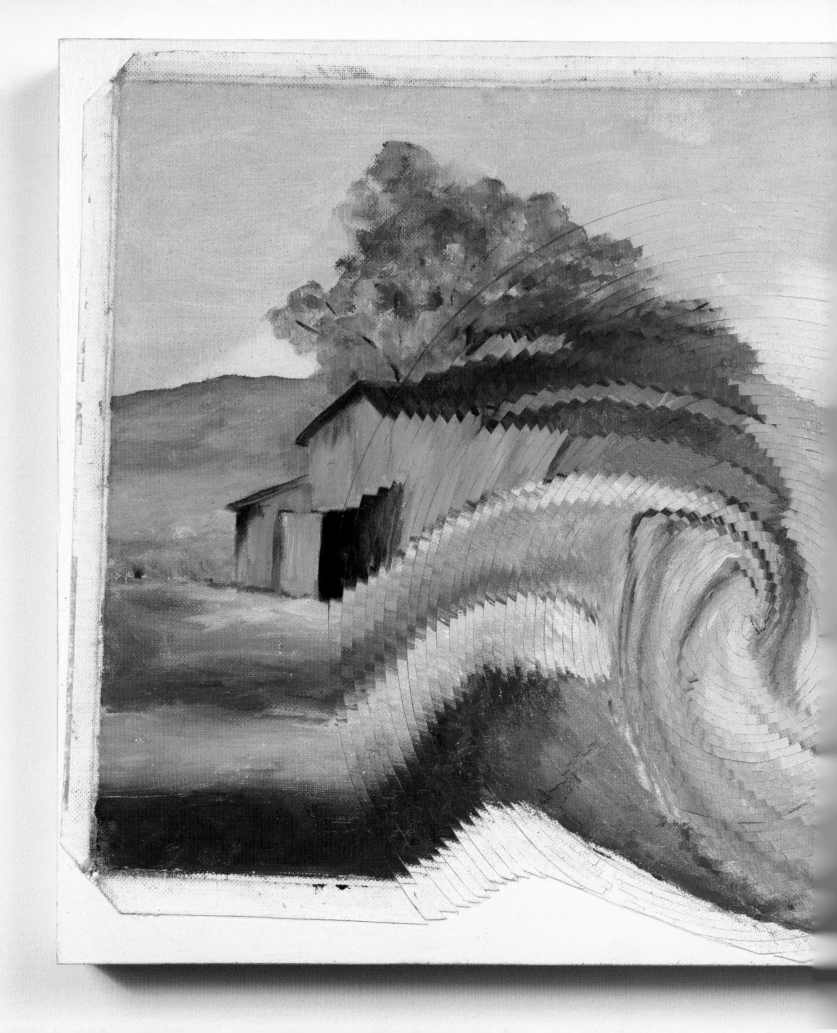

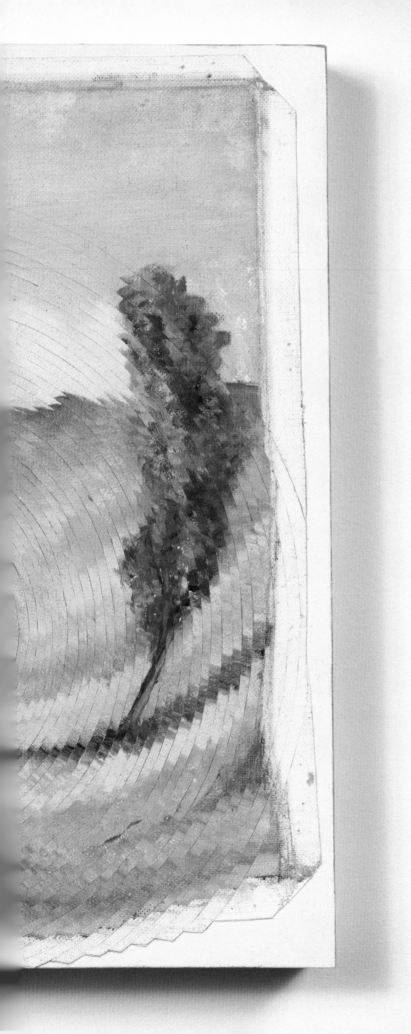

Untitled (Barn with Vortex), 1991
Altered found painting on panel
14 x 17 $^{1}/_{2}$ x 2 in.
(35.6 x 44.5 x 5.1 cm)

Volume Control, 1992
Paper, aluminum foil, and glue
on panel
76 (diam.) x 2 in. (193 x 5.1 cm)

Alter, 1993
Pastel on fabric on panel
58 x 45 x 1 ½ in.
(147.3 x 114.3 x 3.8 cm)

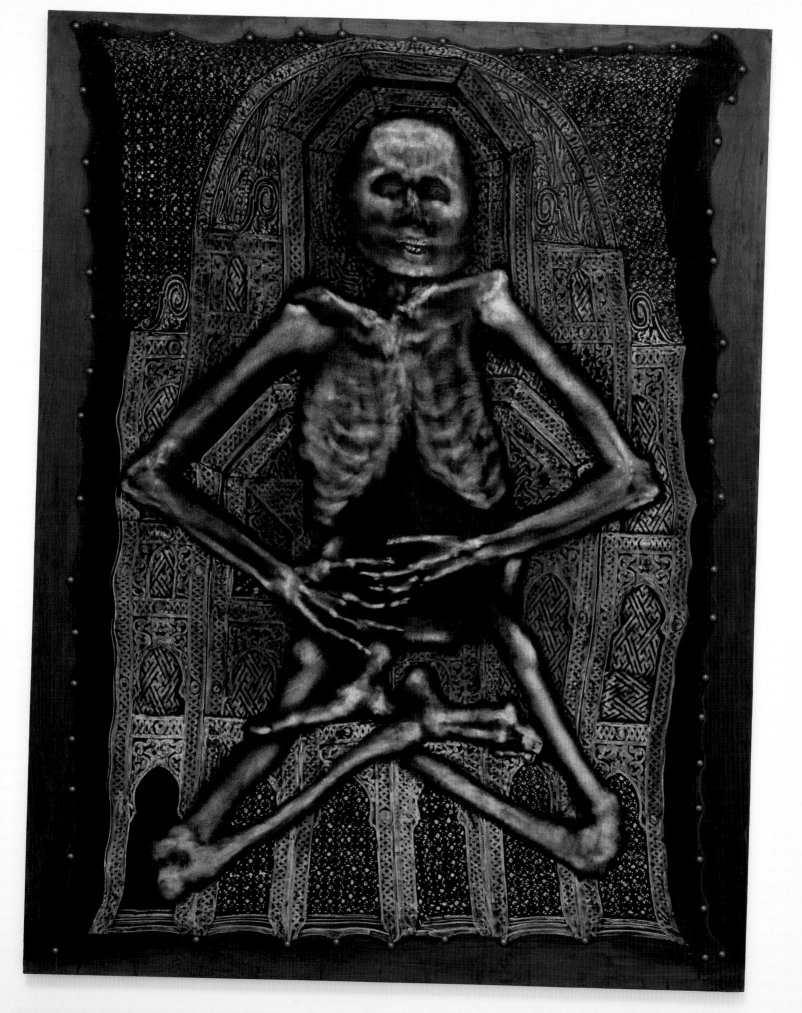

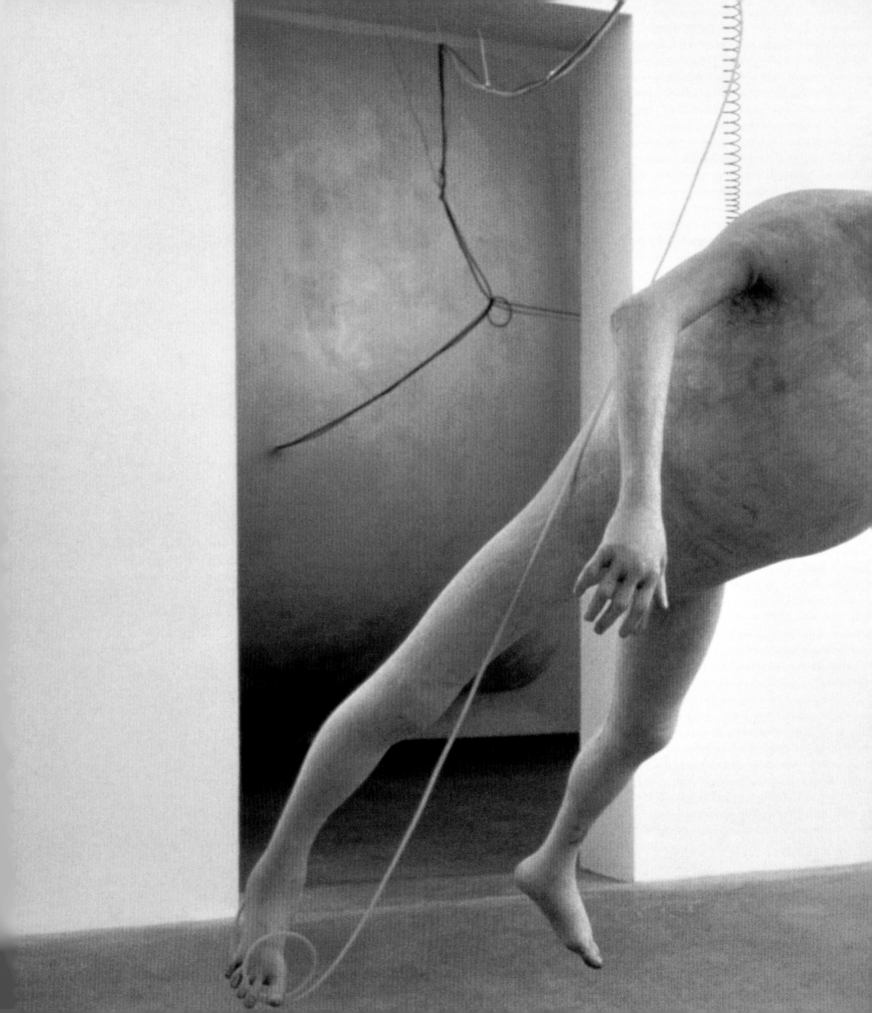

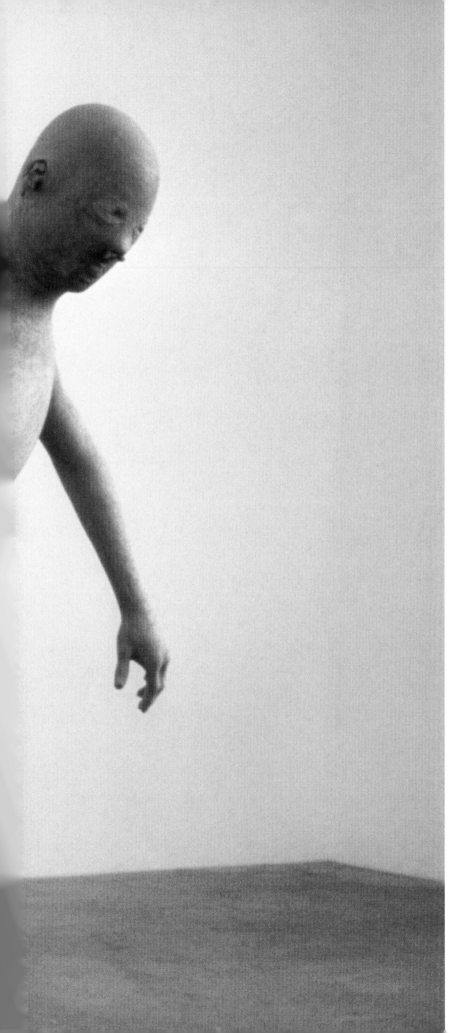

Balloon Self-Portrait, 1993
Latex and air
72 x 48 x 33 in.
(182.9 x 121.9 x 83.8 cm)

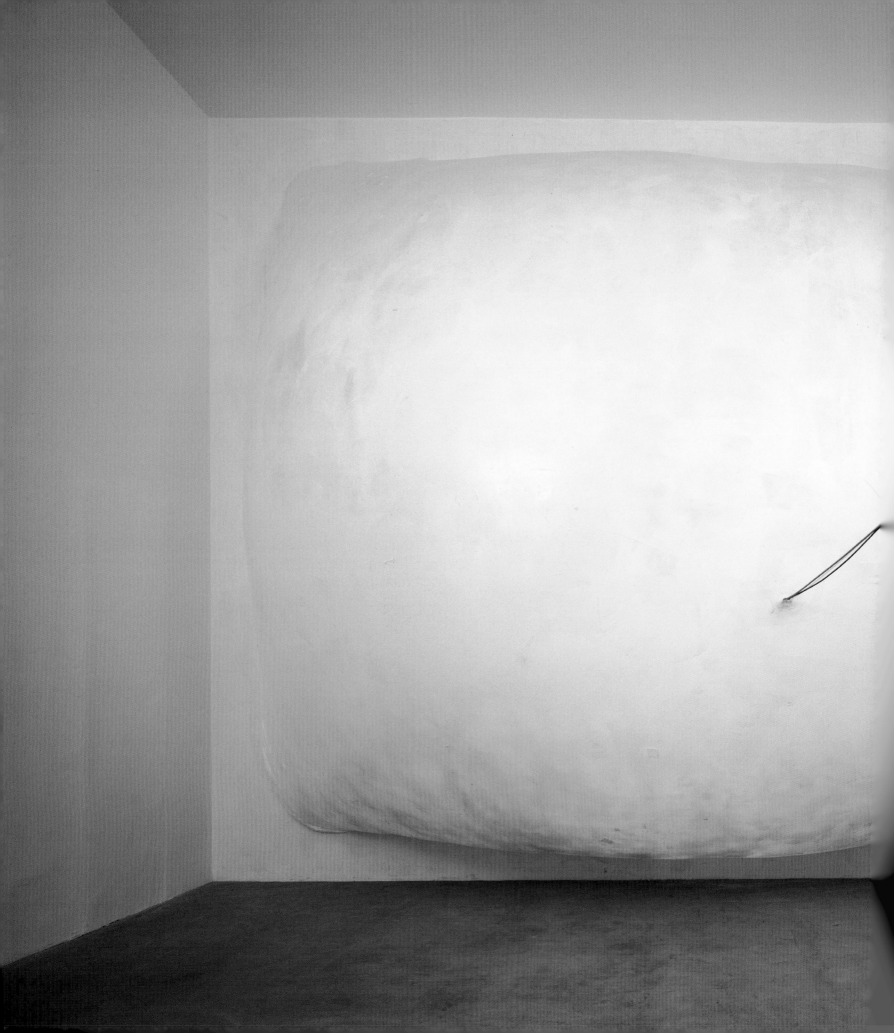

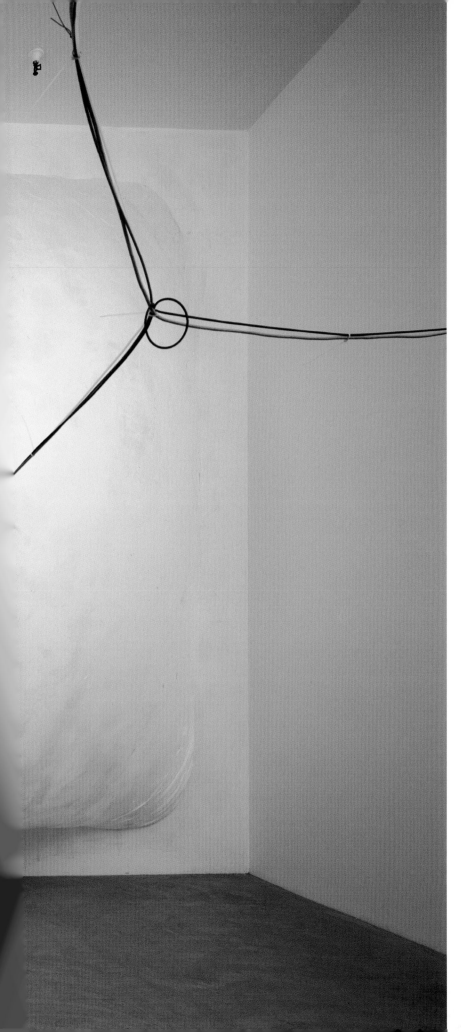

Reservoir, 1993
Latex on wall, air, tubing, and blower
Dimensions variable

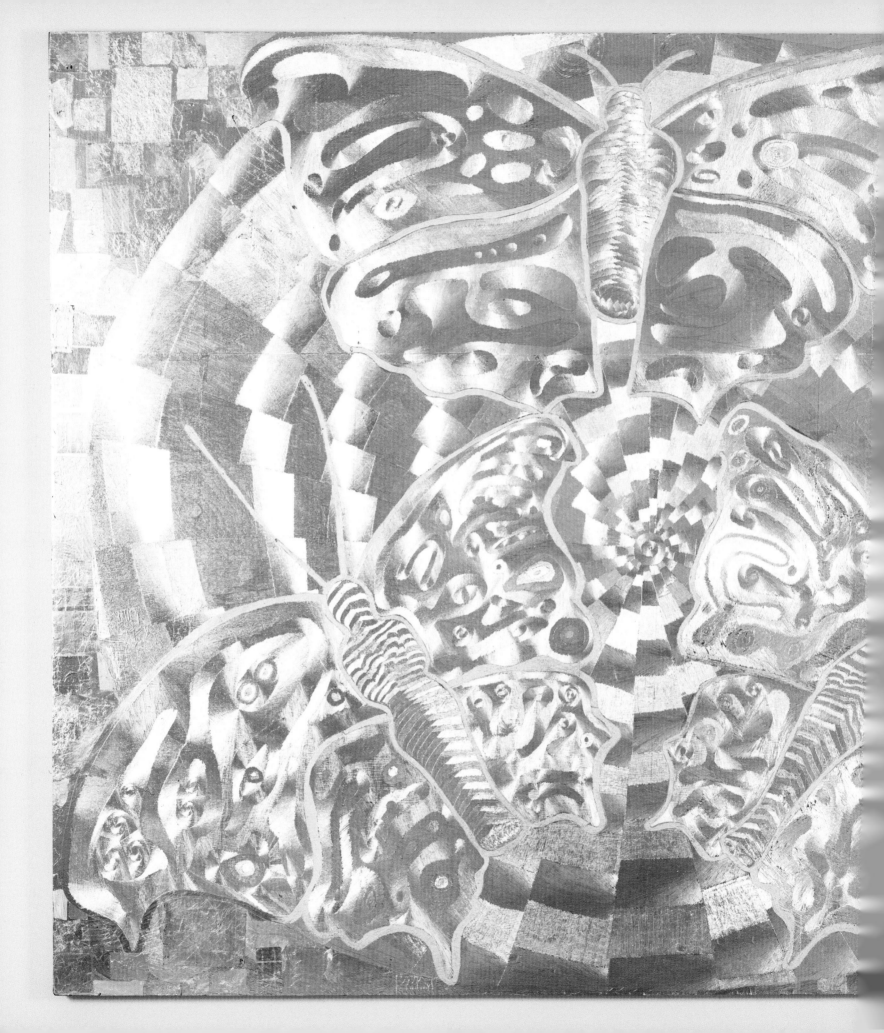

Butterflummies, 1993
Aluminum foil on wood panel
72 x 96 in. (182.9 x 243.8 cm)

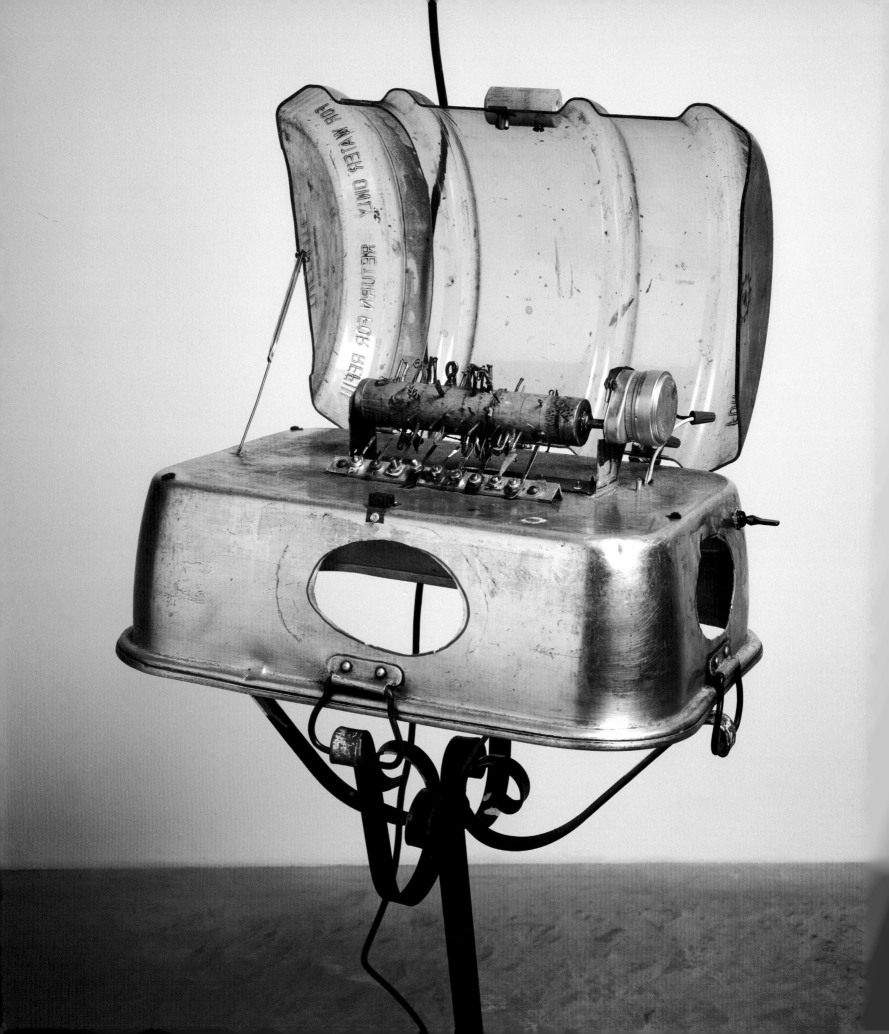

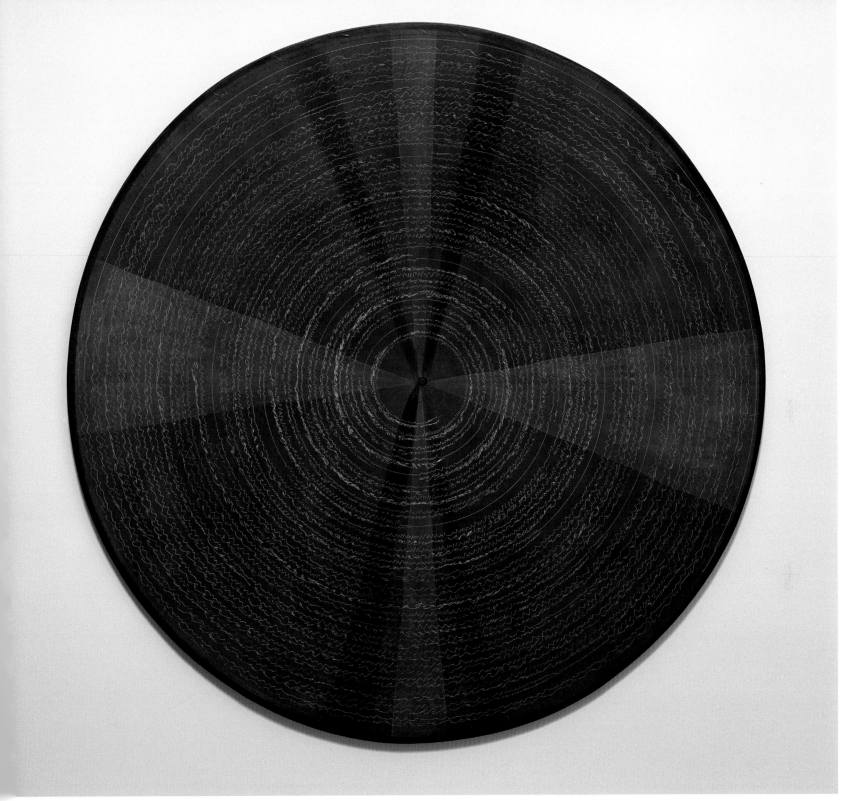

My Favorite Things, 1993 (details)
Music box: roasting pan, plastic water bottle,
plant stand, and metal; motorized
Disks: gesso, wax, ink, and shellac on paper
on panel
Music box: 43 x 17 x 16 in. (109.2 x
43.2 x 40.6 cm); disks: 46 ½ in. (118.1 cm)
(diam.) each

Signature, 1993
School desk, paper, wood,
and metal; motorized
37 x 28 x 24 in.
(94 x 71.1 x 61 cm)

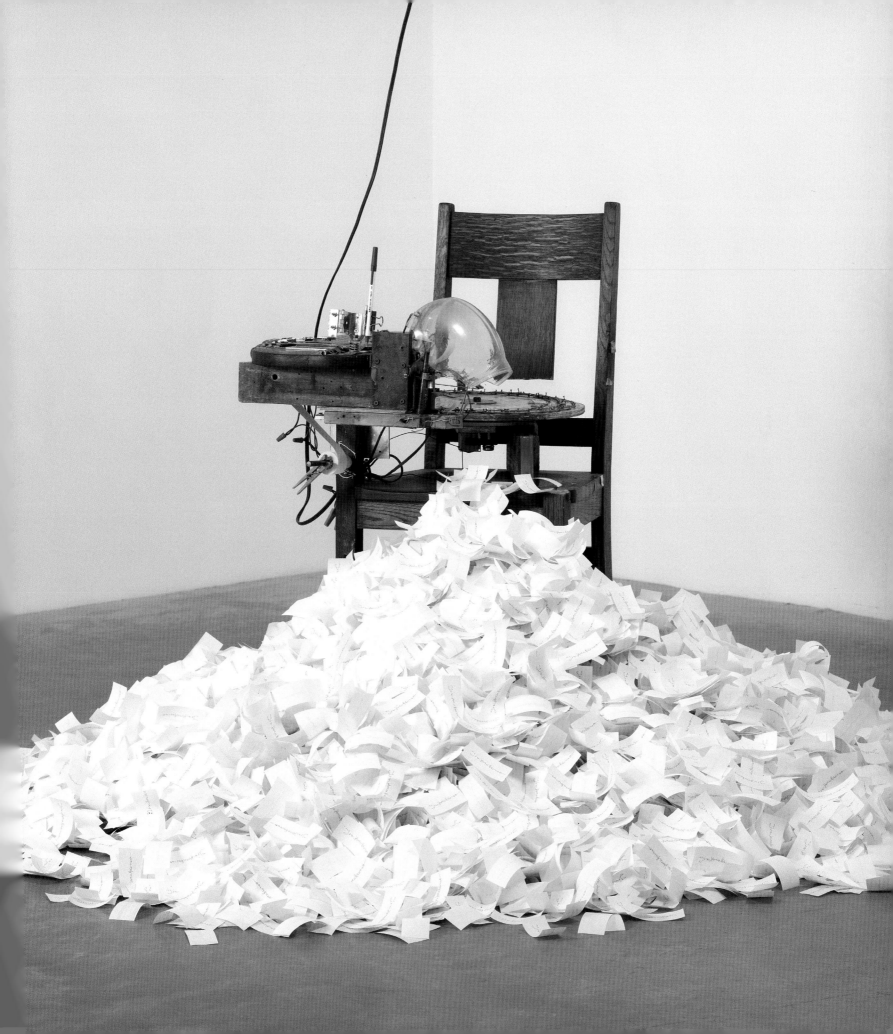

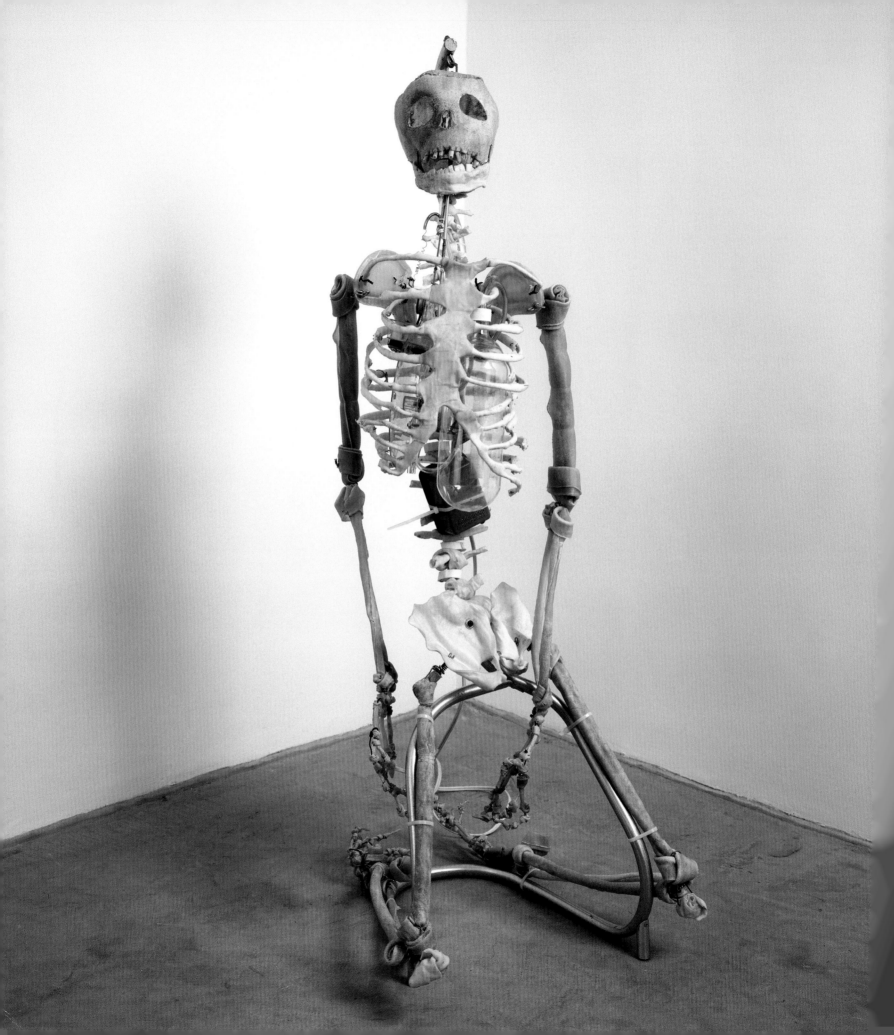

Penitent, 1994
Rawhide dog chews and slide
whistle; motorized, with sound
48 x 18 x 18 in.
(121.9 x 45.7 x 45.7 cm)

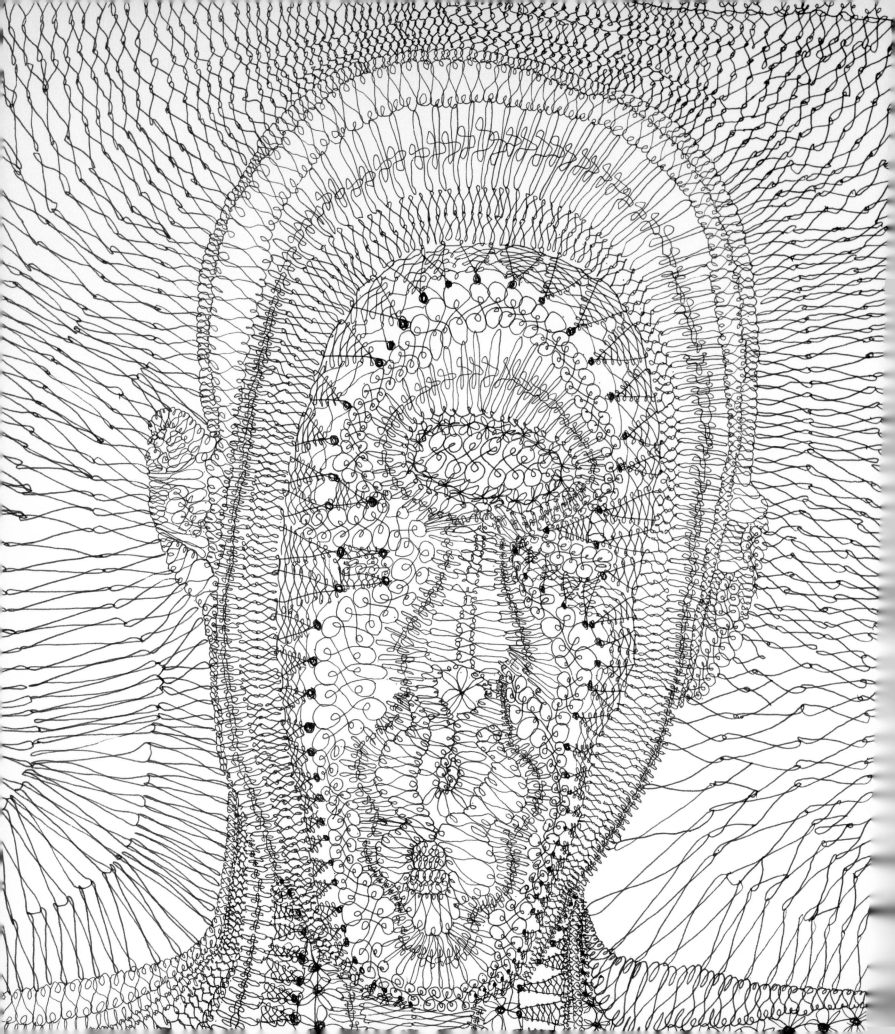

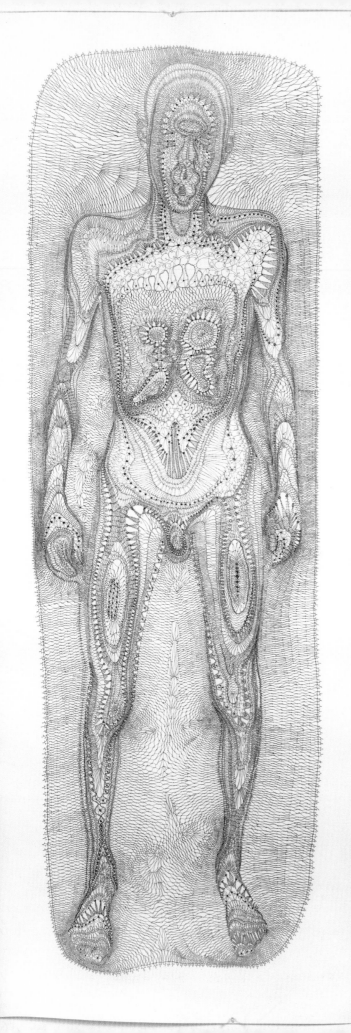

Bathtub-Generated Contour Lace,
1995 (detail, left)
Ink on paper
80 x 32 $\frac{1}{2}$ in. (203.2 x 82.6 cm)

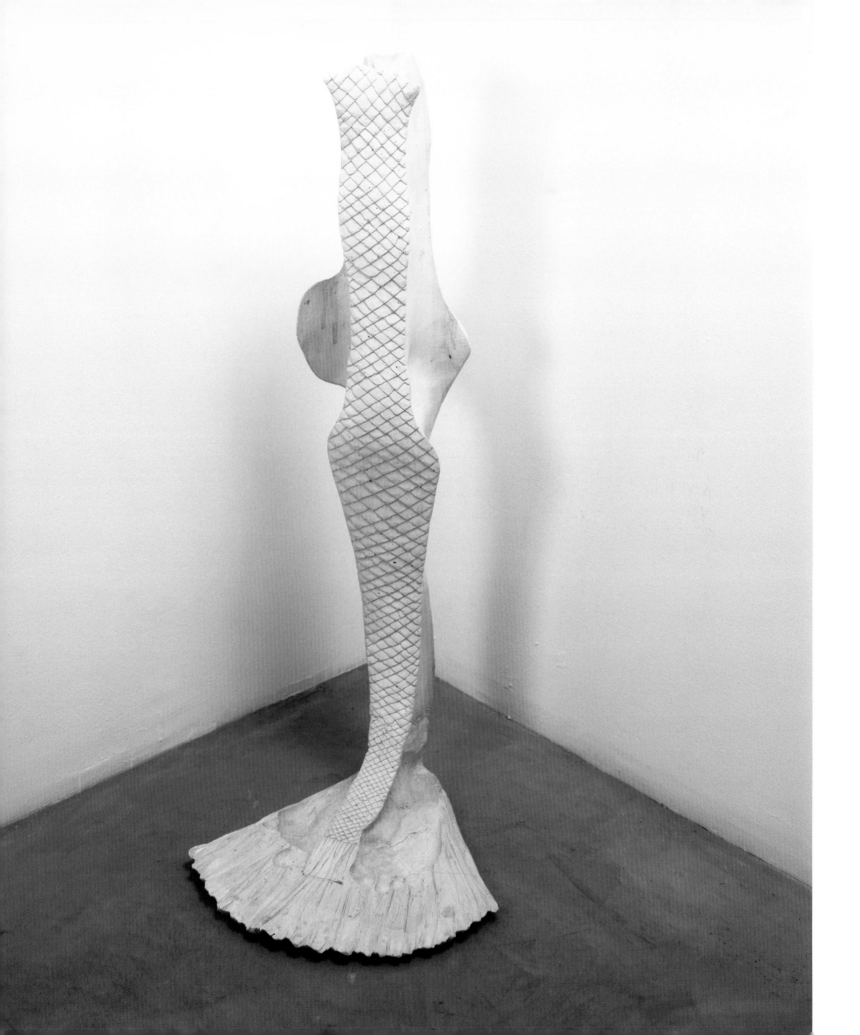

The Fin Within, 1995
Plaster
36 x 15 x 15 in.
(91.4 x 38.1 x 38.1 cm)

H.M.S.O., 1995
Wood, fabric, and string
90 (diam.) x 10 in.
(228.6 x 25.4 cm)

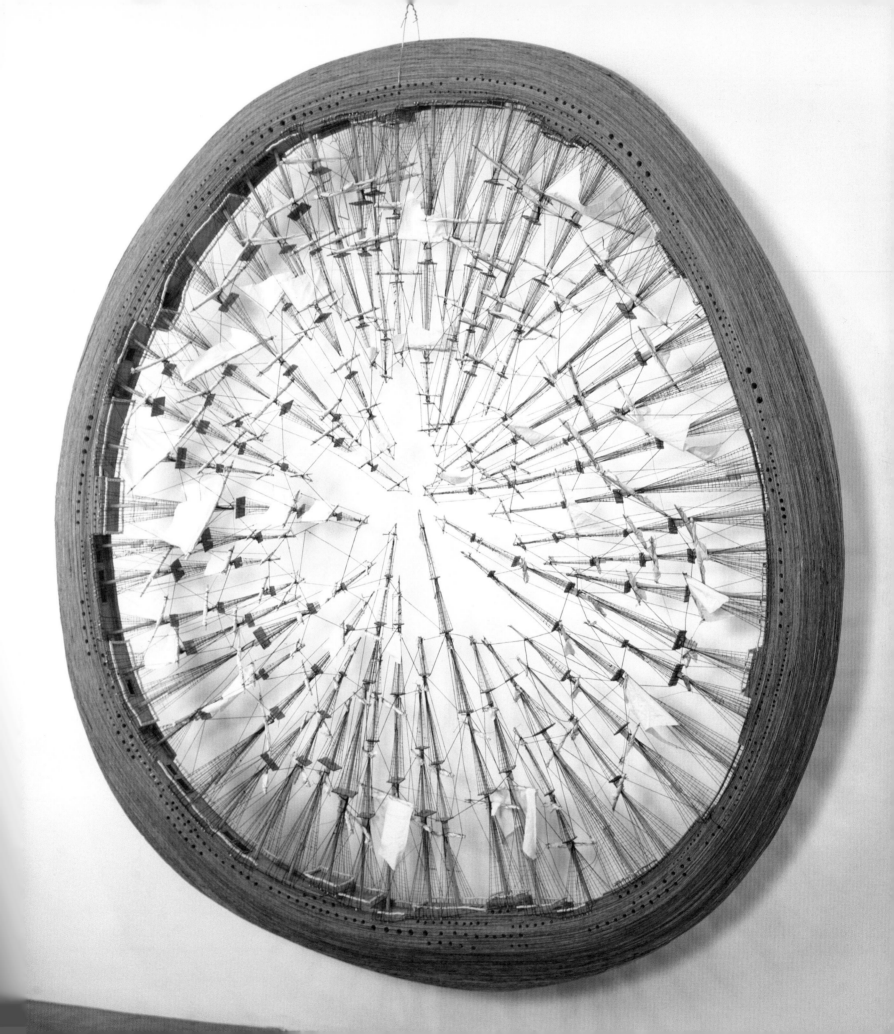

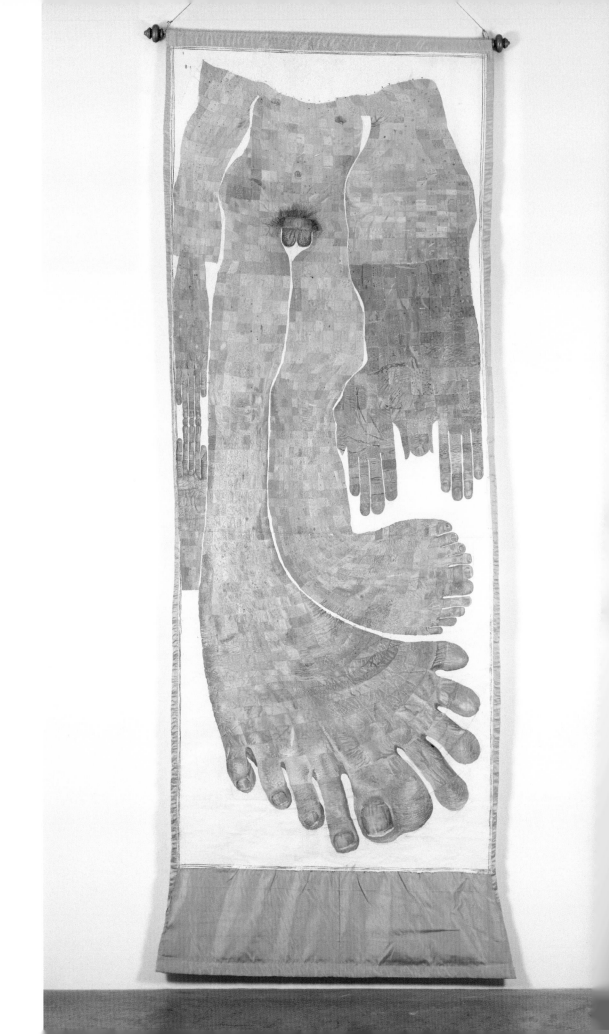

Humongolous, 1995 (detail, right)
Synthetic polymer on rag paper
on fabric
172 x 48 in. (436.9 x 121.9 cm)

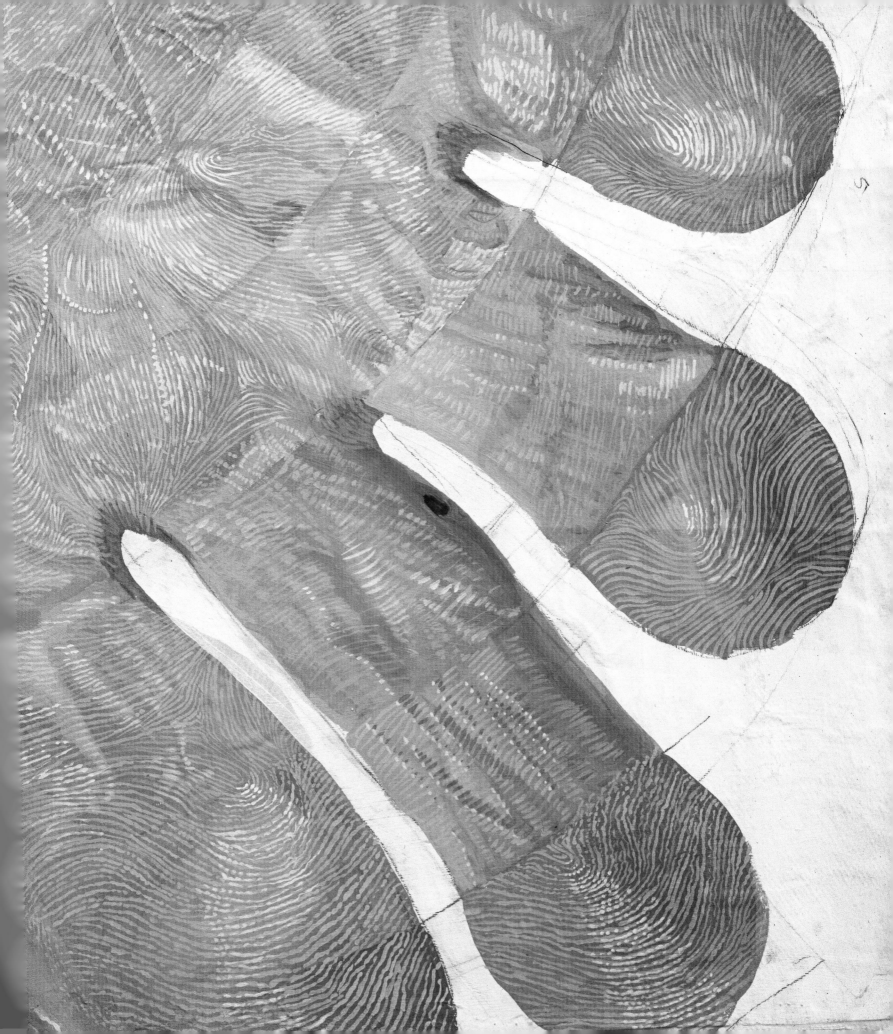

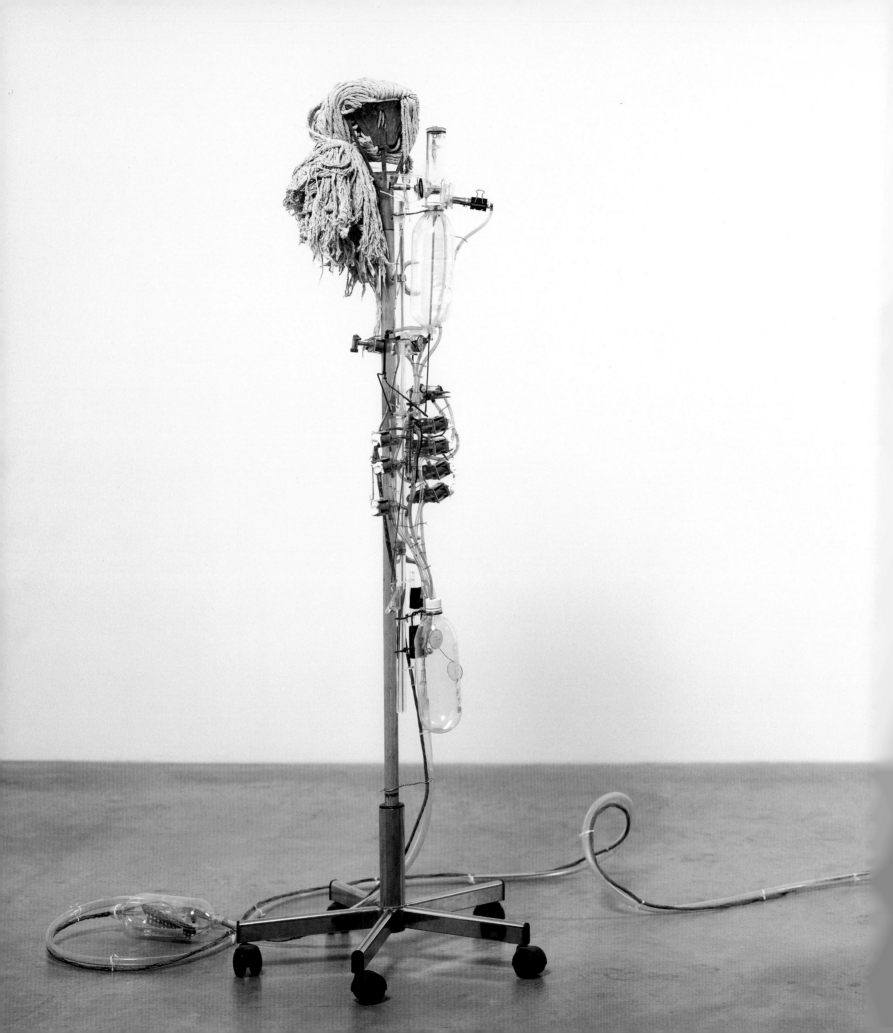

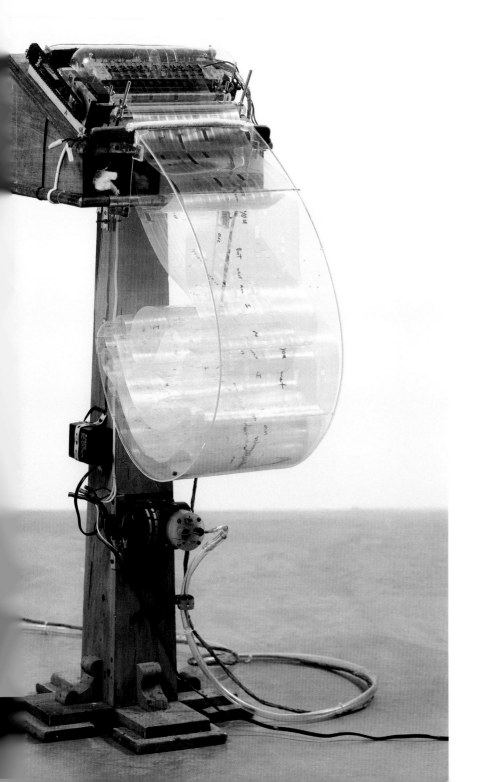

Ranting Mop Head (Synthesized Voice), 1995
Mop, lectern, and mixed media; motorized,
with sound
Mop: 67 x 24 x 24 in. (170.2 x 61 x 61 cm);
lectern: 50 x 17 x 27 in. (127 x 43.2 x
68.6 cm); cable: 204 in. (518.2 cm) (length)

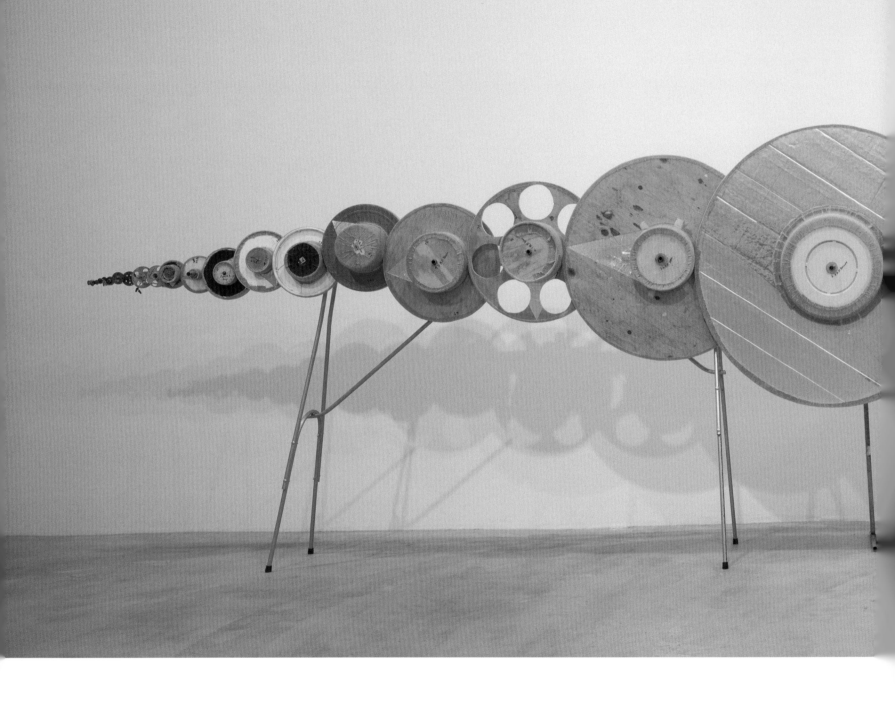

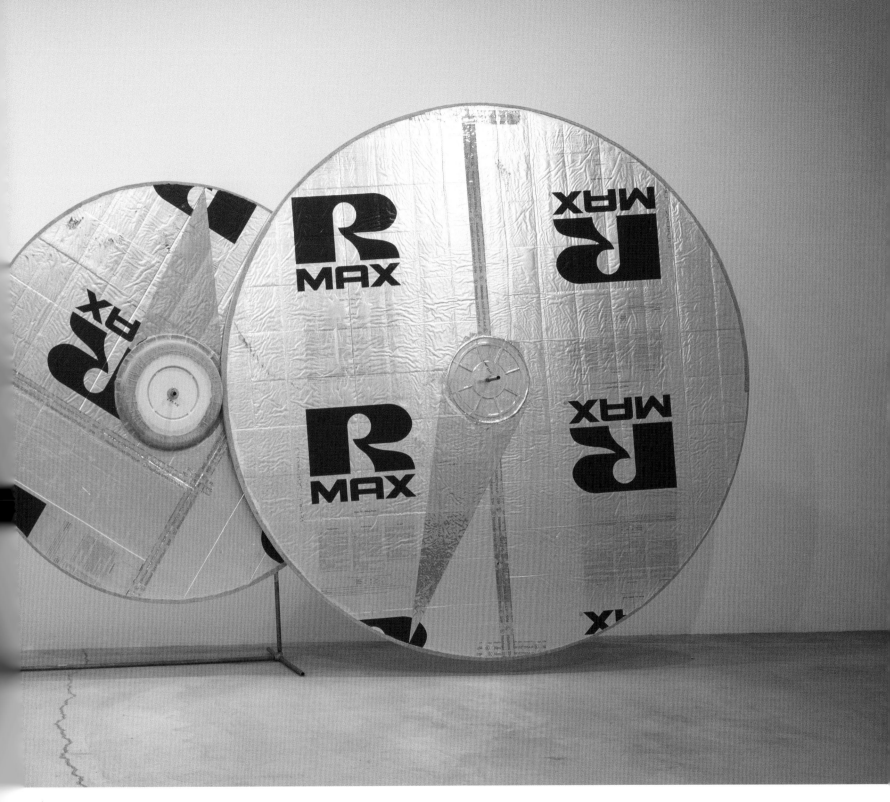

Spin Sink (1 Rev./100 Years), 1995
Twenty-four gears, steel, plywood,
foam, plastic, and corduroy; motorized
96 x 277 x 48 in.
(243.8 x 703.6 x 121.9 cm)

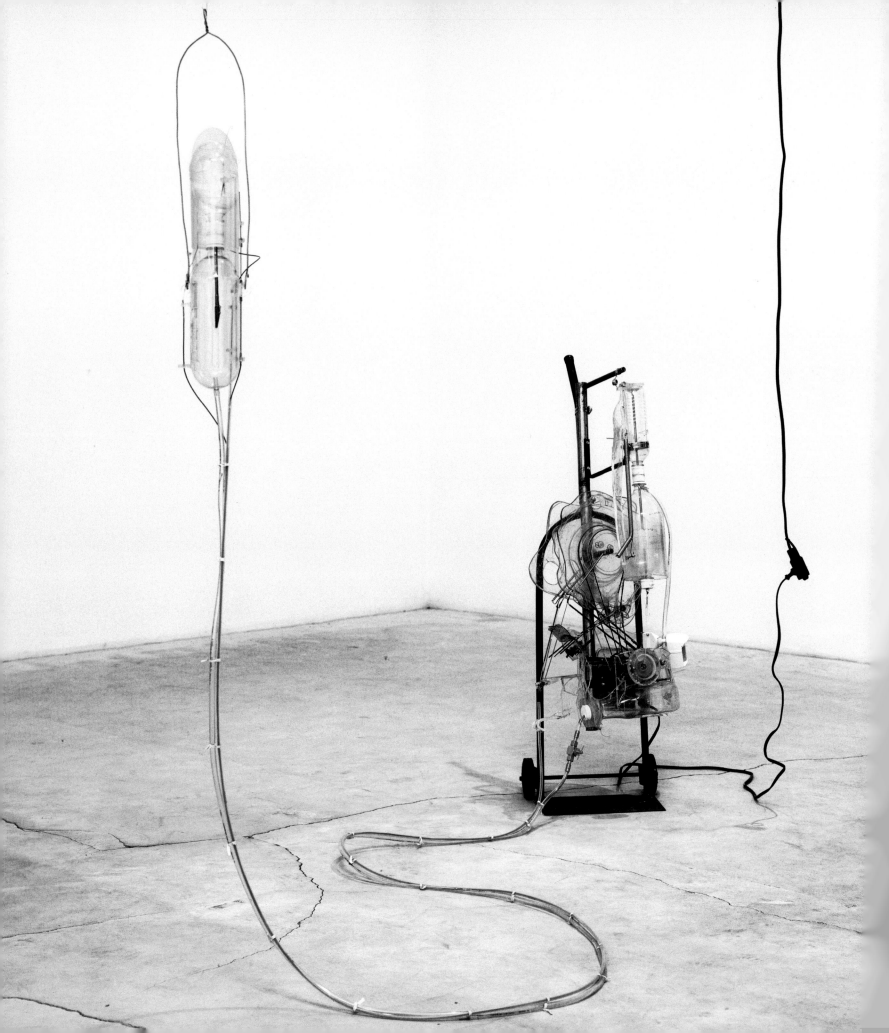

Tuva, 1995
Plastic bottles, handcart, and air;
motorized, with sound
Handcart: 44 x 24 x 20 in. (111.8 x 61 x
50.8 cm); bottles: 23 x 4 x 5 in.
(58.4 x 10.2 x 12.7 cm); cable: 132 in.
(335.3 cm) (length)

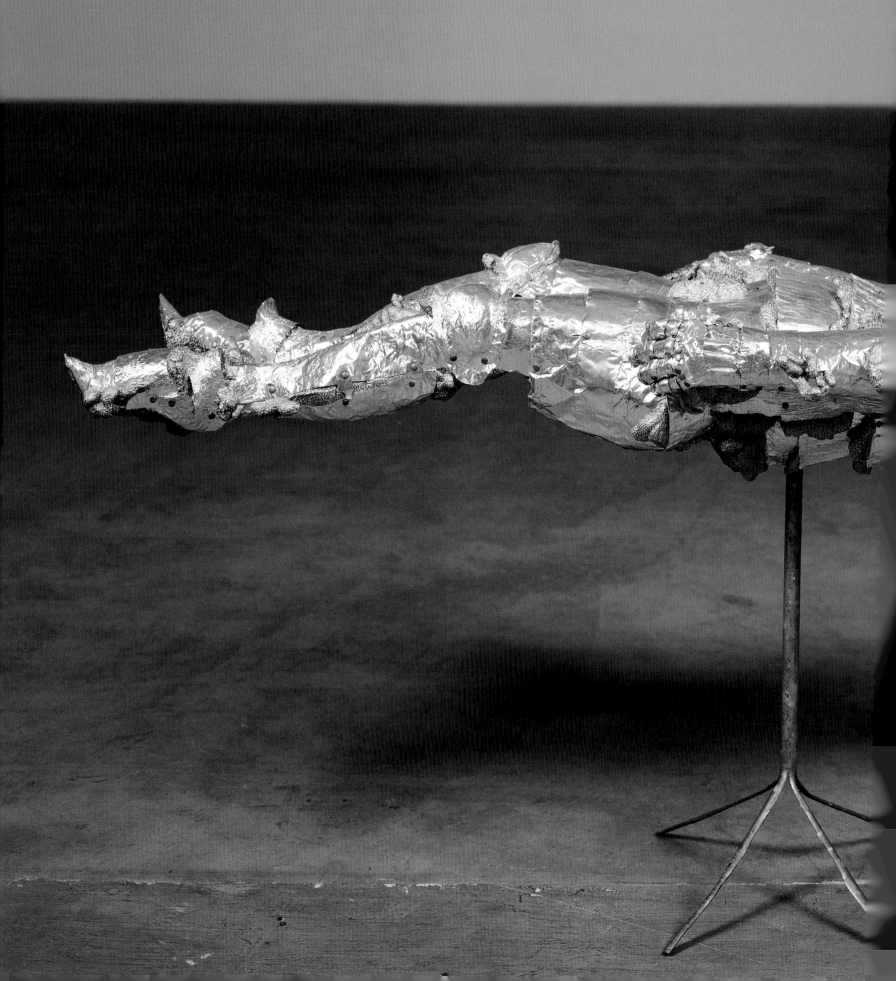

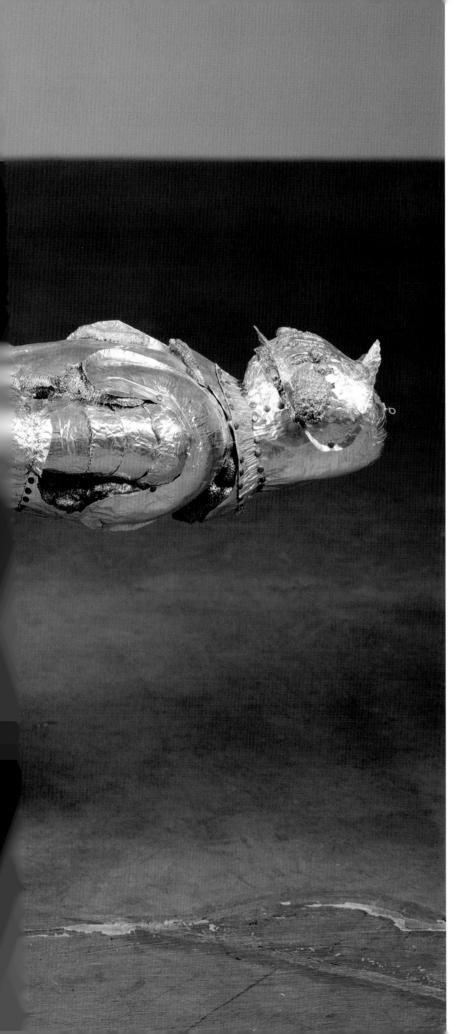

Armor Ooze, 1996
Aluminum foil, synthetic polymer on
urethane foam, and brass brads
37 $\frac{1}{2}$ x 78 $\frac{1}{2}$ x 25 $\frac{1}{2}$ in.
(95.3 x 199.4 x 64.8 cm)

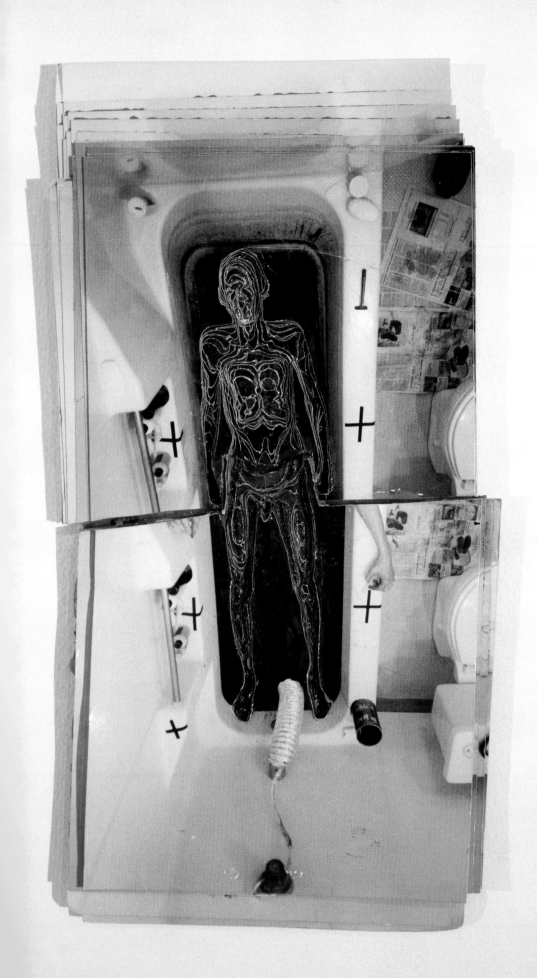
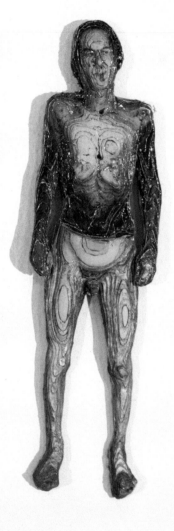

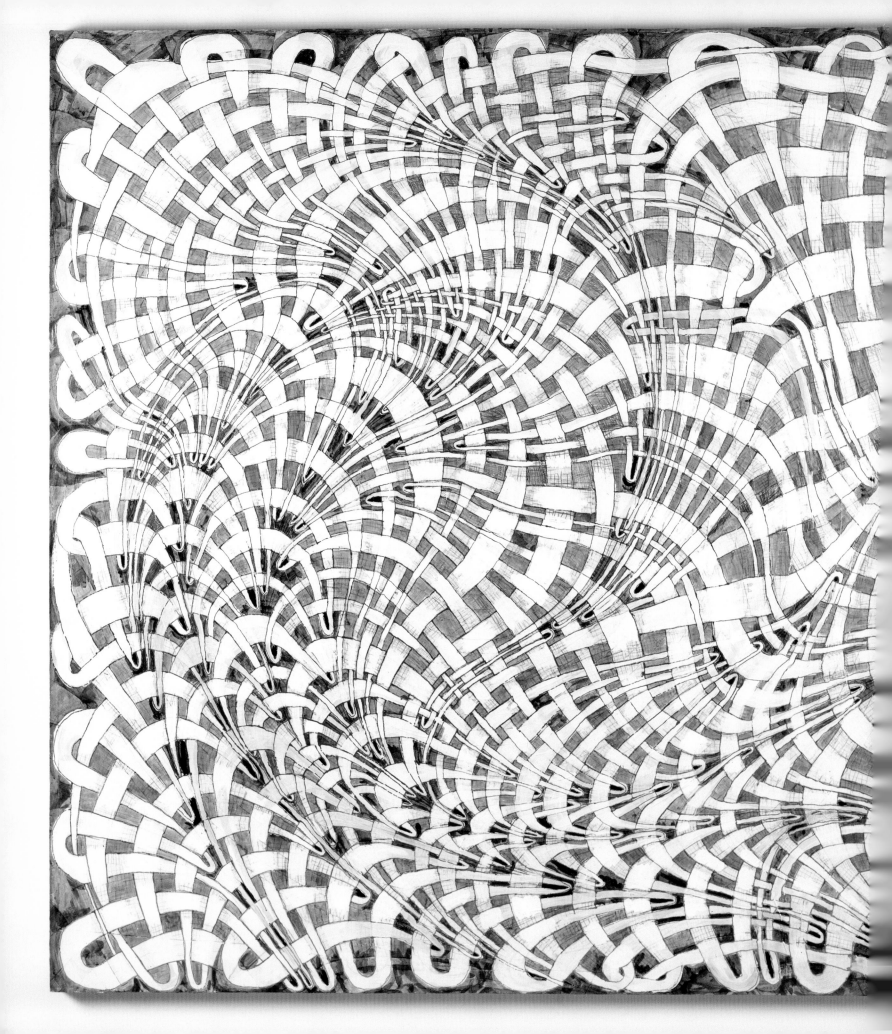

Draw! Paint! Weave! Spin!, 1996
Graphite and synthetic polymer
on paper on panel
64 x 61 $\frac{1}{2}$ in. (162.6 x 156.2 cm)

Bucket Clock, 1996,
from *Secret Sync*
Plastic bucket and clock motor
14 $^1/_4$ x 12 $^1/_2$ in. (diam.)
(36.2 x 31.8 cm)

Clamp Lamp Clock, 1996,
from *Secret Sync*
Clamp lamp and clock motor
17 $\frac{1}{2}$ x 2 $\frac{1}{2}$ x 11 in.
(44.5 x 6.4 x 27.9 cm)

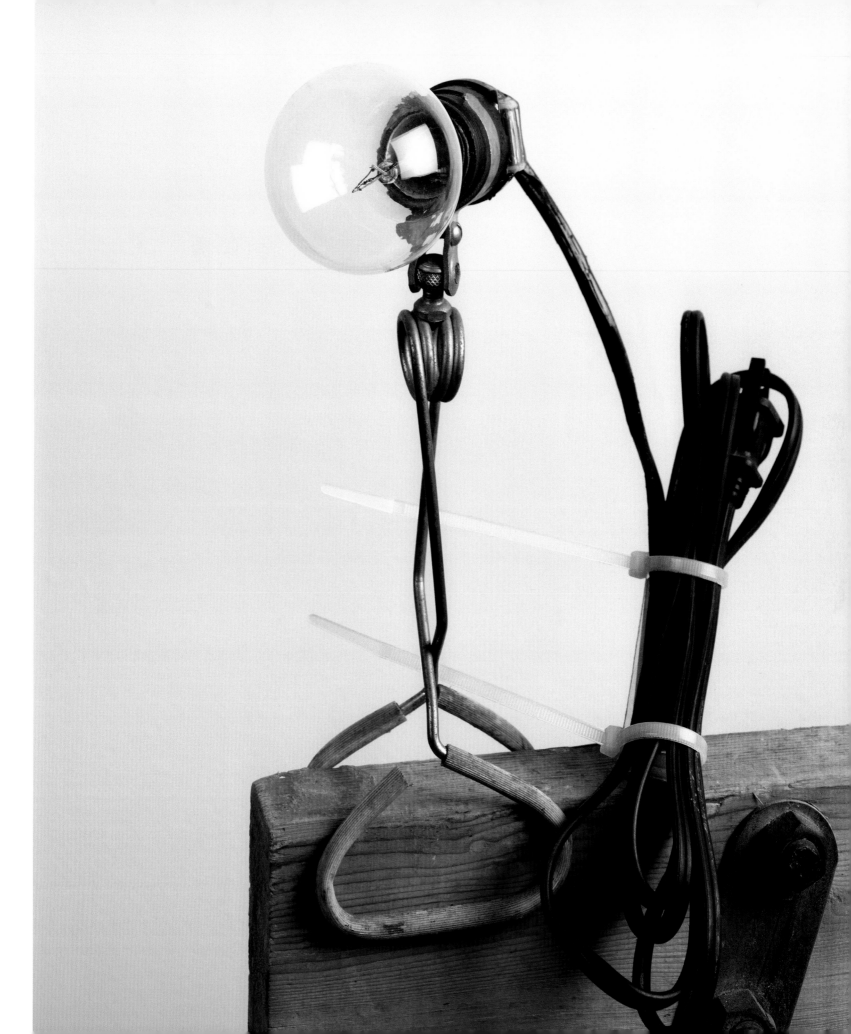

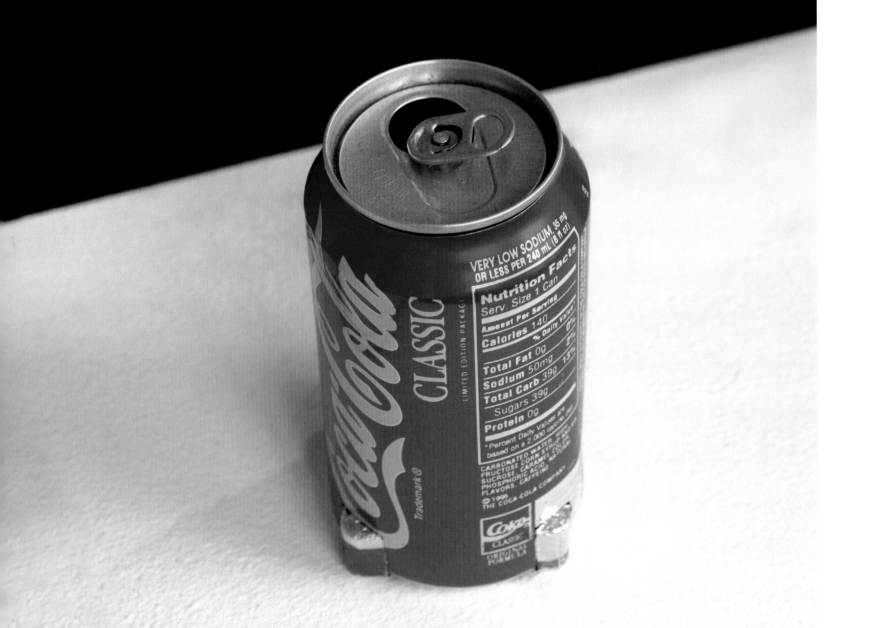

Coke Clock, 1996,
from *Secret Sync*
Coke can and clock motor
4 $^3/_4$ x 2 $^1/_2$ in. (diam.)
(12.1 x 6.4 cm)

Envelope Clock, 1996,
from *Secret Sync*
Manila envelope and clock motor
15 $^1/_2$ x 12 x 1 in.
(39.4 x 30.5 x 2.5 cm)

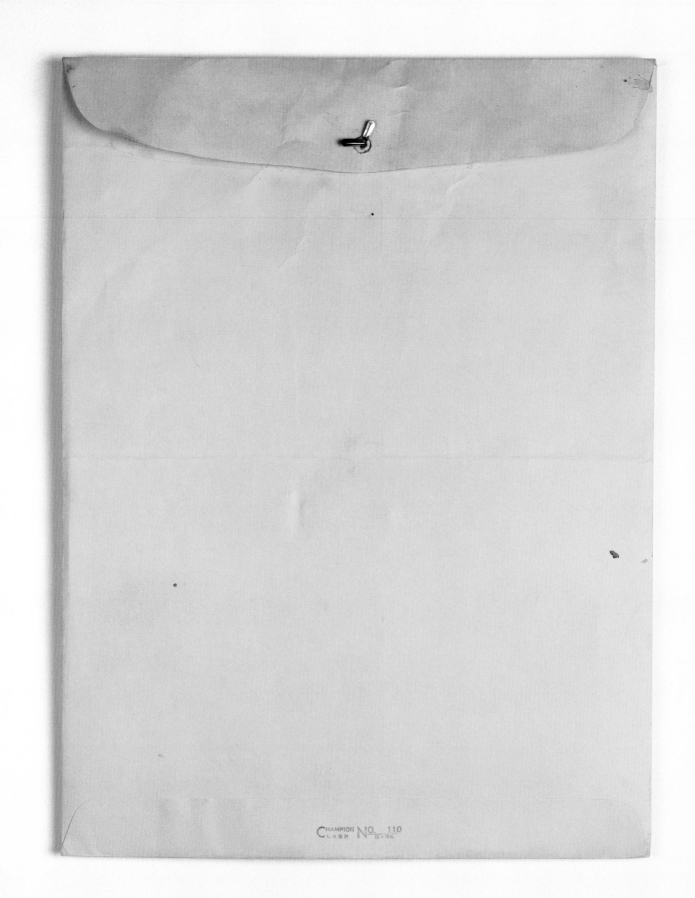

CHAMPION No. 110
CLASP 13 x 10½

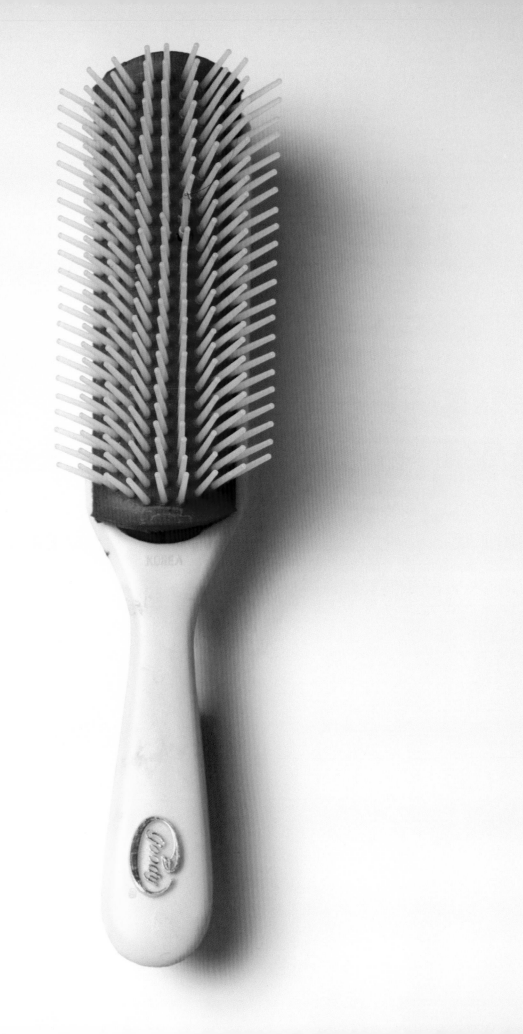

Hairbrush Clock, 1996,
from *Secret Sync*
Hairbrush, hair, and clock motor
$2 \times 2 \frac{1}{2} \times 8 \frac{1}{4}$ in.
(5.1 x 6.4 x 21 cm)

Packing Peanuts Clock, 1996,
from *Secret Sync*
Plastic bag, polystyrene pellets,
twist tie, and clock motor
13 $^3/_4$ x 13 $^1/_2$ x 19 $^3/_4$ in.
(34.9 x 34.3 x 50.2 cm)

Tape Measure Clock, 1996,
from *Secret Sync*
Tape measure, twist tie, and
clock motor
8 x 3 $^1/_2$ x 2 in. (20.3 x 8.9 x 5.1 cm)

Toothpaste Clock, 1996,
from *Secret Sync*
Toothpaste tube, caulking,
and clock motor
3 x 3 x 2 in.
(7.6 x 7.6 x 5.1 cm)

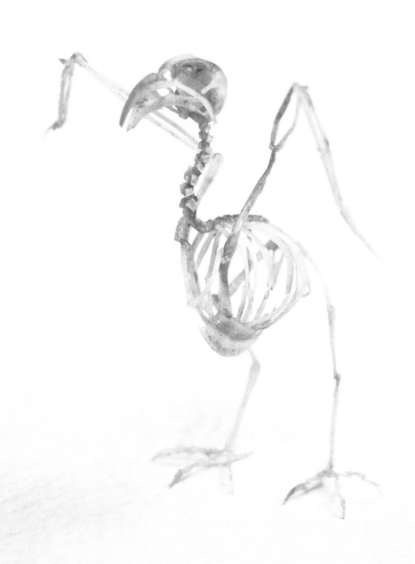

Bird, 1997
Fingernail parings and superglue
2 x 2 $\frac{1}{4}$ x 2 in. (5.1 x 5.7 x 5.1 cm)

Egg, 1997
Ground fingernails, hair,
and superglue
1 x 1 ½ x 1 in.
(2.5 x 3.8 x 2.5 cm)

Feather, 1997
Hair and superglue
2 $\frac{1}{4}$ x 2 x $\frac{1}{2}$ in.
(5.7 x 5.1 x 1.3 cm)

Web, 1998
Hair and superglue
48 x 35 in.
(121.9 x 88.9 cm)

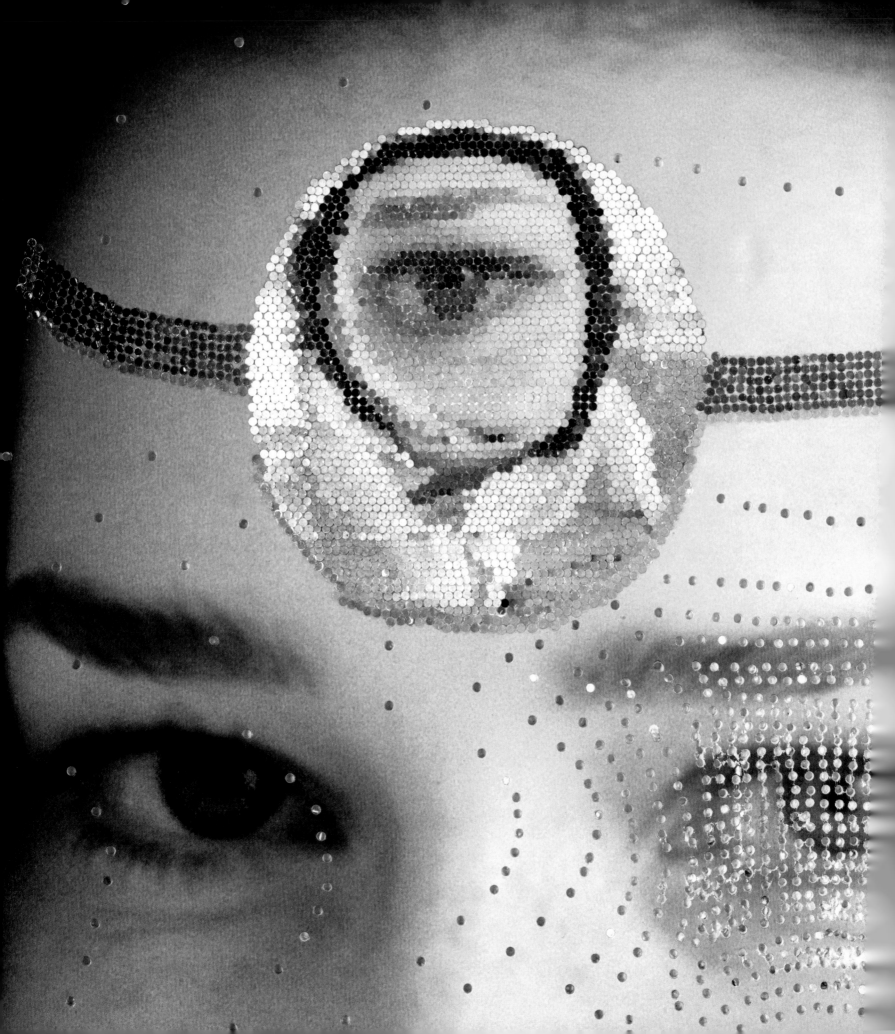

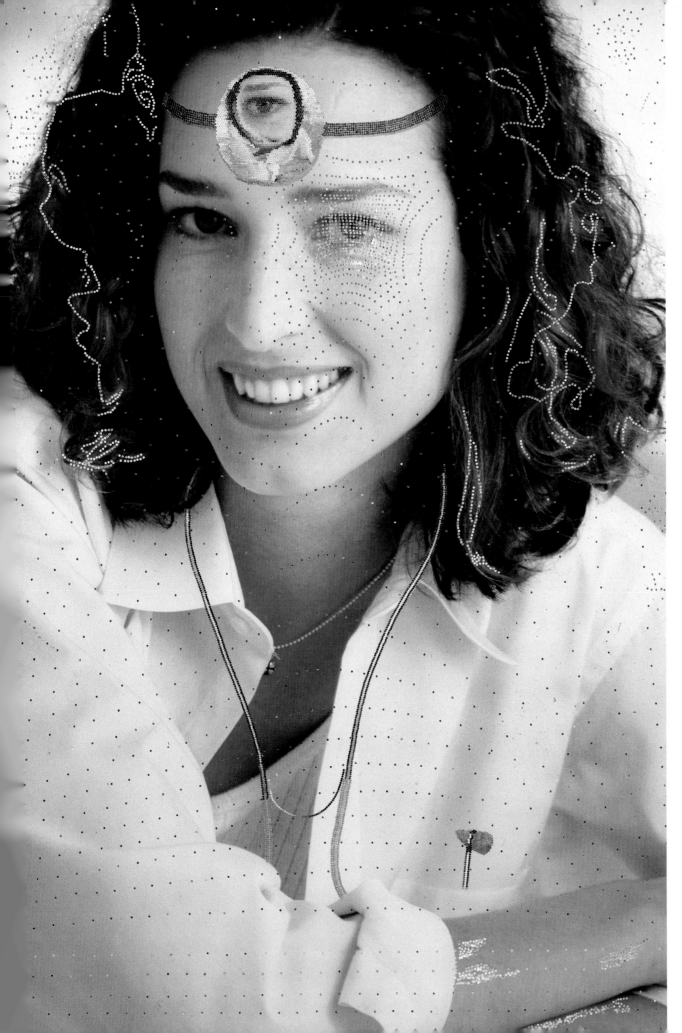

Cyctor, 1997
(detail, left)
Altered poster print
60 x 40 in.
(152.4 x 101.6 cm)

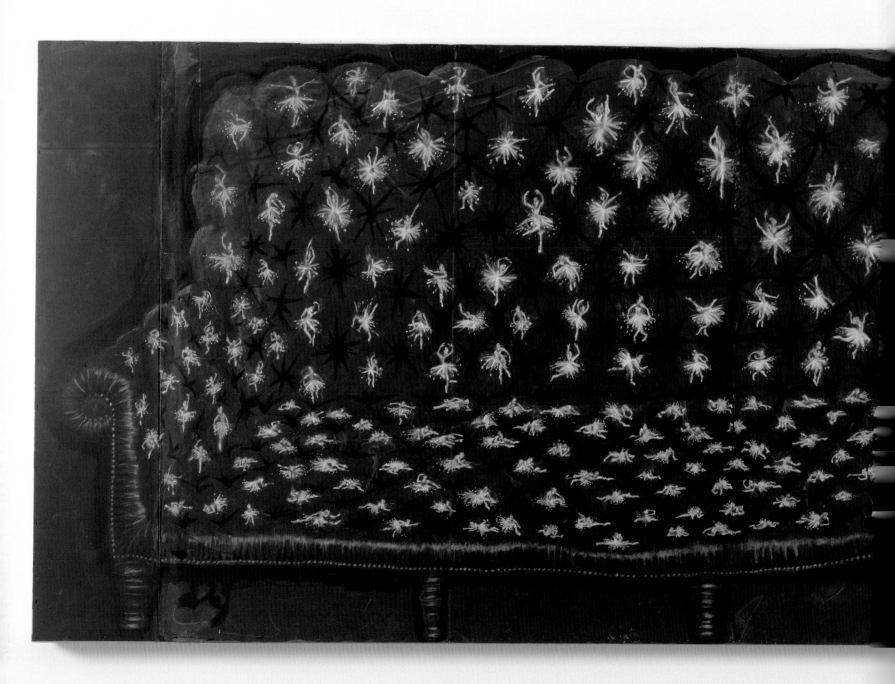

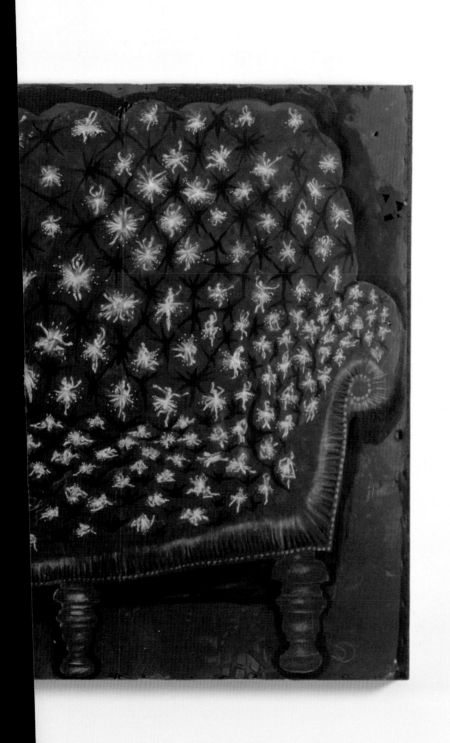

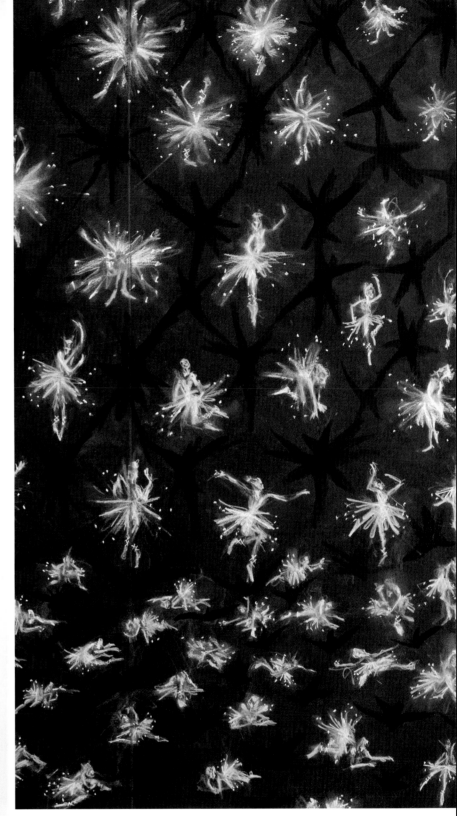

Divan, 1997 (detail, above)
Pastel on paper on foam core on panel
48 x 107 in. (121.9 x 271.8 cm)

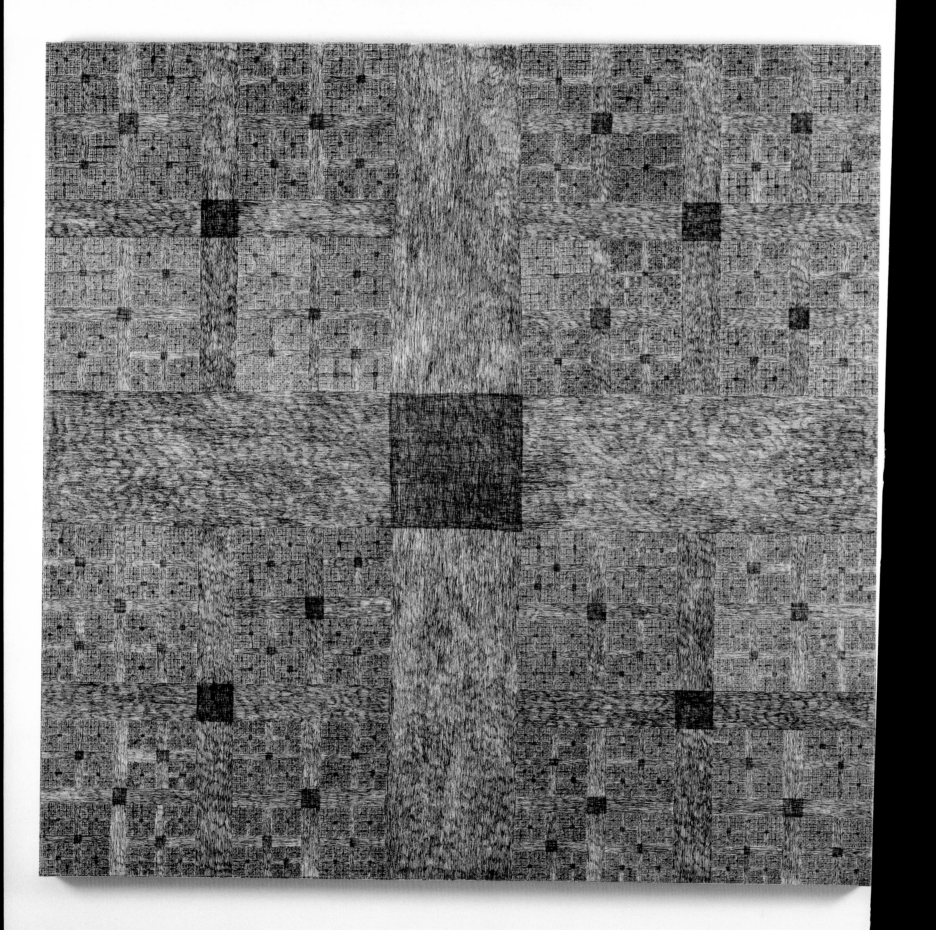

Jerusalem Cross, 1997
Ink on paper on panel
62 x 60 in. (157.5 x 152.4 cm)

Organ, 1997
Electric organ wiring
44 x 26 x 52 in.
(111.8 x 66 x 132.1 cm)

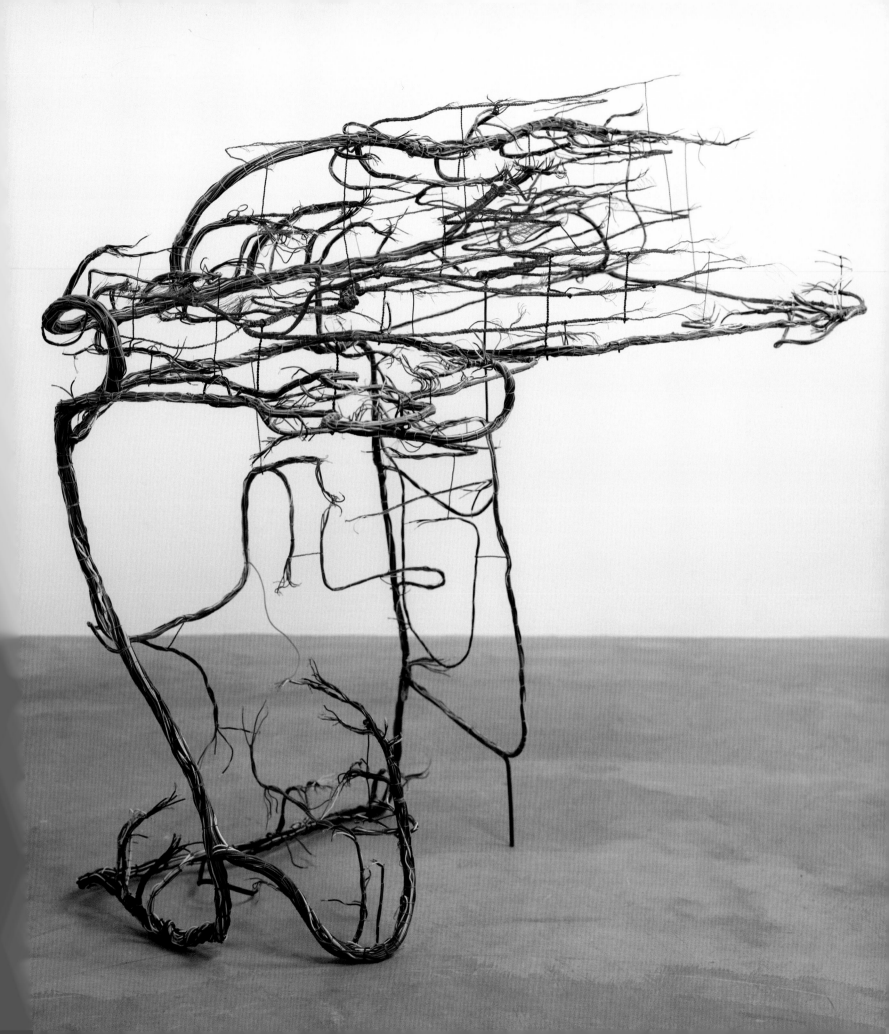

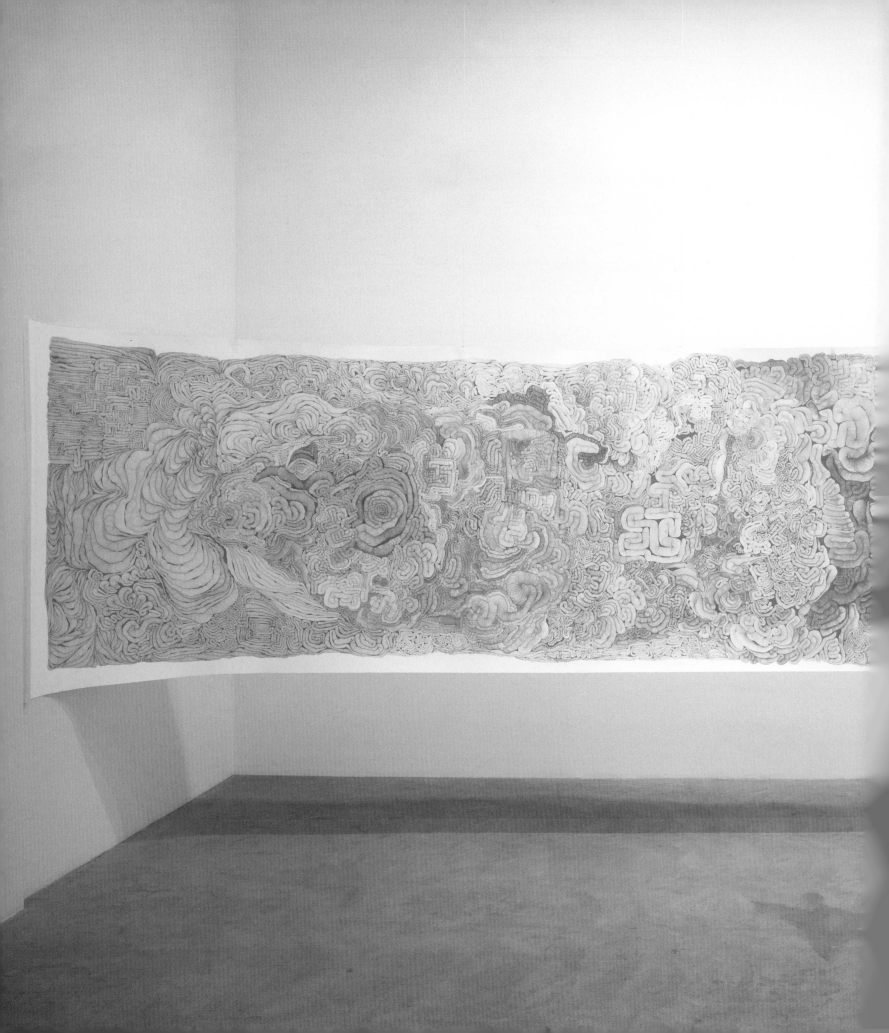

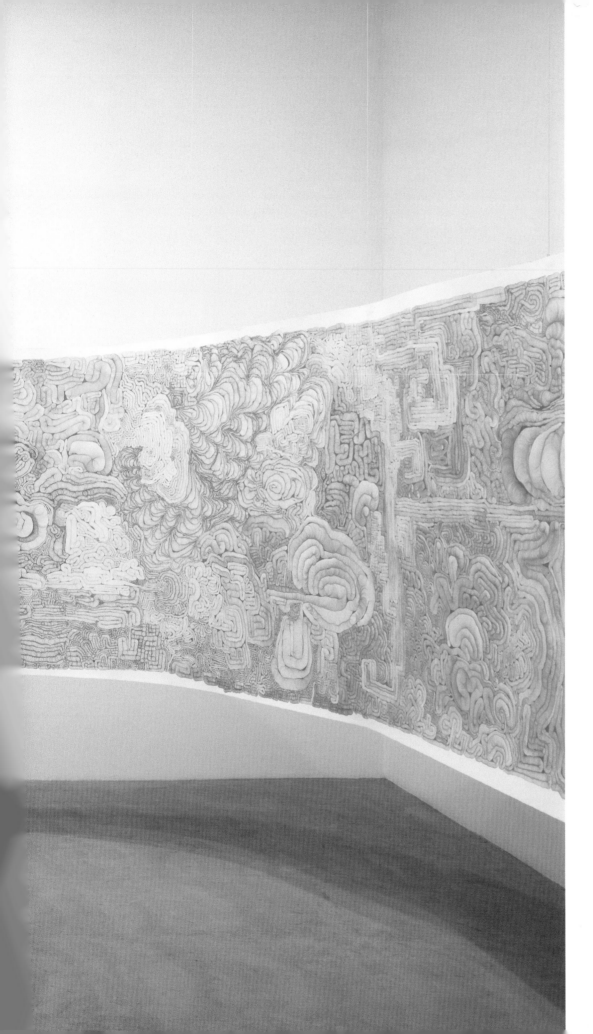

Wall Chart of World History from
Earliest Times to the Present, 1997
Ink and colored pencil on paper
51 x 420 in. (129.5 x 1066.8 cm)

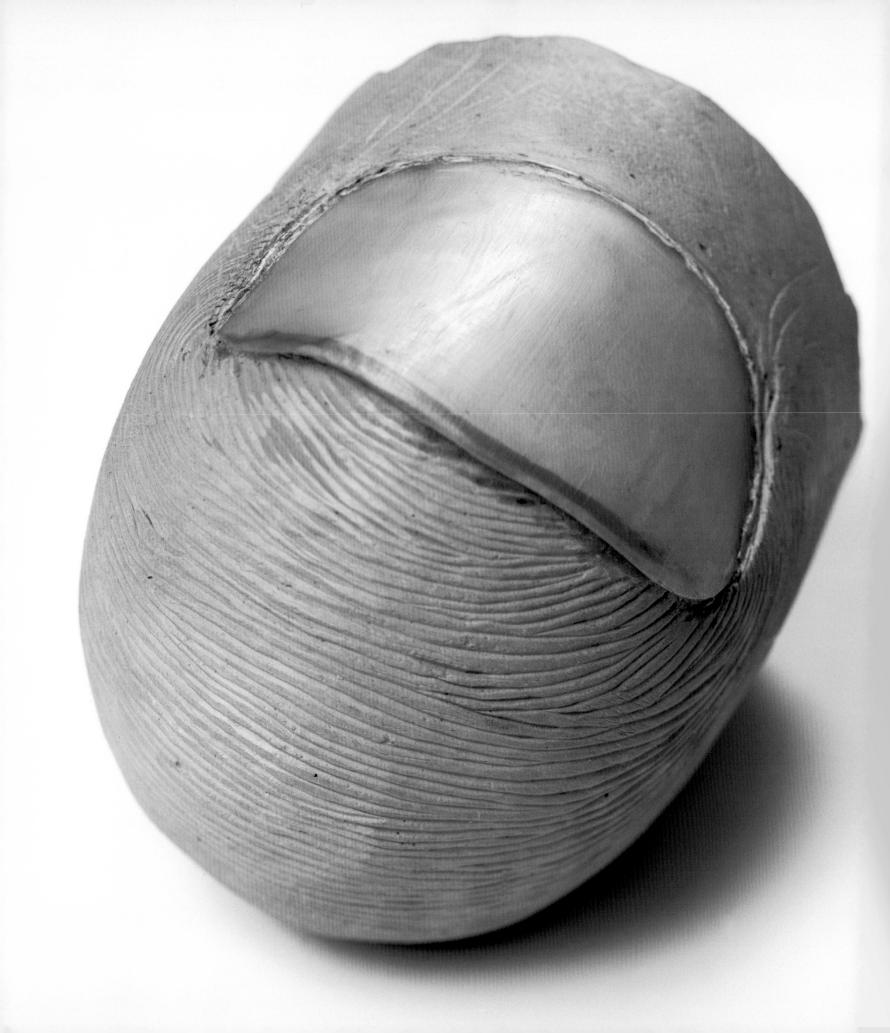

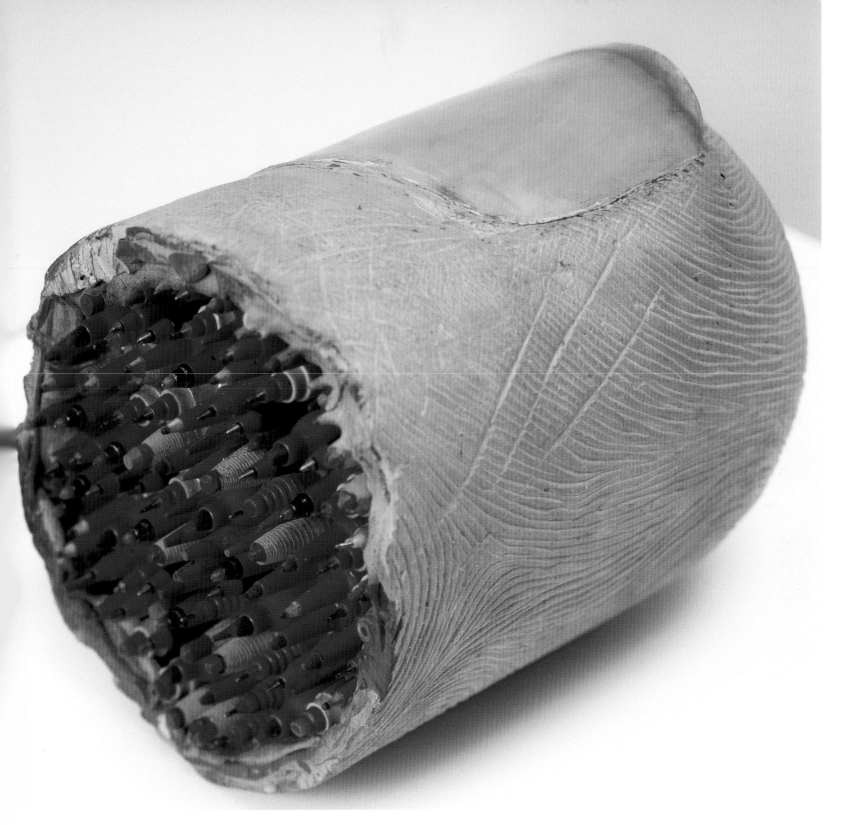

(Index) Finger, 1997
Pens, pencils, and
polyester resin
5 x 5 x 6 in.
(12.7 x 12.7 x 15.2 cm)

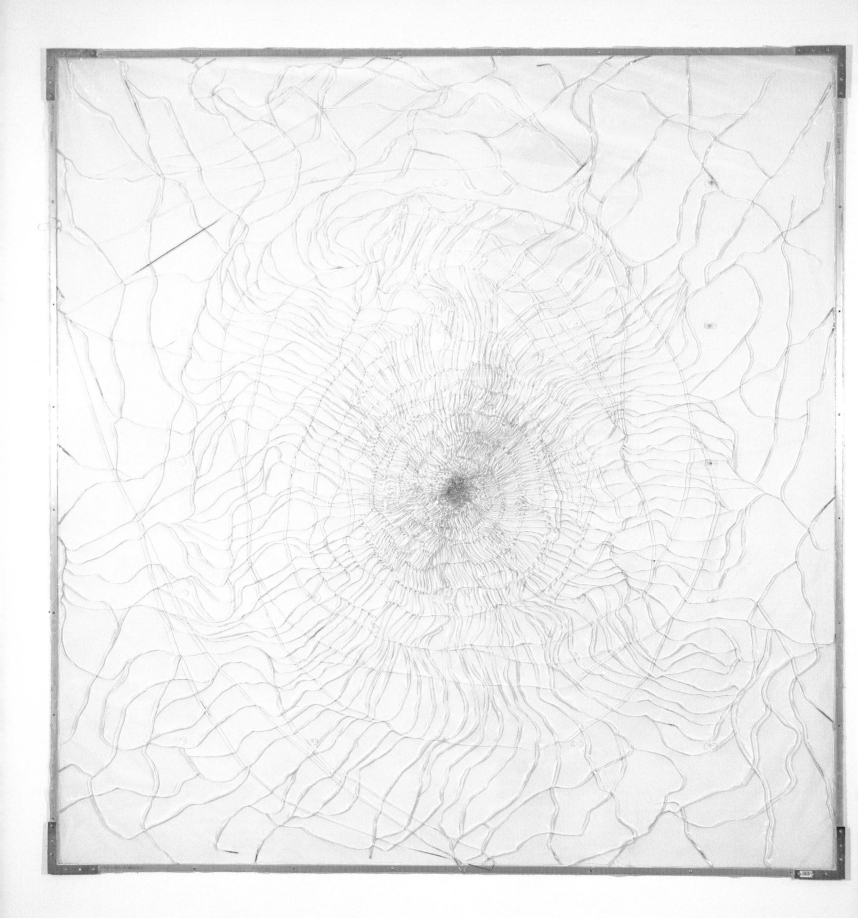

Shatter, 1998
Mirrored acetate, polyester,
and aluminum
84 x 84 in. (213.4 x 213.4 cm)

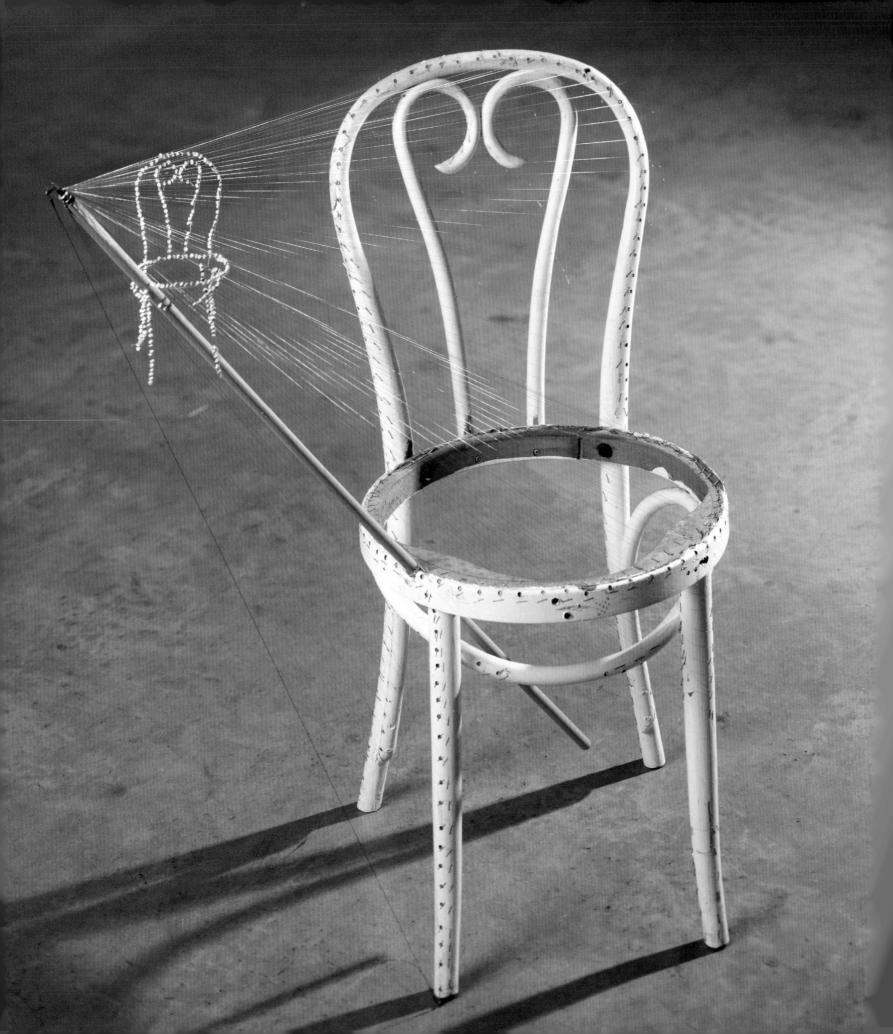

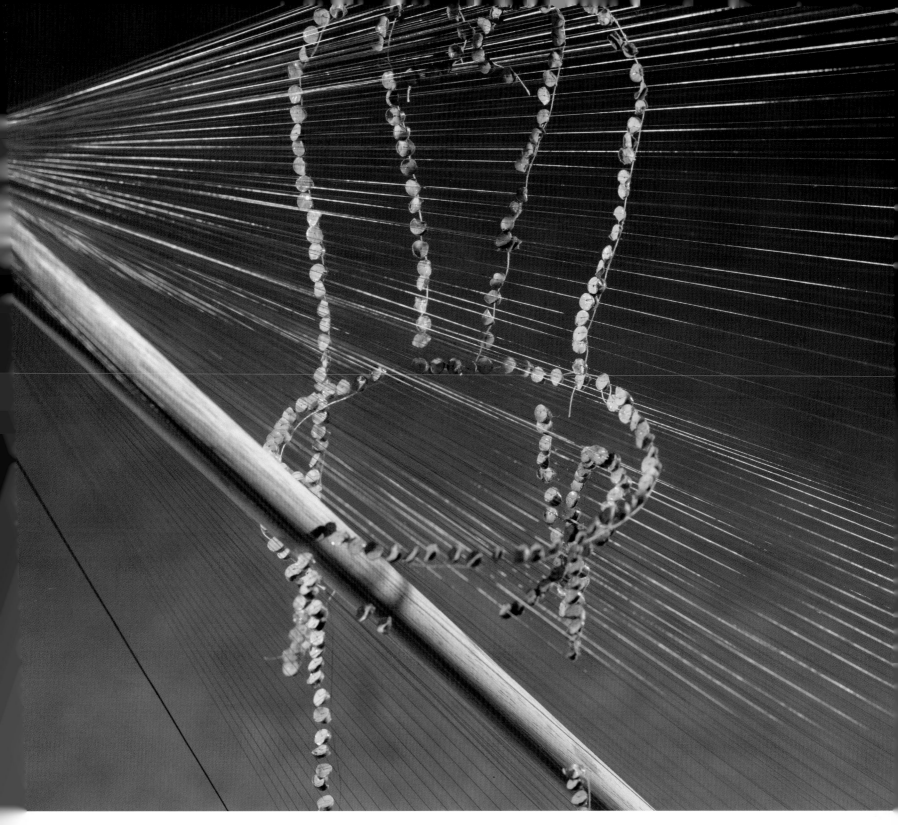

Shrink, 1998 (detail, above)
Wooden chair and monofilament
38 x 27 x 14 in.
(96.5 x 68.6 x 35.6 cm)

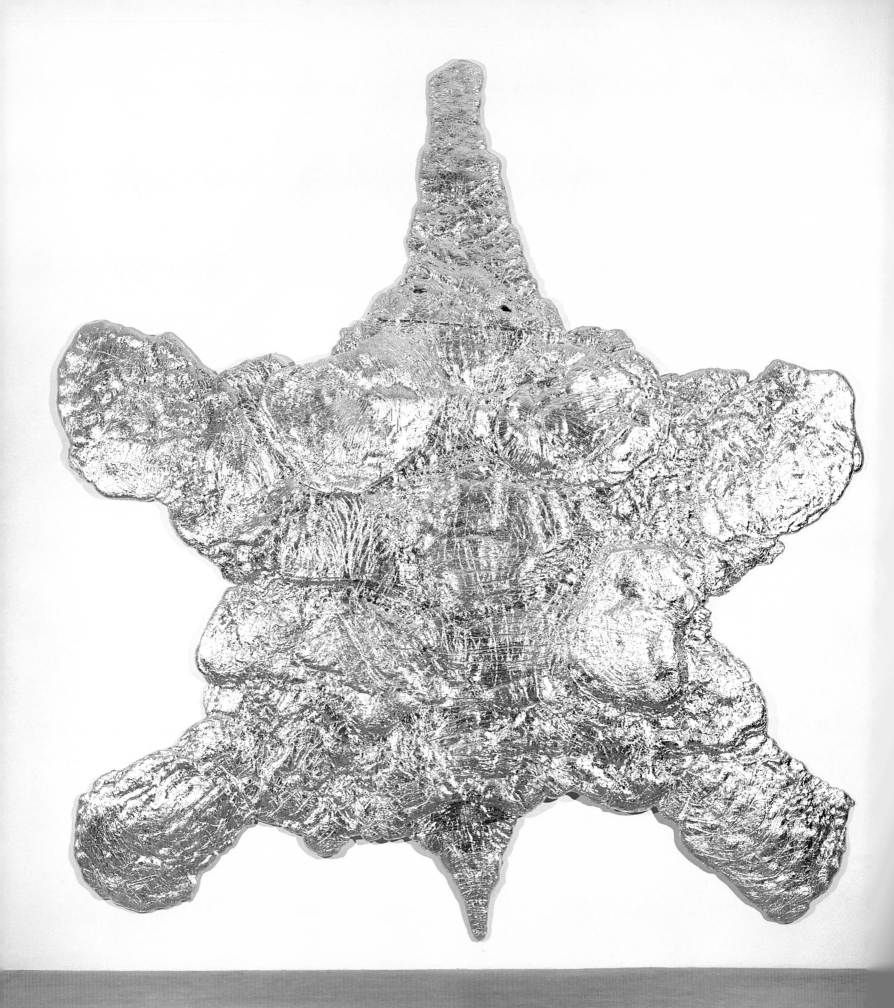

Elephant Skin #2, 1999
Aluminum foil, urethane foam, and felt
130 x 125 x 6 in.
(330.2 x 317.5 x 15.2 cm)

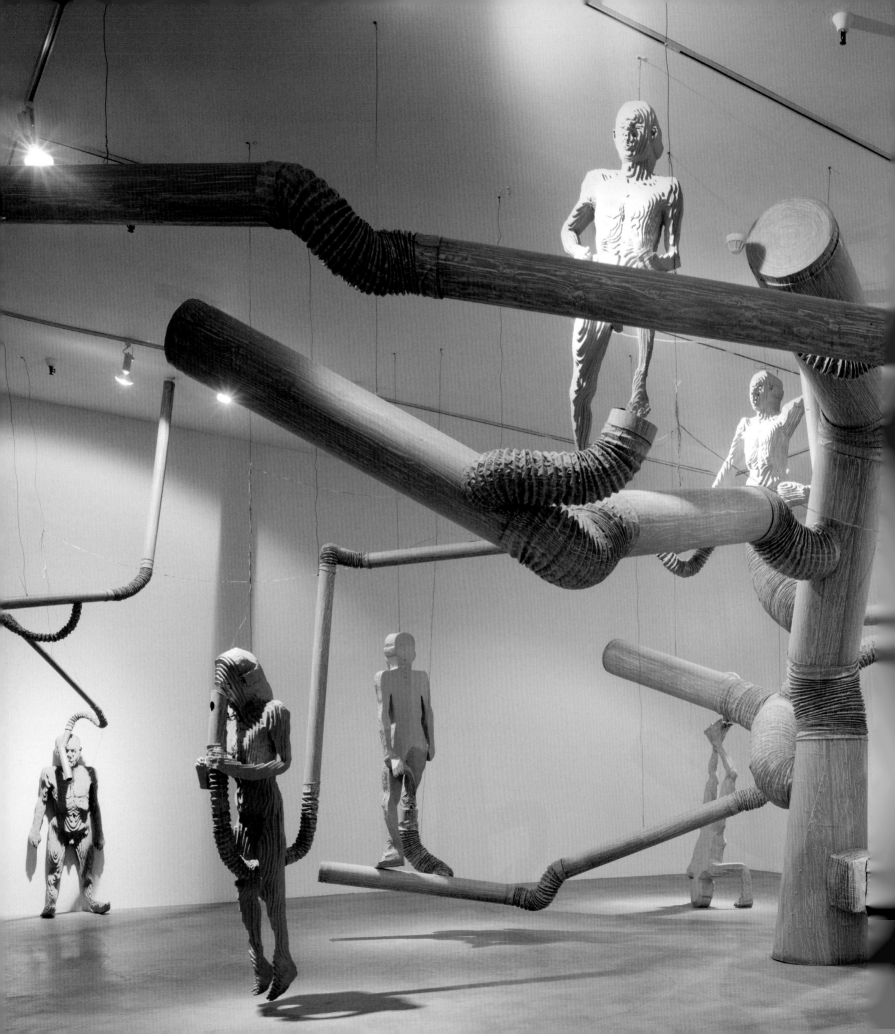

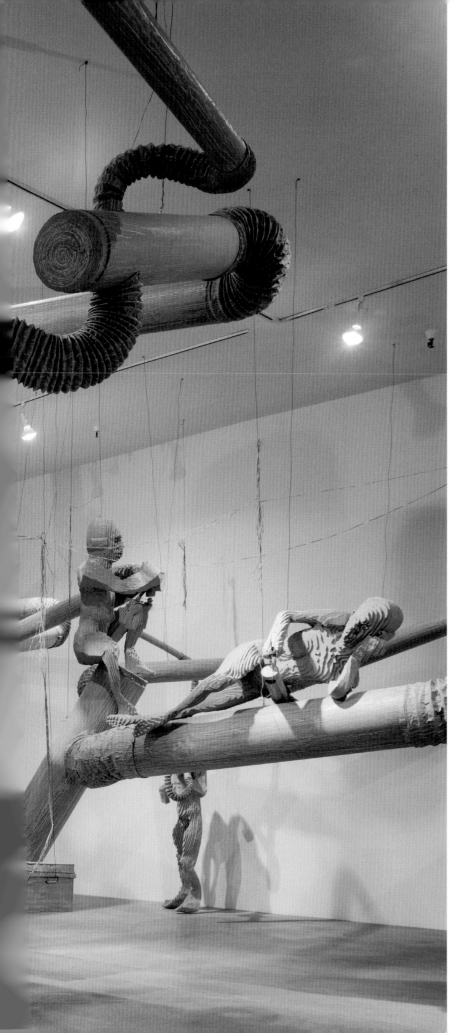

Pentecost, 1999
Polyurethane foam, sonotubes,
solenoids, found computer program,
and mechanical components
Dimensions variable

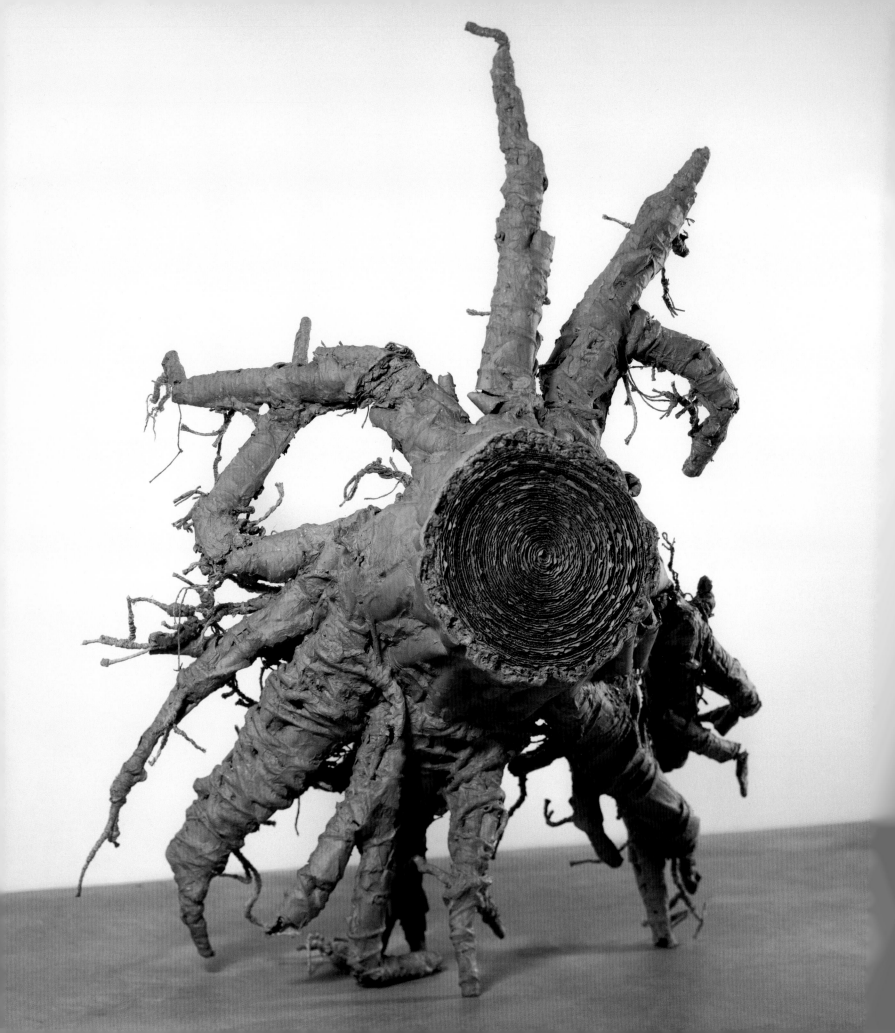

Root Ball, 1999
Paper, cardboard, rope, twine, string,
and glue
80 x 60 x 34 in.
(203.2 x 152.4 x 86.4 cm)

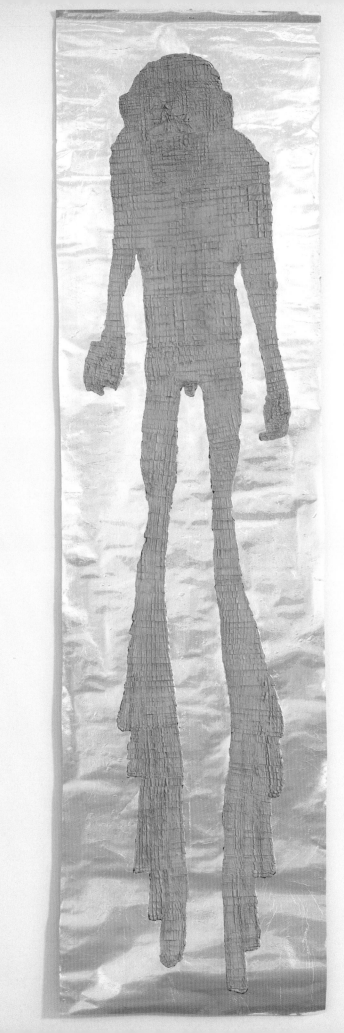

Life-Size Mirror Self-Portrait, 2000
(detail, right)
Synthetic polymer and aluminum foil
on polyester
80 $^7/_8$ x 22 in. (205.4 x 55.9 cm)

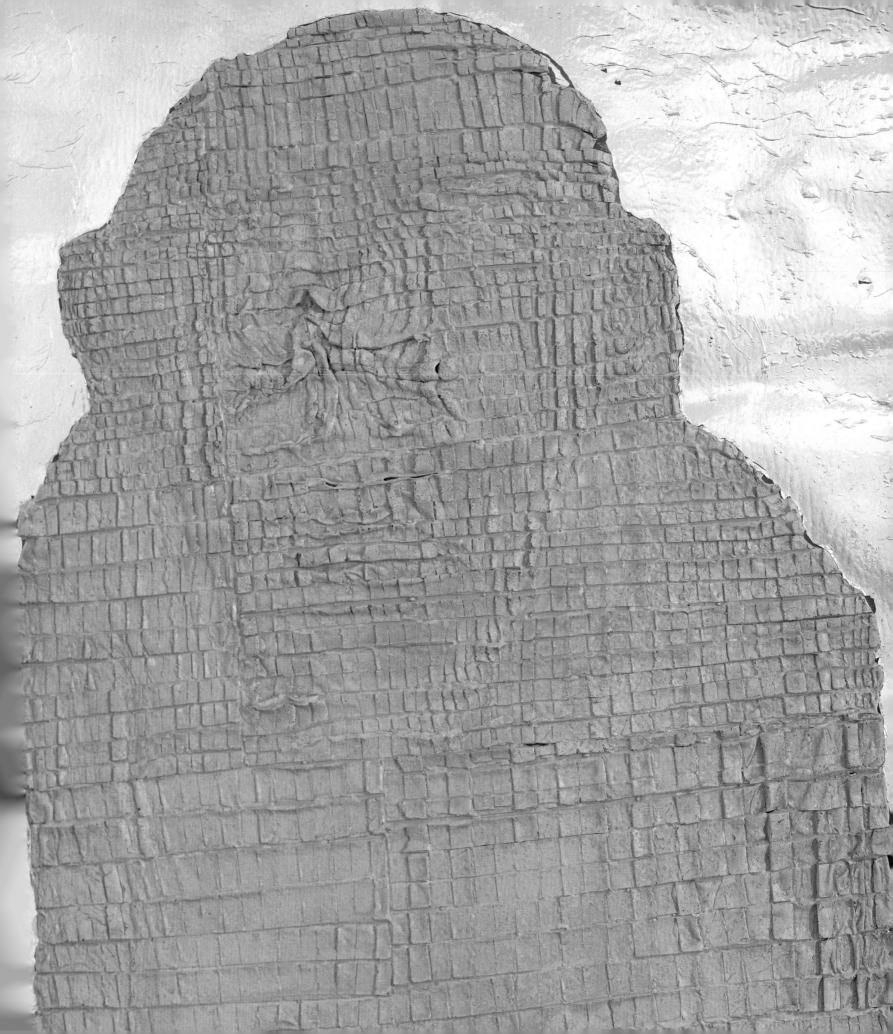

Daisy Clock, 2001
Dried flower, glass bottle, and
clock motor
12 x 2 x 2 in. (30.5 x 5.1 x 5.1 cm)

Finger Clock, 2001
Plastic resin and clock motor
3 $\frac{1}{4}$ x 1 x $\frac{3}{4}$ in.
(8.3 x 2.5 x 1.9 cm)

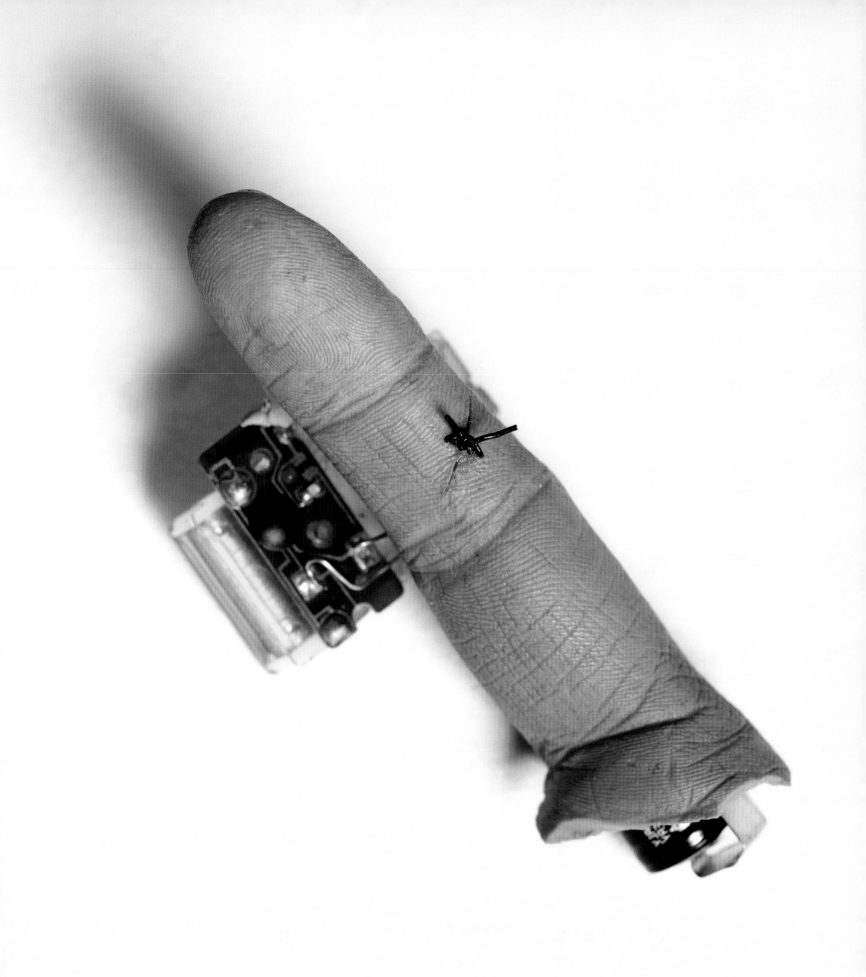

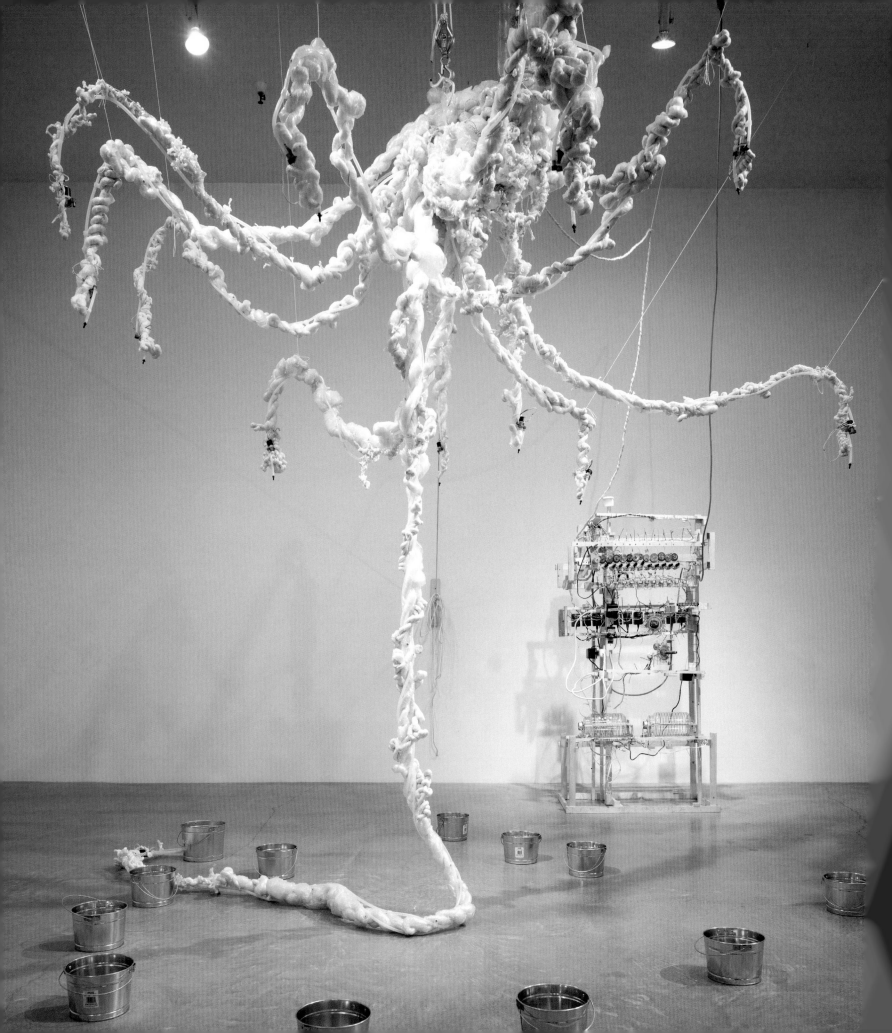

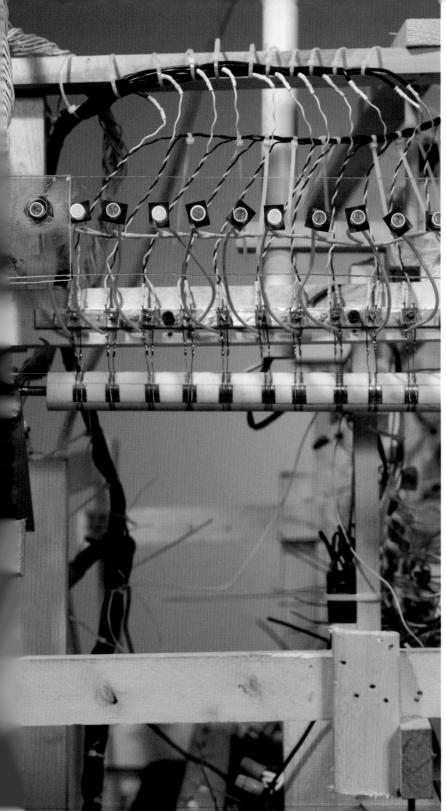 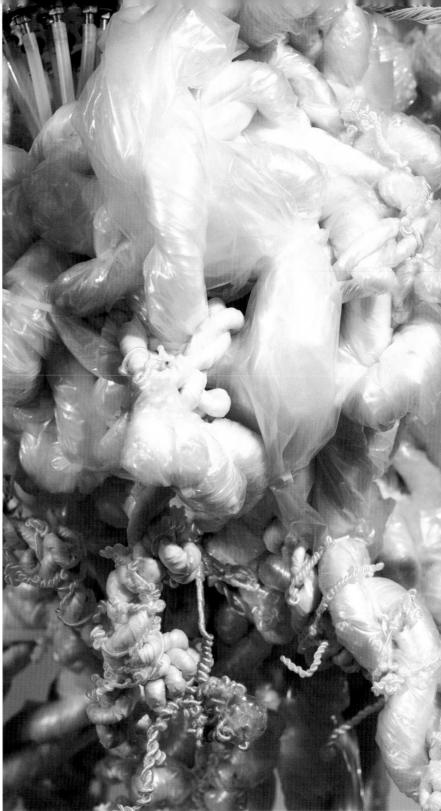

Drip, 2002 (details, above)
Polyethylene, mechanical component,
and water
Dimensions variable

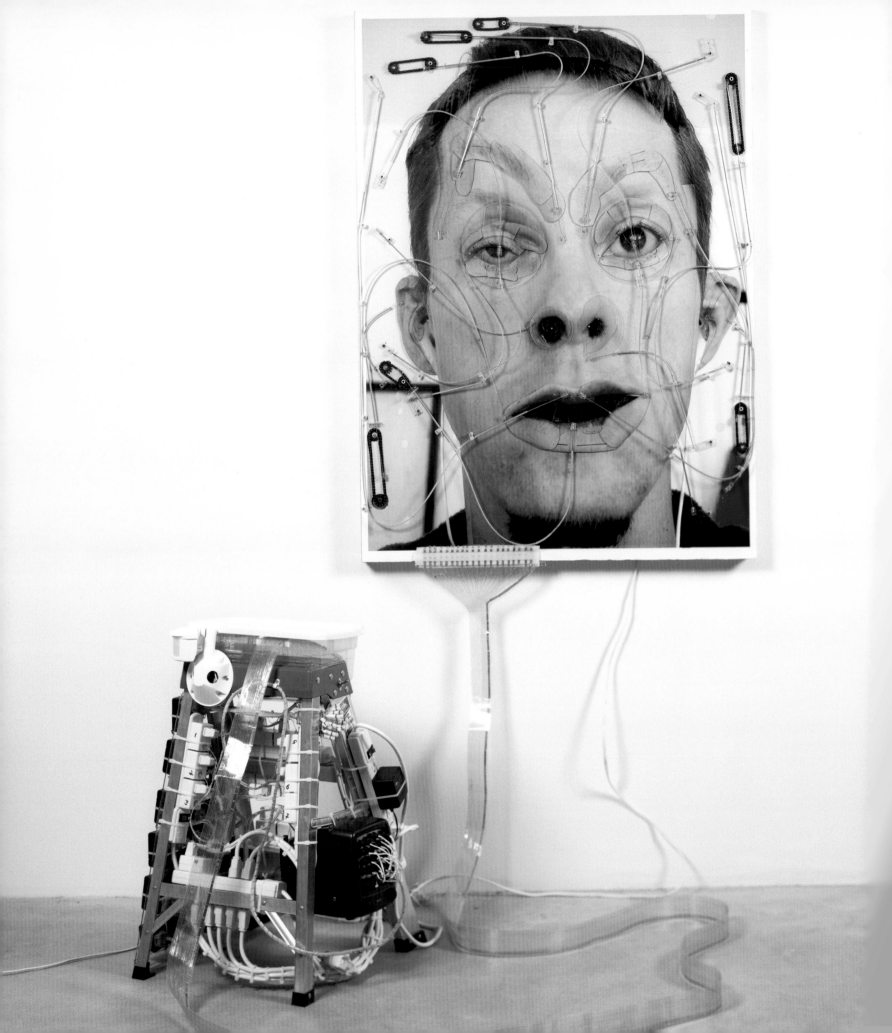

Emoter, 2002 (detail)
Altered ink-jet print on plastic and
foam core on panel, monitor, step-
ladder, and mechanical components
Print: 49 x 36 x 4 in. (124.5 x 91.4 x
10.2 cm); stepladder: 27 x 24 x 19 in.
(68.6 x 61 x 48.3 cm); cable: 174 in.
(442 cm) (length)

Magdalen, 2003 (detail, above)
Paper, wire, string, foam rubber,
and caulking
156 x 64 x 32 in.
(396.2 x 162.6 x 81.3 cm)

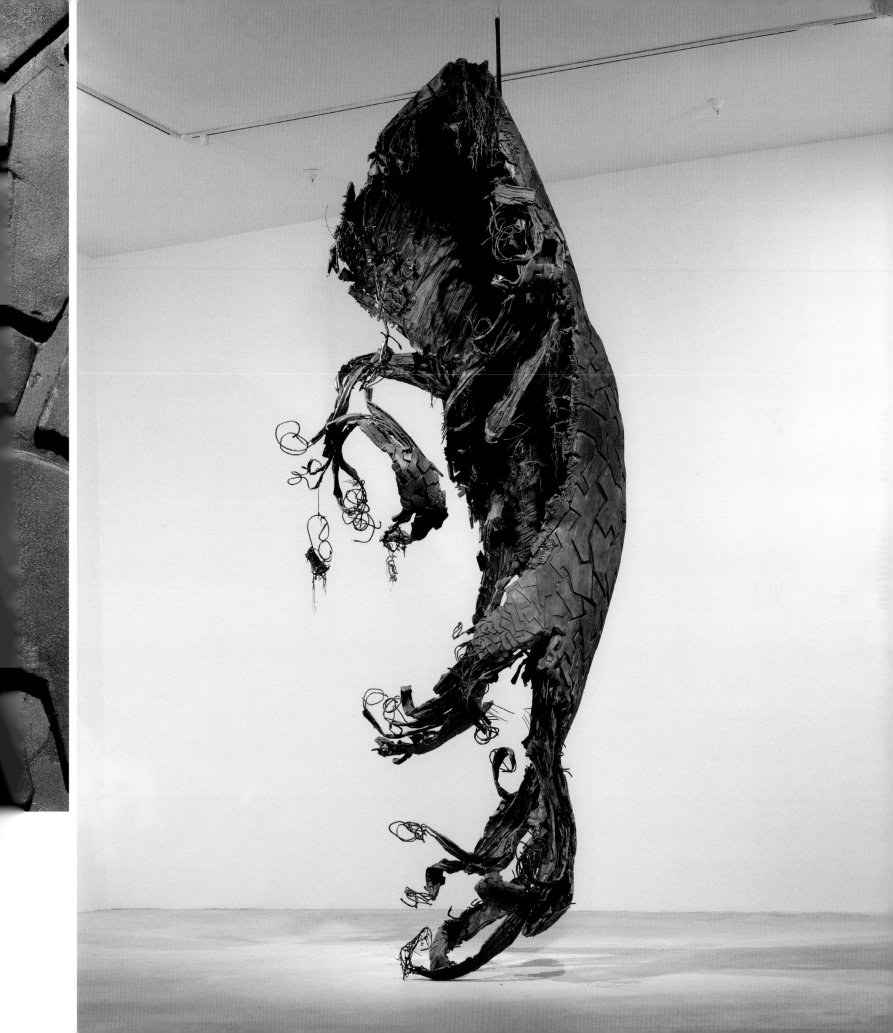

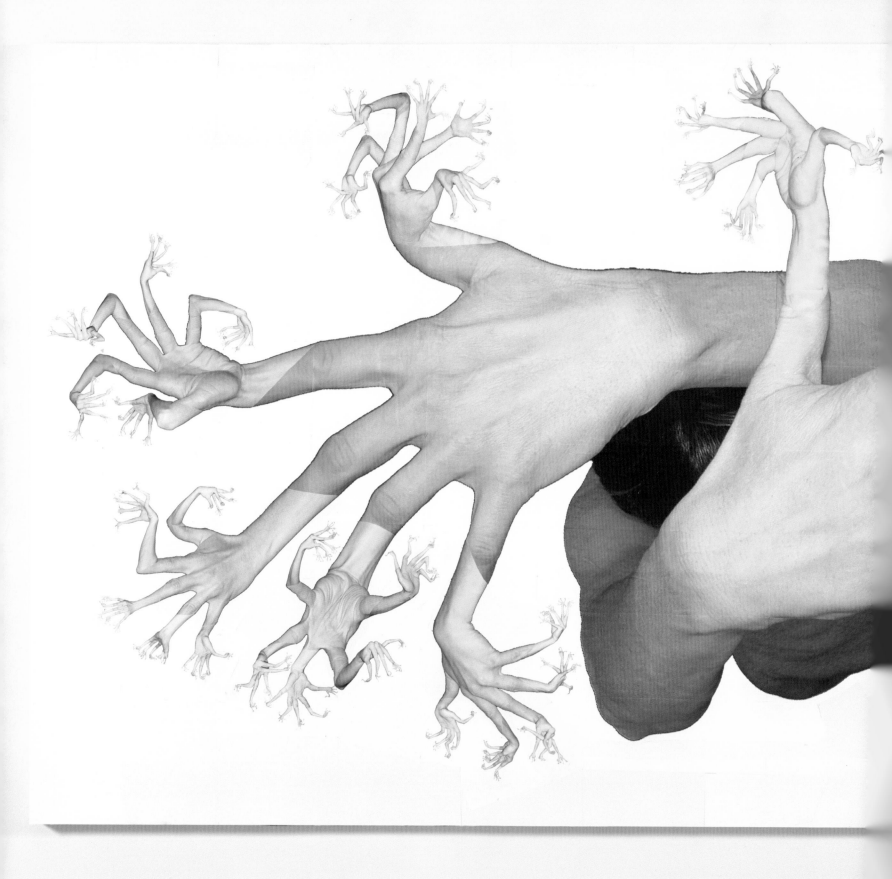

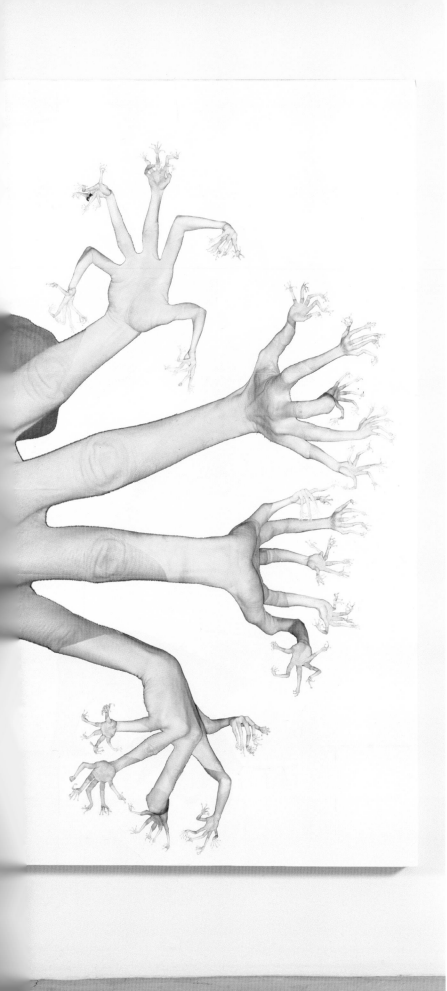

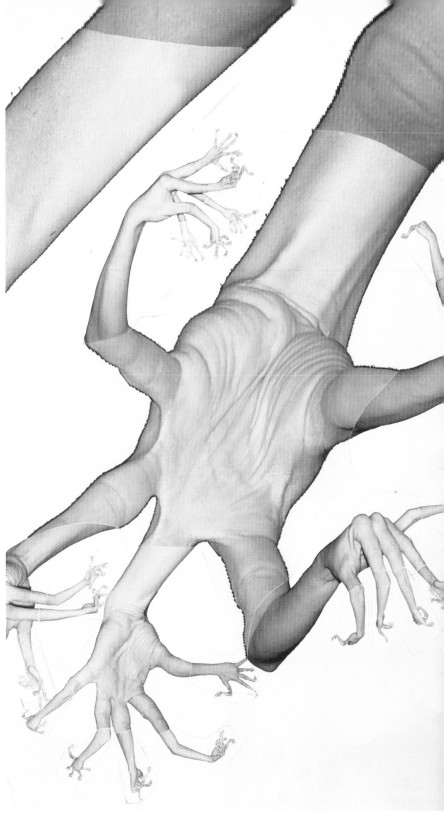

Untitled, 2003 (detail, above)
Ink-jet prints on foam core on panel
68 x 117 in. (172.7 x 297.2 cm)

Selected Works
and Descriptions
Tim Hawkinson

Items set in bold text appear in
the exhibition.

Dimensions are in inches, followed
by centimeters; height precedes
width precedes depth.

Mirror-image drawings of the Pulgas
water temple near San Francisco. A sheet
of striated glass obscures the lower
drawing to suggest a reflecting pool.

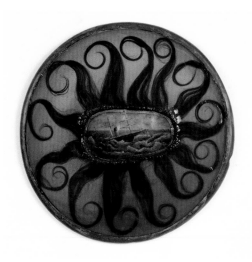

Untitled (Sinking Ship), 1987
Oil on wig on wooden chair seat and varnish
16 (diam.) x ³/₄ (40.6 x 1.9)
Private collection

The image of a sinking ship painted on
the fabric liner of a wig and embedded
in a thick blanket of varnish.

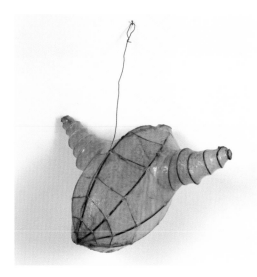

Untitled (Chicken), 1986
Chicken skin and wire
6 x 13 x 10 (15.2 x 33 x 25.4)

Private collection; courtesy Ace Gallery
The skin, carefully kept intact, was
removed from a chicken. This was then
stretched and dried over a wire armature.

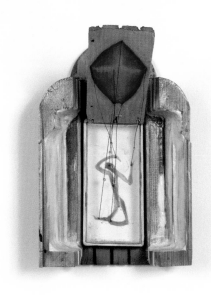

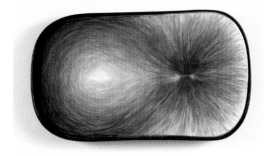

Advancing/Receding, 1988
Oil on canvas
15 x 24 x 3 ¹/₂ (38.1 x 61 x 8.9)
Collection of Kim and Michael McCarty

The left side of this painting has a
central point that physically projects
from the plane of the canvas (light
yellow); the right side has one that
recedes (light purple).

St. Francis Reliquary, 1987
Oil and chicken on wooden object
9 ¹/₂ x 4 x 5 (24.1 x 10.2 x 12.7) closed;
10 x 7 x 5 (25.4 x 17.8 x 12.7) open
Private collection

A wall-mounted kitchen-knife block,
cut and hinged together, opens to
reveal a crude figure made of desic-
cated chicken. The figure appears to
be receiving stigmata.

Reflected Temple, 1987
Graphite on paper with
distorting glass
22 x 17 x 2 (55.9 x 43.2 x 5.1)
Collection of Gil Friesen

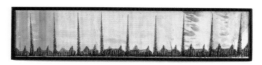

Echocardiograph Landscape, 1988
Watercolor on paper
9 x 43 (22.9 x 109.2)
Collection of David Wexler

My echocardiogram determined the heights of the trees in a watercolor painting of a forest.

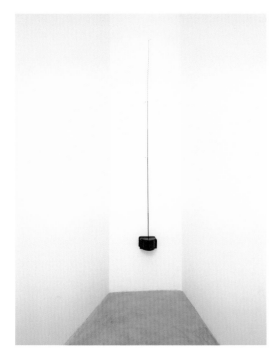

Clock, 1988
Clock and brass rods
90 x 7 ¾ x 4 ½ (228.6 x 19.7 x 11.4)
Collection of Tony and Gail Ganz

Hour, minute, and sweep second hands project off of a central axis that protrudes from the face of an upturned clock.

Landscape with Trail, 1988
Oil on canvas
7 ½ x 15 x 1 ¾ (19.1 x 38.1 x 4.4)
Private collection; courtesy Ace Gallery

A trail seen from two different angles—frontally and sideways—as it winds around a mountain.

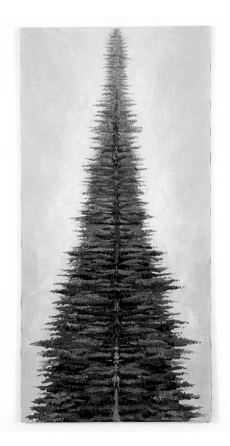

Right/Left Tree, 1988
Oil on canvas
48 x 24 (121.9 x 61)
Collection of Tony Krantz

Painted with right and left hands simultaneously.

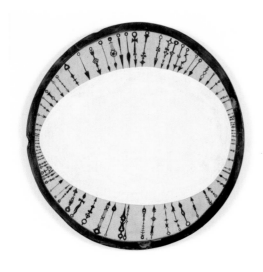

Conception of Time, 1988
Oil on canvas on wooden chair seat
16 ½ (diam.) x ¾ (41.9 x 1.9)
Collection of Jeff Kerns

The painted hands of clocks encircle a painted oval as if to penetrate it.

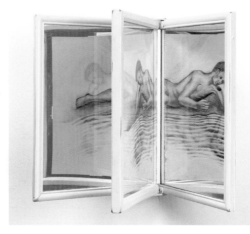

Narcissus, 1988
Graphite on paper with mirrors
13 ½ x 15 x 11 ¼ (34.3 x 38.1 x 28.6)
Collection of Janet Dreisen

Half of the figure was drawn on the front and half on the back of the same sheet of paper. The two sides of the drawing were assembled in mirrors projecting from the base of the frame. The complete figure can be seen in reflection.

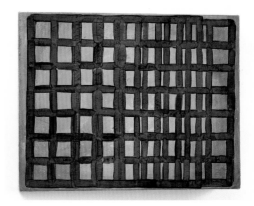

Separating Grids, 1988
Oil and wax on canvas
19 ¼ x 25 ½ x 4 (48.9 x 64.8 x 10.2)
Collection of Gheri Sackler

Two overlapping grids on a wedge-shaped canvas, drawn in perspective as if separated by the space contained in the wedge.

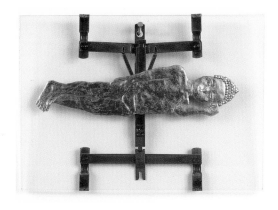

Sleeping Deity, 1988
Oil clay and gold leaf on glass
8 1/4 x 11 3/4 (21 x 29.8)
Private collection

A reclining figure sandwiched between two panes of glass, sculpted on the inner surface of the second pane and covered in gold foil.

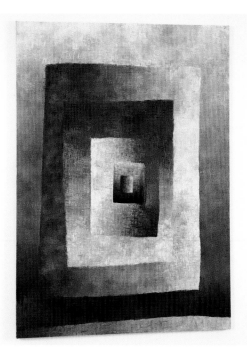

Untitled (Brown Rectangles), 1988
Oil on canvas
52 x 38 x 2 (132.1 x 96.5 x 5.1)
Private collection

Rectangles painted in rectangles. The smallest rectangle angles back dimensionally toward the wall.

peeled away, leaving the concrete core. (The tone bar is lodged in the top.)

Alphabet Divided into Consonants and Vowels, 1989
Buttons on rag board on panel
10 3/4 x 38 3/4 (27.3 x 98.4)
Collection of Pablo and Leslie Lawner

Garment buttons with the letters of the alphabet printed on them were arranged alphabetically and divided into consonants and vowels. The two lines are linked by the either/or letter Y.

Spun Drawing, 1988
Graphite on paper, glass, and wood
17 x 14 1/4 (43.2 x 36.2)
Private collection

First, draw a building. Next, fit the drawing into a glass tube and spin at a high rpm. Now, make a drawing of the first drawing while it is spinning.

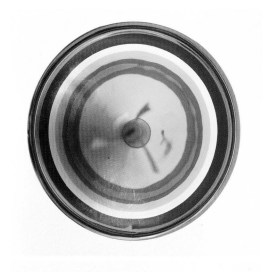

Violin, 1988
Concrete
13 x 7 3/4 x 3 1/4 (33 x 19.7 x 8.3)
Collection of Harry W. and Mary Margaret Anderson

Cement was poured into a violin through the f-holes, and then the wood was

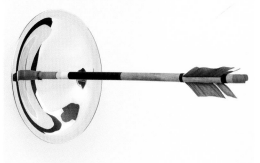

Arrow with Bowl, 1989
Polychrome on arrow with silver bowl
7 1/2 (diam.) x 14 1/2 (19.1 x 36.8)
Collection of Janet Cross

Bands around the shaft of an arrow are reflected in a silver bowl to suggest the rings of a target.

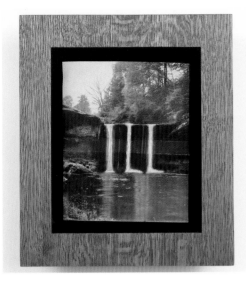

Ill Fall, 1989
Mixed media
13 ¹/₂ x 11 ³/₄ x 2 ¹/₂ (34.3 x 29.8 x 6.4)
Collection of Miriam and Barry Bernstein

A found image of a waterfall, altered
with eraser and Wite-Out.

Life Exit, 1989
Mixed media
13 x 16 ³/₄ x 10 (33 x 42.5 x 25.4)
Collection of Tony Krantz

Nine progressively larger *Life* magazine
logos arranged on a steel spine in front
of an EXIT sign.

Oozing House, 1989
Oil clay and plaster on found drawing
10 x 25 ³/₄ x 1 ¹/₂ (25.4 x 65.4 x 3.8)
Private collection

A found architectural drawing is
swallowed up on one side by a mass
of modeling clay.

Realigned Photo, 1989
Altered found photograph
9 ¹/₂ x 14 (24.1 x 35.6)
Collection of Mr. and Mrs. Bernard
Greenberg

A photograph of a horse and carriage
was sliced into horizontal strips.
Each strip was shifted slightly to sug-
gest an abrupt change in velocity.

Untitled (Seascape), 1989
Enamel on canvas
50 x 76 x 3 (127 x 193 x 7.6)
Los Angeles County Museum of Art; gift
of Dean Valentine and Amy Adelson

A triangular blending band of sea and sky
focuses the horizon on the right side and
turns this rectangle into a trapezoid.

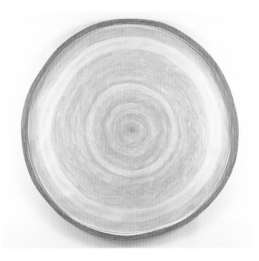

705 Year Tree, 1989
Graphite on paper
79 (200.7) (diam.)
Newport Harbor Art Museum, California

Concentric rings were drawn around a cen-
tral point. Variations in tone occurred
as different pencils were employed.

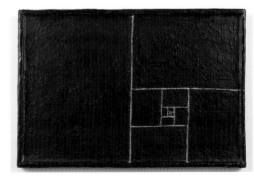

Smallest Denominator, 1989
Bitumen on canvas

12 ¼ x 18 ¼ (31.1 x 46.4)
Private collection

Painted on coarsely woven canvas, a
black mass is divided down to the size
of a single weave in the canvas.

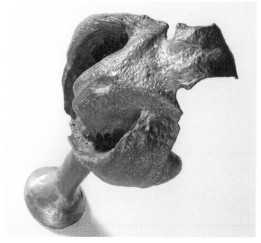

2 & 3 Dimensional Drawing, 1989
Ink on paper with wire
10 x 19 x 5 ½ (25.4 x 48.3 x 14)
Private collection

A drawing of a meandering line is contin-
ued in a length of wire, which threads
its way through a hole in the glass.

Envelope after Simone Martini, 1990
Ink on envelope
12 x 15 (30.5 x 38.1)
Collection of Stewart Mills

Cancellation stamps on a previously
posted envelope become the halos of
saints in this drawing of Martini's
Annunciation.

Mouth, 1990
Lead
2 x 3 ½ x 6 (5.1 x 8.9 x 15.2)
Collection of Tony and Gail Ganz

All the dental-impression compound my
mouth could contain, cast in lead.

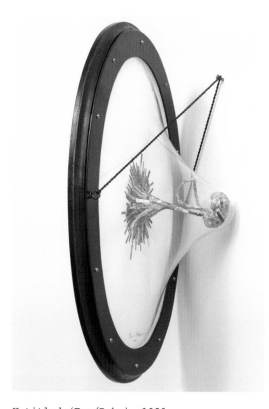

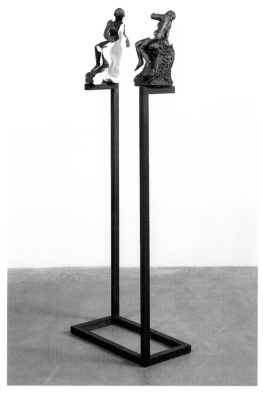

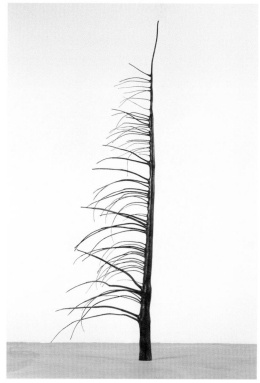

Realigned Fir Tree, 1990
Creosote on tree
82 x 26 x 7 (208.3 x 66 x 17.8)
Collection of Eileen Harris-Norton and
Peter Norton

A Christmas tree was cut at each point
where a branch intersects the trunk.
The sections of trunk and branch were
then rotated and the branches aligned.

Untitled (Ear/Baby), 1989
Mixed media
20 ½ x 15 ½ x 6 ½ (52.1 x 39.4 x 16.5)
Collection of Stanley and Nancy Singer

**A drawing of an ear. On the reverse
is a fetus suspended by a meandering
umbilical cord that seems to grow
from the inner ear.**

The Kiss, 1990
Plaster
50 x 19 x 9 (127 x 48.3 x 22.9)
Private collection

One figure extracted from the other by
means of a jeweler's saw.

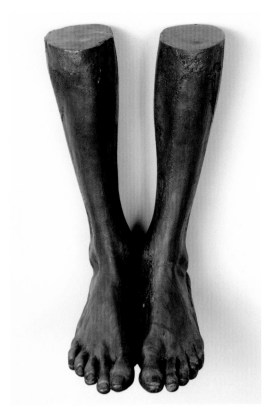

Self-Portrait (Height Determined by Weight), 1990
Lead
15 ¹/₂ x 9 ¹/₄ x 11 (39.4 x 23.5 x 27.9)
Private collection

The equivalent of my weight in molten lead was poured into a mold of my body.

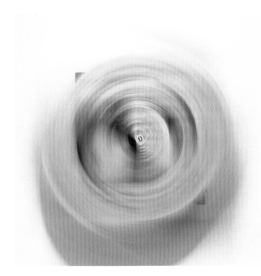

Spinning Headlines, 1990
Current newspaper; motorized
18 (diam.) x 4 (45.7 x 10.2)
Collection of Eileen Harris-Norton and Peter Norton

The front page of a current newspaper is held in a motorized frame, which spins and periodically stops.

Untitled (Bleached Football Game), 1990
Altered found photograph
7 ¹/₂ x 19 ¹/₂ x ³/₄ (19.1 x 49.5 x 1.9)
Collection of Jane Erickson Allen

A found image of a football game in which everything but the numbers on the athletes' jerseys has been bleached out.

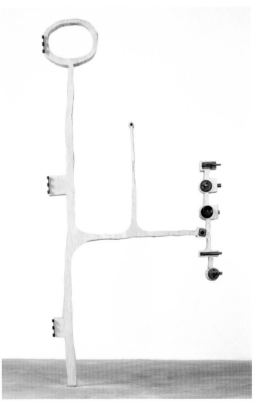

Untitled (Key II), 1990
Altered wooden door, doorknob, hinges, and handle
78 ¹/₂ x 36 ¹/₂ x 6 ¹/₂ (199.4 x 92.7 x 16.5)
Collection of Harry W. and Mary Margaret Anderson

A skeletonized door retains just enough wood to hold the hardware — hinges, handle, locks, and spy hole — in place.

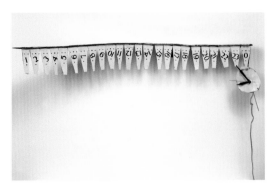

Altered Clock, 1991
Altered clock; motorized
9 x 41 x 3 (22.9 x 104.1 x 7.6)
Private collection

The face of a 24-hour clock cut into pie sections and straightened out into a line.

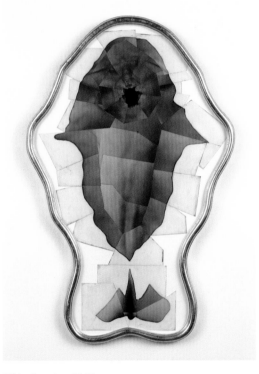

Blindspot, 1991
Photomontage
22 x 16 x ³/₄ (55.9 x 40.6 x 1.9)
Collection of Tony and Gail Ganz

The areas of my body that I could not directly see were identified by tracing the inner periphery of my visual field with pen along my skin. The areas within these boundaries were photographed. The photographs were assembled into a map of my body's blind spots.

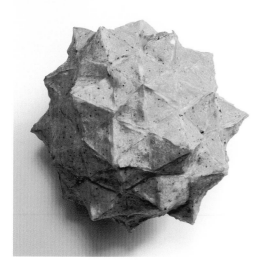

Dorito Polyhedron, 1991
Corn chips and foam
13 (33) (diam.)
Private collection

The inherent geometry of a corn chip deter-
mined the size of this geodesic sphere.

Hospital with Aneurisms, 1991
Enamel on paper on panel
16 1/2 x 101 1/4 (41.9 x 257.2)
Collection of Seth Landsberg

The floor plan of a hospital becomes a
vascular structure in which a given color-
coded fluid running through the central
hallway opens up, pooling out to form a
recovery room, surgery, w.c., etc.

Lipstick Self-Portrait, 1991
Lipstick and varnish on mirror on panel
24 1/2 x 36 1/2 (62.2 x 92.7)
Private collection

My reflection traced on the pieces of a
broken mirror.

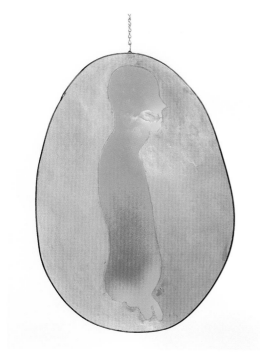

Egg Self-Portrait, 1991
Steel, plaster, and plastic resin
42 x 31 x 3/4 (106.7 x 78.7 x 1.9)
Private collection

A vertical cross-section of the center
of my body cast in plastic resin and
embedded in a plaster oval.

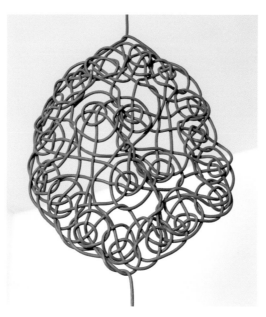

Knot, 1991
Extension cord
30 x 30 (76.2 x 76.2)
Private collection

**A functioning extension cord woven into
an ornamental knot.**

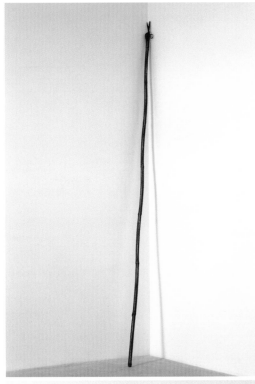

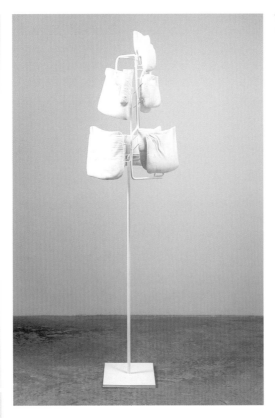

The bowls of spoons welded together to
form an enclosure.

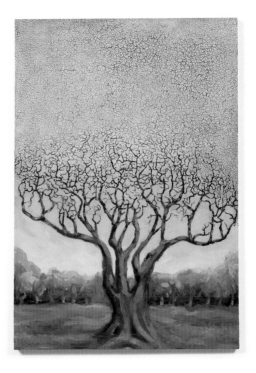

Pocket Self-Portrait, 1991
Plaster and steel
53 x 16 x 13 (134.6 x 40.6 x 33)
Private collection

Plaster was poured into each of the pock-
ets of a three-piece suit I was wearing.
Extracted from the suit, these plaster
pockets were affixed to an armature that
maintained their original orientation.

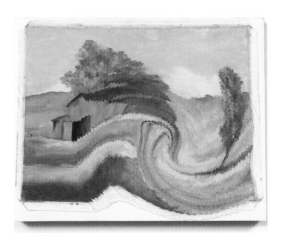

Tree with Cracks, 1991
Oil on panel
38 $^1/_2$ x 27 (97.8 x 68.6)
Private collection

The smallest, uppermost branches of
a tree become cracks in the surface
of this artificially aged painting.

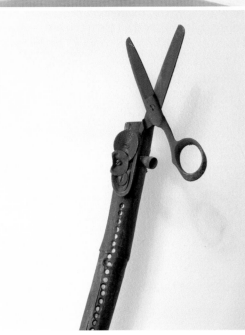

*Untitled (Lunar Calendar on Pruning
Pole)*, 1991
Paper and found pruning pole
123 x 4 x 1 $^1/_2$ (312.4 x 10.2 x 3.8)
The Museum of Contemporary Art,
Los Angeles; gift of Gary and
Tracy Mezzatesta

A found homemade gardening implement
(pruning pole) inlaid with images of
the moon in all of its phases.

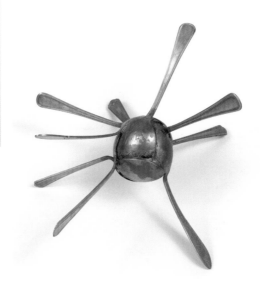

Spoon Ball, 1991
Spoons
7 x 7 x 7 (17.8 x 17.8 x 17.8)
Private collection

Untitled (Barn with Vortex), 1991
Altered found painting on panel
14 x 17 $^1/_2$ x 2 (35.6 x 44.5 x 5.1)
Collection of Douglas Kennedy

Concentric circles were cut into this
found painting. Each was rotated slightly
to transform the original composition.

Alphabetized Alphabet, 1992
Paper on panel
20 ¾ x 19 (52.7 x 48.3)
Collection of Gay Browne

The letters of the alphabet arranged in alphabetical order according to their phonetic spelling.

Alphabetized Soup, 1992
Alphabet noodles and enamel on glass
32 ½ x 19 (82.6 x 48.3)
Private collection

The noodles from a can of alphabet soup arranged in alphabetically ordered lines on glass.

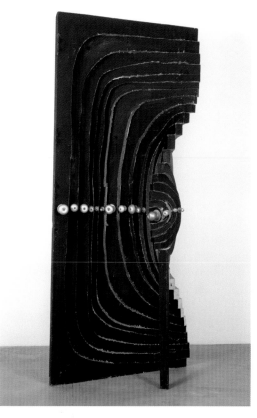

Cochlea Door, 1992
Altered wooden door and doorknobs
79 x 32 x 16 (200.7 x 81.3 x 40.6)
Collection of Robert Conn

Concentric arcs were cut around the handle in a solid-core door and the arcs rearranged to form a helix.

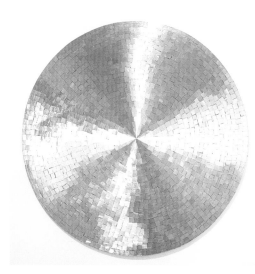

Dimmer Switch, 1992
Mirrored polyester film ribbon on panel
85 (diam.) x 1 ½ (215.9 x 3.8)
Sun America

Corrugated metallicized plastic film cut into tiles and pieced together to create a reflected pattern of light.

Garbage Heads, 1992
Found refuse, toy eyes, shellac on enamel, and plastic laminate on panel
48 x 73 ½ (121.9 x 186.7)
Collection of Robert Conn

Pieces of well-trampled refuse, picked up off the street, each outfitted with craft-store bobble eyes, arranged as a crowd with a central figure in the background.

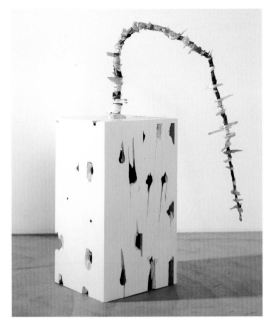

Untitled (Pedestal with Knots), 1992
Enamel on wood and steel cable
42 1/2 x 27 x 14 1/2 (108 x 68.6 x 36.8)
The Museum of Contemporary Art,
Los Angeles; gift of Gary and
Tracy Mezzatesta

All the knots were removed from a wooden pedestal, strung together, and fastened to the top of the pedestal.

Rug, 1992
Detritus from studio floor and enamel on canvas
96 x 54 (243.8 x 137.2)
Collection of Ben Bourgeois

Canvas was covered with glue and laid over my unswept studio floor. The image of an oriental rug was then painted over this irregular surface containing the detritus of other projects.

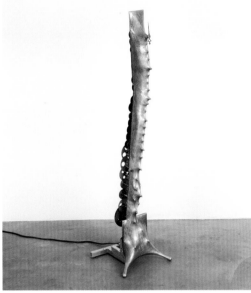

Slug, 1992
Gears, plastic resin, aluminum, and steel; motorized
54 x 14 x 13 (137.2 x 35.6 x 33)
Museum of Contemporary Art San Diego; museum purchase with funds from the Murray and Ruth Gribin Foundation

A motor at the base of the slug turning at 8 rpm engages a train of gears that reduces the rotation to one revolution in 10,000 years. This motion is indicated by the arrow at the top of the slug.

Volume Control, 1992
Paper, aluminum foil, and glue on panel

76 (diam.) x 2 (193 x 5.1)
Private collection; courtesy Ace Gallery

A flat disk with striated aluminum foil surface was cut into concentric rings and reassembled. Each ring was shifted a few degrees clockwise, progressing from the center outward. The striated rings reflect or absorb light, depending on their orientation to a light source. When viewed together, they give the feeling of ripples on the surface of the panel.

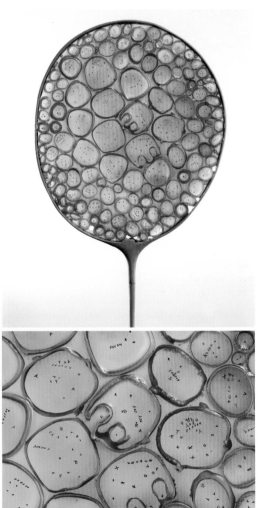

X's & O's, 1992
Doll, steel, varnish, ink, and enamel
72 x 14 x 12 (182.9 x 35.6 x 30.5)
Private collection

A vinyl doll cut into cross-sections, which were randomly arranged in an oval form and embedded in varnish, with *X*s and *O*s drawn in to suggest stages of cell division.

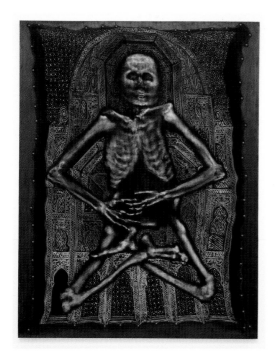

Alter, 1993
Pastel on fabric on panel
58 x 45 x 1 ½ (147.3 x 114.3 x 3.8)
Private collection

Pastel was rubbed over pieces of fabric
while they were held against my body.
The pastel was deposited over as many
bony protuberances as I could locate,
producing a simulated X-ray.

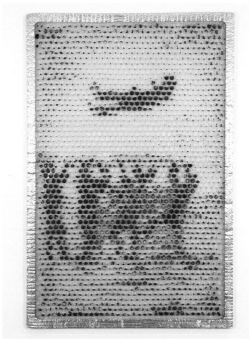

Blanket, 1993
Bubble wrap and ketchup
78 x 53 (198.1 x 134.6)
Private collection

A sheet of bubble wrap whose enclosures
were filled to varying degrees with
ketchup becomes a half-tone photograph
of a figure being tossed in a blanket.

The *Blindspot* image was upscaled to an
8-foot painting. The words "fat head"
course through the veins and arteries
seen just under the surface of the skin.

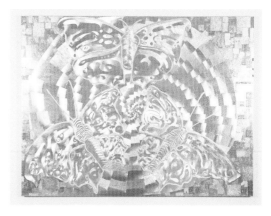

Butterflummies, 1993
Aluminum foil on wood panel
72 x 96 (182.9 x 243.8)
Private collection; courtesy Ace Gallery

Mummy chrysalises sprouting butterfly
wings fly out of a spiraling vortex. A
glass cutter was used to score the stri-
ated patterns of densely packed parallel
lines, which define the composition,
onto a surface composed of scavenged
scraps of foil wrappers.

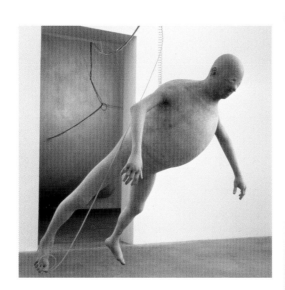

Balloon Self-Portrait, 1993
Latex and air
72 x 48 x 33 (182.9 x 121.9 x 83.8)
Ace Gallery

Latex rubber was painted over my depila-
toried body, then removed, turned inside
out, and inflated with air.

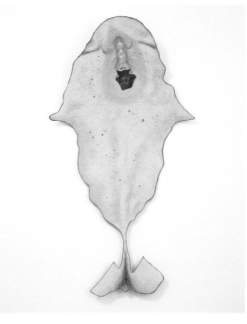

Blindspot (Fat Head), 1993
Synthetic polymer, hide glue, resin, and
wax on paper on steel
103 x 56 x 18 (261.6 x 142.2 x 45.7)
Los Angeles County Museum of Art; Modern
and Contemporary Art Council, 1996 Art
Here and Now Purchase

Clock (Red Arrows), 1993
Plastic, lead, and aluminum; motorized
Dimensions variable; less than 68
(172.7) (diam.)
Private collection

The hour hand connected to the minute hand
connected to the second hand. A clock
made up of mechanized cantilevered arrows,
one rotating off of the end of the other,
continuously reconfigures itself.

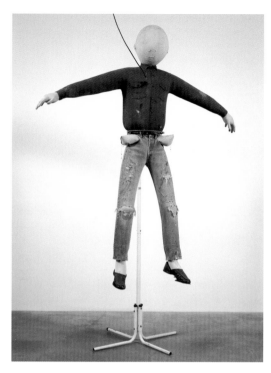

Fat Head Balloon Self-Portrait, 1993
Studio clothing, latex, air, and basket-
ball hoop
101 x 70 x 40 (256.5 x 177.8 x 101.6)
Collection of Tony and Gail Ganz

Rubber "skins" lifted from my head,
hands, and knees, welded into a rubber-
sealed body made up of shirt, pants, and
socks, inflated with air, and suspended
in a basketball hoop.

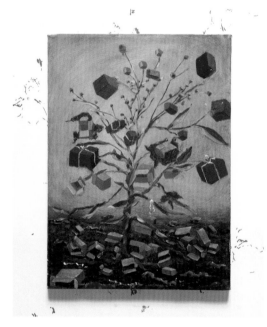

Gift Tree, 1993
Oil on canvas
16 x 12 (40.6 x 30.5)
Private collection

Gift-wrapped packages sprout and bloom on
the branches of a weed. Empty discarded
boxes are the withered flower-husks
fallen to the ground.

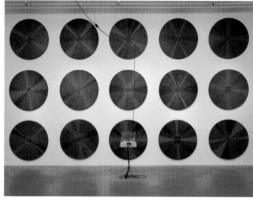

My Favorite Things, 1993
Music box: roasting pan, plastic water
bottle, plant stand, and metal; motorized
Disks: gesso, wax, ink, and shellac on
paper on panel
Music box: 43 x 17 x 16 (109.2 x 43.2 x
40.6); disks: 46 ½ (118.1) (diam.) each
Private collection; courtesy Ace Gallery

The record drawings were made on slowly
revolving disks, simultaneously using
my right (melody) and left (rhythm)
hands. This produced a two-track, inward-
spiraling record of my response to the
music being played. The drawings took
their titles from the LPs that were their
sources. Accompanying the drawings is a
music box that plays "My Favorite Things"
from the musical *The Sound of Music*.

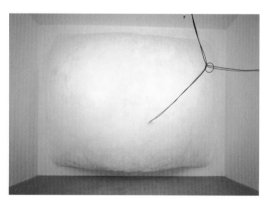

Reservoir, 1993
Latex on wall, air, tubing, and blower
Dimensions variable
Private collection; courtesy Ace Gallery

Latex rubber, painted onto a wall, was
peeled away up to the edges and inflated
with air. *Reservoir* provides air pres-
sure for other inflated objects, such as
Balloon Self-Portrait, to which it is
attached via an air hose.

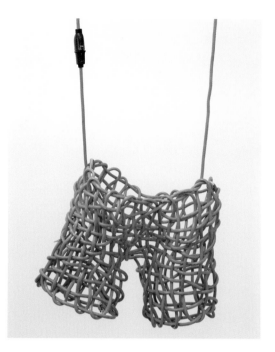

Shorts, 1993
Extension cord
14 x 14 x 10 (35.6 x 35.6 x 25.4)
Collection of Judy Slutzky

A functioning extension cord woven into
the shape of a pair of shorts.

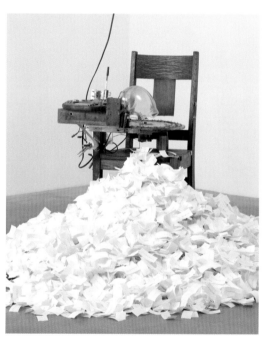

Signature, 1993
School desk, paper, wood, and metal;
motorized
37 x 28 x 24 (94 x 71.1 x 61)
Collection of Tony Krantz

A machine that signs my name onto a roll
of paper, chops it off, and drops it into
a pile.

Stomach, 1993
Aluminum foil, tape, and gum
24 ¹/₂ x 18 ¹/₂ (62.2 x 47)
Private collection

With an Allen wrench a honeycomb pattern
was poked onto an aluminum foil-covered,
thick, gummy surface and framed in lay-
ers of tape.

Thick and Thin, 1993
Rags, rope, twine, string, extension
cord, and hose
56 x 56 (142.2 x 142.2)
Private collection

Scraps of fabric were twined together
to make a long cord, starting out as a
2-inch-thick bundle and tapering down
to about ¹/₈ of an inch. The cord was
woven back on itself to make a grid of
stepped intersections: smaller in the
upper left corner, graduating to larger
in the lower right corner. This becomes
the canvas for a free-formed sampler
cross-stitched in electrical extension
cord, garden hose, etc.

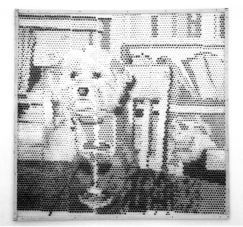

Winer, 1993
Bubble wrap, yarn, beans, seeds, candy,
and other materials
92 x 97 (233.7 x 246.4)
PaineWebber Group, Inc., New York

This picture of my dog was made up of
odds and ends of varying dimensions
found around the studio and inserted
into the compartments of a large sheet
of bubble wrap.

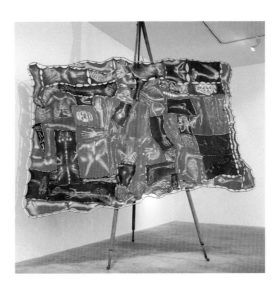

X-rays, 1993
Pastel on fabric, steel, and wood
180 x 159 x 95 (457.2 x 403.9 x 241.3)
Private collection

Pastel-on-fabric body rubbings.
Individual body parts were pieced
together into a patchwork pattern.

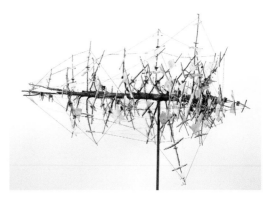

Das Tannenboot, 1994
Christmas tree, fabric, elastic, string,
and metal
66 x 70 x 43 (167.6 x 177.8 x 109.2)
Whitney Museum of American Art, New
York; gift of Eileen Harris-Norton and
Peter Norton 96.49

A found Christmas tree turned sideways,
stripped of its secondary branches, and
outfitted with masts, sheets, rigging,
lifts, backstays, braces, yards,
footropes, halyards, booms, studsail
tacks, etc.

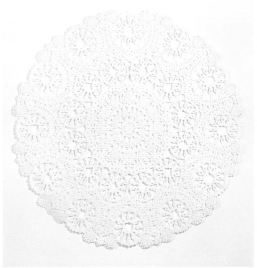

Doily, 1994
Butcher paper
96 (243.8) (diam.)
Collection of Eileen Harris-Norton and
Peter Norton

An 8-foot-diameter paper disk cut out
in the shape of the ubiquitous pastry
underlay.

Pearl Vision, 1994
Strapping tape on cardboard on panel
76 x 85 (193 x 215.9)
Collection of Eileen Harris-Norton and
Peter Norton

By applying strapping tape in concentric
rings, keeping the fibers of a given
ring parallel to each other, and shift-
ing each ring a few degrees in relation
to the previous ring, the illusion of a
surface ripple was created.

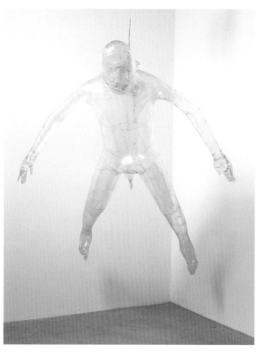

Pneuman, 1994
Vinyl and air
79 x 54 x 38 (200.7 x 137.2 x 96.5)
Collection of Mitchell Shaheen

Balloon Self-Portrait served as the
"mold" for this balloon made of sheets
of vinyl welded together and inflated
with air.

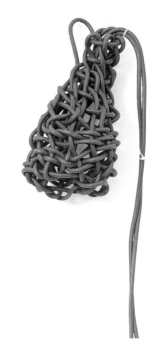

Vessel, 1994
Extension cord
12 x 5 x 5 (30.5 x 12.7 x 12.7)
Collection of Juan R. Lezcano

**A working electrical extension cord
woven into the shape of a bottle.**

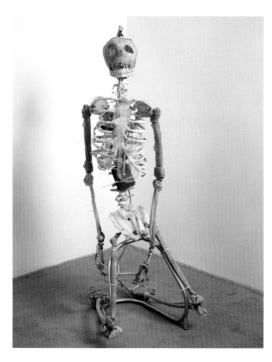

Penitent, 1994
**Rawhide dog chews and slide whistle;
motorized, with sound**
48 x 18 x 18 (121.9 x 45.7 x 45.7)
Collection of Steven Neu

**Rawhide dog bones were assembled into
a human skeleton. The ribcage houses a
device that emits a whistle as if
calling for a dog.**

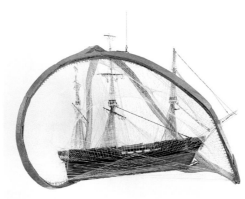

Siren Trouble, 1994
Model ship, string, wood, and wire
24 x 36 x 24 (61 x 91.4 x 61)
Collection of Jeff Kerns

A plastic model of the *USS Constitution*
suspended within a Naum Gabo-like
construction of wood and string.

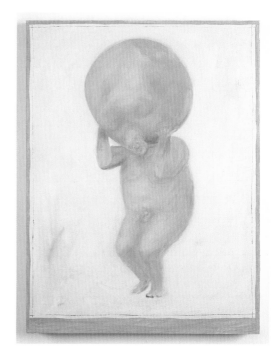

Alvin, 1995
Oil on panel
31 1/2 x 24 (80 x 61)
Private collection

A painting of a baby in which the
infant's large, round head is the earth,
supported by Atlas's shoulders.

Arborchrom, 1995
String, cardboard, and wood
75 x 18 x 25 (190.5 x 45.7 x 63.5)
Collection of Barry Blumberg

The branch of a tree made of cardboard
and string sprouts a twig construction:
Roman numerals I through XII are arranged
in a circle to form the face of a clock.

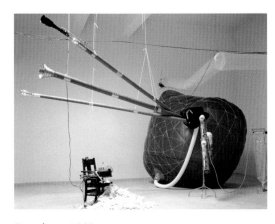

Bagpipe, 1995
Vinyl and cardboard tube; motorized,
with sound
96 x 120 x 240 (243.8 x 304.8 x 609.6)
Galleria Sperone

The big green bag is a lung that blows air
through the three longer tubes suspended
from the ceiling (drones) and the shorter
tube on the stand in front of the bag
(the chanter, which plays the melody).
The other freestanding structure tells
the bagpipe what to play. Tunes include
"Amazing Grace," the theme from the Olym-
pics, "A Bicycle Built for Two," "Good
King Wenceslas," "Simple Gifts," and the
Irish Spring soap commercial jingle.

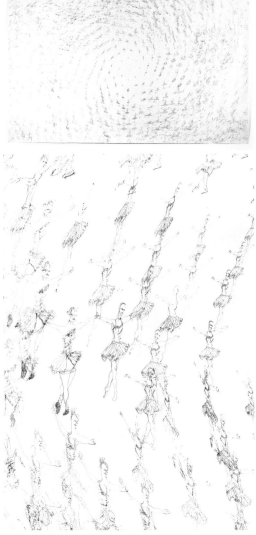

Ballerinas, 1995
Ink on paper
90 x 151 (228.6 x 383.5)
Private collection

A device for making graduated multiple
drawings was improvised using approxi-
mately forty ballpoint pens and a col-
lapsible hat rack. The pens were wired
onto the pegs of the hat rack. The hat
rack was anchored to the center of a
sheet of paper by one of the corner pegs,
and a large ballerina was drawn with
the opposing peg-pen at the outer edge
of the paper, producing a phalanx of
thirty-nine increasingly smaller bal-
lerinas, each distinguished from the
others by height and width. Repeating
this process completed a whirlpool of
pirouetting ballerinas.

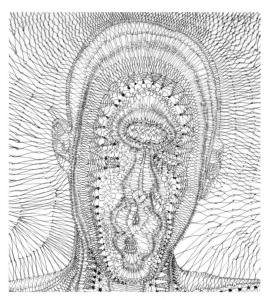

Bathtub-Generated Contour Lace,
1995 (detail)
Ink on paper
80 x 32 ½ (203.2 x 82.6)
Private collection; courtesy Ace Gallery

I lay in a bathtub that was slowly being
filled with black paint. A photograph was
taken every few minutes as the liquid
crept up and over diminishing islands of
my skin. Superimposing these images, a
contoured pattern emerged that I then
rendered in a drawing of lace.

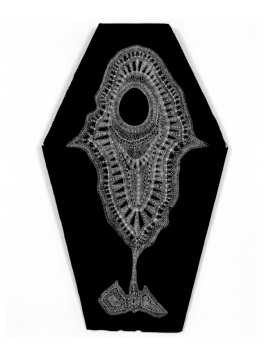

Blindspot Lace Drawing, 1995
Ink and resin on steel
19 ¾ x 12 ½ (50.2 x 31.8)
Collection of Cecilia Dan

Blindspot was the pattern for this draw-
ing of an intricately woven lace collar.

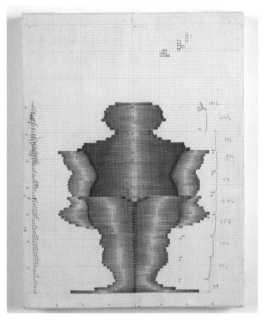

Circumference Self-Portrait (Study), 1995
Ink on panel
11 x 8 ½ (27.9 x 21.6)
Collection of Patty Wickman

I recorded the circumferences of my body, taking the measurements at 1-inch intervals from head to toe. The results are displayed in a graph.

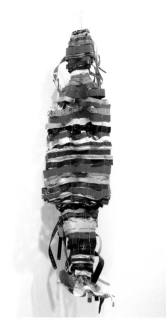

Hangman of My Circumferences, 1995
Belts and steel wire
72 x 14 x 18 (182.9 x 35.6 x 45.7)
Private collection

The circumferences of my body, taken at 1-inch intervals, were measured in thrift store belts, which were reassembled into a cocoon form.

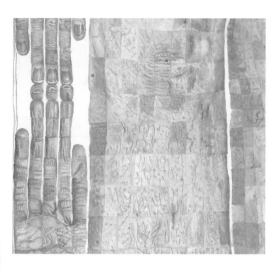

Humongolous, 1995 (detail)
Synthetic polymer on rag paper on fabric
172 x 48 (436.9 x 121.9)
Private collection; courtesy Ace Gallery

Humongolous is a map charting all the surfaces of my skin that I could see directly. Starting with my left hand, I gridded off my palm and depicted it, square by square, onto a larger grid drawn on paper. In this way I wound around my hand, up my arm, and across the rest of my epidermis, mapping my body, detailing and expanding the areas that were more accessible.

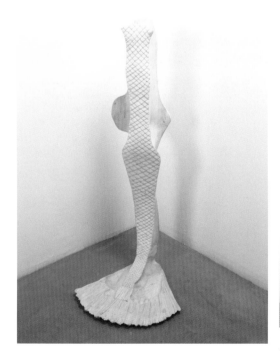

The Fin Within, 1995
Plaster
36 x 15 x 15 (91.4 x 38.1 x 38.1)
Private collection; courtesy Ace Gallery

I made a plaster mold of the space between my legs and carved the outer surfaces to look like a fish's tail.

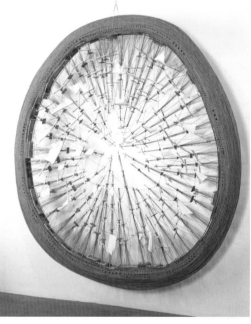

H.M.S.O., 1995
Wood, fabric, and string
90 (diam.) x 10 (228.6 x 25.4)
Collection of Dean Valentine and Amy Adelson

A circular hull made of laminated wooden strips outfitted with masts and jibs, yard-arms, sails, ladders, crow's nests, etc.

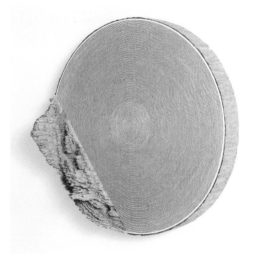

Log Section, 1995
String, cardboard, wooden craft sticks, and wooden toothpicks
30 ½ (diam.) x 10 (77.5 x 25.4)
Private collection

Toothpicks, Popsicle sticks, cardboard, and string make up this reconstruction of the cross-section of a tree.

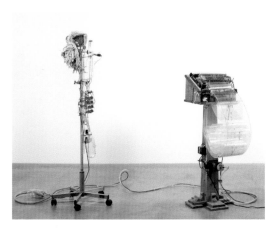

Ranting Mop Head (Synthesized Voice), 1995
Mop, lectern, and mixed media; motorized,
with sound
Mop: 67 x 24 x 24 (170.2 x 61 x 61);
lectern: 50 x 17 x 27 (127 x 43.2 x
68.6); cable: 204 (518.2) (length)
Collection of Tony and Gail Ganz

A stream of compressed air hits a plastic
reed located at the base of the mop, mak-
ing a sound that is textured and manipu-
lated by different valves, diaphragms, and
resonating chambers. Hard consonant and
harmonic vowel sounds are created. The
sounds were worked into a vocabulary of
speech fragments, assembled into simple
words, and the words were put together
into a few basic, often bizarre phrases:
"Are you my mommy?", "I want to mop your
violin." The cues for these phrases were
recorded, player-piano fashion, onto a
repeating scroll that runs through the
playing mechanism built into the podium,
telling the mop head what to say.

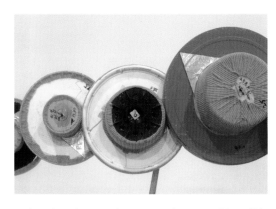

Spin Sink (1 Rev./100 Years), 1995 (detail)
Twenty-four gears, steel, plywood, foam,
plastic, and corduroy; motorized
96 x 277 x 48 (243.8 x 703.6 x 121.9)
Private collection

The rapid motion of a tiny motor spin-
ning at 1,400 rpm is absorbed by a gear
train that reduces the spin to one revo-
lution per century. As the motion slows,
the gears become bigger and softer. The

consideration of a material's resistance
to wear determined steel gear teeth at
the fast end and corduroy gear teeth at
the slow end, with a variety of materi-
als for teeth in the middle to give more
even wear.

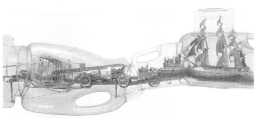

Trajectory, 1995
Toy models and plastic bottles
96 x 14 x 9 (243.8 x 35.6 x 22.9)
Collection of Eileen Harris-Norton and
Peter Norton

Plastic models of sailing ships, automo-
biles, airplanes, and spacecraft were
fused together and encased in a plastic-
bottle vitrine.

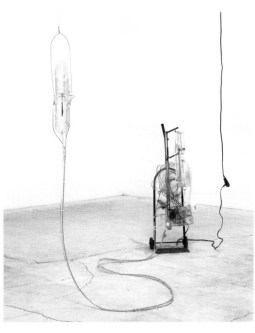

Tuva, 1995
Plastic bottles, handcart, and air;
motorized, with sound
Handcart: 44 x 24 x 20 (111.8 x 61 x
50.8); bottles: 23 x 4 x 5 (58.4 x 10.2 x
12.7); cable: 132 (335.3) (length)
Private collection

Tuva is a machine that hums or moans
polyphonically. It was suggested by
recordings I had heard of people from
Tuva in Central Asia who are able to pro-
duce multiple sounds at one time with
their voices. In this piece, air is pushed
out of a piston made of plastic bottles,
causing a reed to sound. More plastic
bottle parts, making up the "mouth," are
constantly shifting in relation to each
other. By manipulating this resonant
chamber, secondary harmonic tones are
reflected off of the base tone.

Untitled Spun Silver Disk, 1995
Aluminum foil on wood
95 (241.3) (diam.)
Collection of Issey Miyake

A wooden disk, covered with aluminum
foil and anchored in the center, was
spun at a high rpm. The spinning motion
was recorded on the surface of the disk
with a glass cutter.

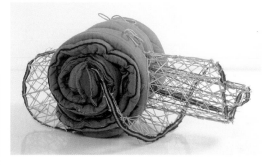

Zipper Train, 1995
Sleeping bag and wooden toothpicks
20 x 35 x 14 (50.8 x 88.9 x 35.6)
Collection of Mitchell Shaheen

The implicit locomotion of a sleeping
bag is released through the zipper,
which is disengaged and rerouted onto
a course that tunnels through and cir-
cumnavigates the bag.

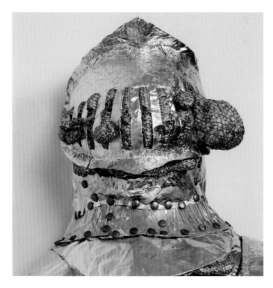

Armor Ooze, 1996 (detail)
Aluminum foil, synthetic polymer on
urethane foam, and brass brads
37 ¹/₂ x 78 ¹/₂ x 25 ¹/₂ (95.3 x 199.4 x 64.8)
Collection of Eileen Harris-Norton and
Peter Norton

A suit of armor made of aluminum foil
riveted together with brass brads. The
armor was so fragile that it would quiver
and nearly collapse in the slightest
breeze. Urethane foam was employed to
reinforce the structure. The foam
expanded and seeped through the cracks
and seams in the armor. These bubbling
protuberances were covered in a chain-
mail pattern of silver acrylic.

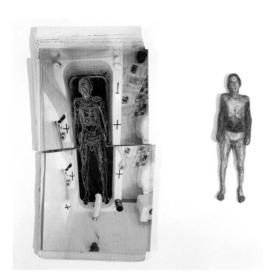

Drain and Plug, 1996
Chromogenic color prints, two parts
9 x 4 ¹/₂ x ³/₄ (22.9 x 11.4 x 1.9);
5 x 1 ¹/₂ x ³/₄ (12.7 x 3.8 x 1.9)
Collection of Duff Murphy and
Janice Miyahira

These are the photographs used for
Bathtub-Generated Contour Lace cut out

and laminated together. The figure is
extracted and appears next to the bath-
tub, leaving a negative depression.

Draw! Paint! Weave! Spin!, 1996
Graphite and synthetic polymer on paper
on panel
64 x 61 ¹/₂ (162.6 x 156.2)
Private collection

A drawing of a grid has been subjected
to a number of transforming processes,
including warping, slicing, twisting,
and remixing.

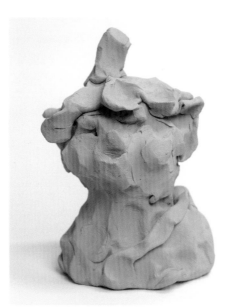

Little Sprout, 1996
Polymer clay
14 x 11 x 9 (35.6 x 27.9 x 22.9)
Collection of Eileen Harris-Norton and
Peter Norton

A bust of a wood sprite as if sculpted
by a very large hand. I made a glove with
2-inch-wide fingerprint pads and wore it
to mold the figure in green polymer clay.

Secret Sync, 1996
An installation of common objects that
have been outfitted with clock motors so
that they all tell the same time, tick-
ing simultaneously.

Bucket Clock, 1996
Plastic bucket and clock motor
14 ¹/₄ x 12 ¹/₂ (diam.) (36.2 x 31.8)
Private collection

A plastic paint bucket whose date of
manufacture stamp — a circular disk with
the numbers 1 through 12 indicating the
month — is motorized, so that the hour of
the day is discreetly indicated on the
bottom of the bucket.

Clamp Lamp Clock, 1996
Clamp lamp and clock motor
17 ¹/₂ x 2 ¹/₂ x 11 (44.5 x 6.4 x 27.9)

Private collection; courtesy Ace Gallery

The filaments of a lightbulb were motorized so that the time of day may be read by looking down at the bulb from above.

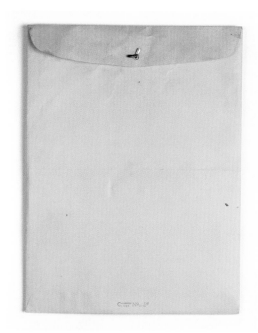

Coke Clock, 1996
Coke can and clock motor
4 $^3/_4$ x 2 $^1/_2$ (diam.) (12.1 x 6.4)
Private collection; courtesy Ace Gallery

The pull tab tells the minute, and the sipping hole, the hour in this clock.

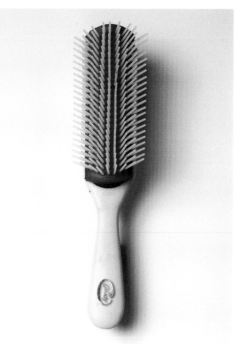

Hairbrush Clock, 1996
Hairbrush, hair, and clock motor
2 x 2 $^1/_2$ x 8 $^1/_4$ (5.1 x 6.4 x 21)
Collection of Eileen Harris-Norton and Peter Norton

Two hairs were stuck in the bristles of this brush and motorized. The first rotates once an hour, the second, twice a day.

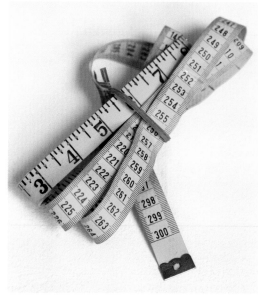

Tape Measure Clock, 1996
Tape measure, twist tie, and clock motor
8 x 3 $^1/_2$ x 2 (20.3 x 8.9 x 5.1)
Private collection; courtesy Ace Gallery

The 12 inches in a foot are looped together and motorized to repeat twice daily. The hour is indicated by the twist tie.

Envelope Clock, 1996
Manila envelope and clock motor
15 $^1/_2$ x 12 x 1 (39.4 x 30.5 x 2.5)
Private collection; courtesy Ace Gallery

The bent metal clasps of a manila envelope were motorized to indicate the minute and hour of the day.

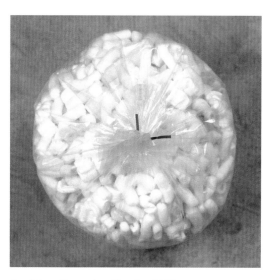

Packing Peanuts Clock, 1996
Plastic bag, polystyrene pellets, twist tie, and clock motor
13 $^3/_4$ x 13 $^1/_2$ x 19 $^3/_4$ (34.9 x 34.3 x 50.2)
Private collection; courtesy Ace Gallery

The two ends of a twist tie, wrapped around the neck of a plastic bag of packing peanuts, rotate as the hands of a clock.

Toothpaste Clock, 1996
Toothpaste tube, caulking, and clock motor
3 x 3 x 2 (7.6 x 7.6 x 5.1)
Private collection; courtesy Ace Gallery

Toothpaste extrusion = minutes; open flip cap = hours.

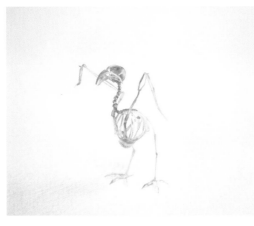

Bird, 1997
Fingernail parings and superglue
2 x 2 ¼ x 2 (5.1 x 5.7 x 5.1)
Andrea Nasher Collection

Nail clippings were collected and glued together to make the skeleton of a small bird. The pinky nail was grown out longer to make the cranium.

Cyctor, 1997
Altered poster print
60 x 40 (152.4 x 101.6)
Collection of Eileen Harris-Norton and Peter Norton

A manipulated advertising poster. Small disks or core samples of the model's head, arm, and clothing were removed and reconfigured to make up a doctor's examination instruments, including stethoscope and reflex hammer. A reflection of the model's face is inverted and distorted in the mirror on her forehead.

Divan, 1997
Pastel on paper on foam core on panel
48 x 107 (121.9 x 271.8)
Collection of Tony and Gail Ganz

A drawing of a chaise longue. The light patterns reflected in the bulges of upholstered black patent leather become hundreds of ballerinas stretching, dancing, and collapsing in exhaustion.

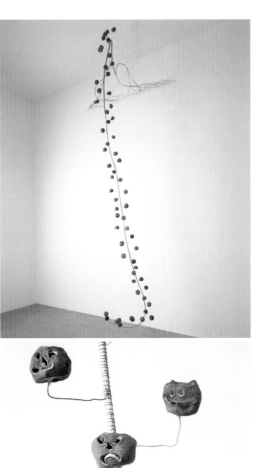

Eel, 1997
Orange peels and wire
158 x 84 x 60 (401.3 x 213.4 x 152.4)
Private collection

Oranges carved like jack-o-lanterns, dried, hollowed out, and strung on a wire vine.

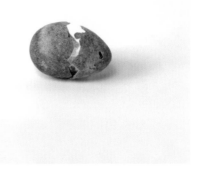

Egg, 1997
Ground fingernails, hair, and superglue
1 x 1 ½ x 1 (2.5 x 3.8 x 2.5)
Andrea Nasher Collection

Pulverized hair and nail clippings mixed with glue make up the walls of a small hatched egg.

Feather, 1997
Hair and superglue
2 ¼ x 2 x ½ (5.7 x 5.1 x 1.3)
Andrea Nasher Collection

A feather made up of my hair. Several hairs were glued together into a bundle to form the spine.

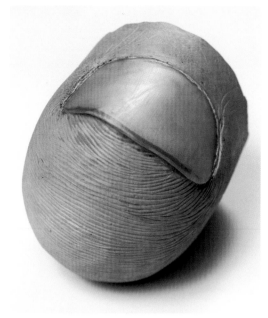

(Index) Finger, 1997
Pens, pencils, and polyester resin
5 x 5 x 6 (12.7 x 12.7 x 15.2)
Private collection; courtesy Ace Gallery

The red pens and pencils used to make the drawing *Wall Chart of World History from Earliest Times to the Present* become the blood and gore of a severed fingertip.

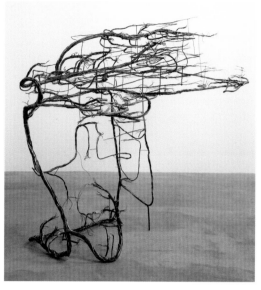

Organ, 1997
Electric organ wiring
44 x 26 x 52 (111.8 x 66 x 132.1)
Private collection; courtesy Ace Gallery

The wiring from a '70s-era electric organ minus chassis, keyboard, and all other nonwire elements was preserved intact and suspended on an armature.

Frankengehry, 1997
Altered poster print and urethane foam
67 x 26 x 30 (170.2 x 66 x 76.2)
Collection of Eileen Harris-Norton and Peter Norton

An advertising poster was cut into small squares and reassembled to create several smaller versions of the original model varying in size and proportion. The images were stapled together into a boxy form and inflated with urethane foam.

Jerusalem Cross, 1997
Ink on paper on panel
62 x 60 (157.5 x 152.4)
Collection of Susan and Michael Rich

The liturgical symbol—a large cross with smaller crosses in each quadrant—is used as the pattern of this drawing of diminishing crosses numbering 4 to the power of 7.

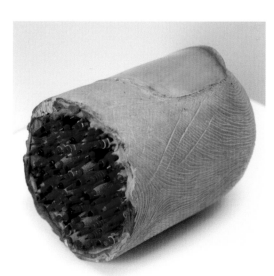

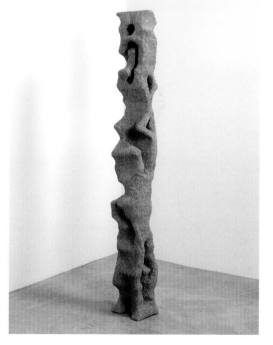

Phonetic Sculpture, 1997
Fiberglass, synthetic sheepskin, and synthetic polymer
70 x 9 x 9 (177.8 x 22.9 x 22.9)
Private collection

This sculpture of the letters of the alphabet, stacked on their backs and morphing into each other, has been given a tonguelike surface.

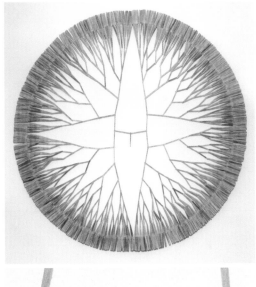

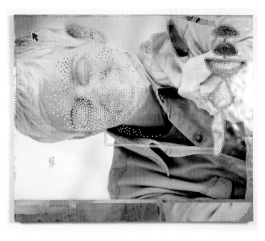

Telecomutant, 1997
Altered poster print on foam core
45 x 53 ½ x 2 (114.3 x 135.9 x 5.1)
Private collection

An advertising poster becomes a computer
screen, in which the model's features
have been relocated and stacked in a row
as icons.

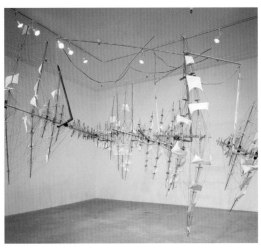

Aerial Mobile, 1998
Television antennae, fabric, and string
Dimensions variable
Collection of Eileen Harris-Norton and
Peter Norton

Television antennae outfitted with
sails, booms, rigging, etc., suspended
and balanced to become a mobile.

Stamträd (Family Tree), 1997
Graphite on wooden craft sticks
76 (193) (diam.)
Private collection

Popsicle sticks, pinned together and
branching out from the center, comprise
a genealogical history recording ten
generations of parents, grandparents,
great-grandparents, etc. Each ancestor
is specifically identified in Swedish.
Mor means mother and *far* is father, so,
mother's father's father's mother would
be Mor-far-far-mor.

**Wall Chart of World History from Earliest
Times to the Present**, 1997 (detail)
Ink and colored pencil on paper
51 x 420 (129.5 x 1066.8)
Private collection; courtesy Ace Gallery

**The rise and fall of world powers,
kingdoms, dynasties, and empires are
loosely depicted as wormlike or intes-
tinal structures growing, thriving,
diminishing, and dying.**

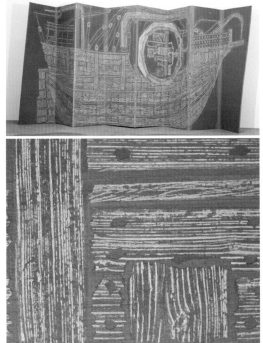

Crow's Nest, 1998
Pastel and wax on craft paper on poly-
styrene substrate
144 x 384 (365.8 x 975.4)
Collection of the artist and Ace Gallery

I made pastel rubbings on craft paper of
a wooden deck containing a hot tub. The
rubbings were reassembled into this
three-masted sailing ship. The hot tub,
with pump, filter, and water heater, is
the ship's crow's nest.

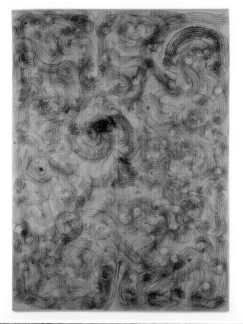

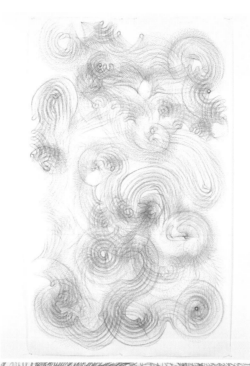

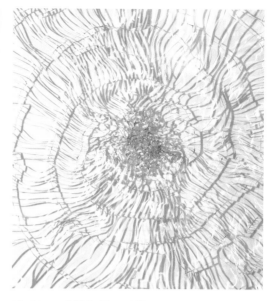

Shatter, 1998 (detail)
Mirrored acetate, polyester, and aluminum
84 x 84 (213.4 x 213.4)
Collection of Eileen Harris-Norton and
Peter Norton

Thin strips of mirrored plastic film
were bent, folded, and glued into the
weblike configuration of a shattered
piece of glass. This skeleton of frac-
tures was then sandwiched between two
sheets of plastic film.

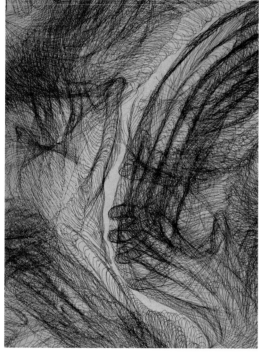

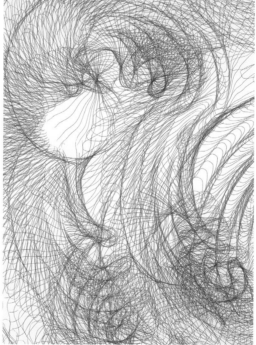

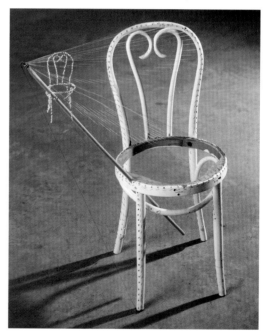

Elephant Drawing, 1998
Ink on paper on wood panel
148 x 109 ½ (375.9 x 278.1)
Collection of Tony and Gail Ganz

I used my hand as a template, tracing
it repeatedly, moving it a fraction of
an inch each time, to track the pattern
that might occur when washing an ele-
phant by hand. The end of the elephant's
trunk can be seen in the upper right
corner, its tail, at the bottom center.

Making Waves, 1998
Ink on paper
83 x 51 (210.8 x 129.5)
Private collection

Free-form spirographic trajectories were
created by tracing my hand as it moved in
slow-motion arcing patterns over a sheet
of paper.

Shrink, 1998
Wooden chair and monofilament
38 x 27 x 14 (96.5 x 68.6 x 35.6)
Private collection

Core samples of ⅛ of an inch taken at
approximately 1-inch intervals were
drilled out of a wooden chair. Each disk

was positioned on a thread that connects the disk's original position on the chair to a vanishing point just to the left of the chair. By maintaining a proportional distance between the disks and the vanishing point, the chair is effectively shrunk.

Web, 1998
Hair and superglue
48 x 35 (121.9 x 88.9)
Collection of Eileen Harris-Norton and Peter Norton

This is a spiderweb made of my hair held together with superglue.

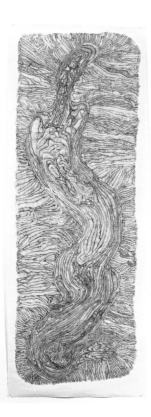

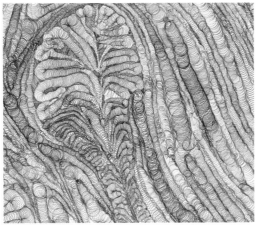

Bath Jinn, 1999
Ink on paper
123 x 47 (312.4 x 119.4)
Collection of Tony and Gail Ganz

The *Bathtub-Generated Contour Lace* pattern is stretched and distorted, rendered in spirographic blue ballpoint pen.

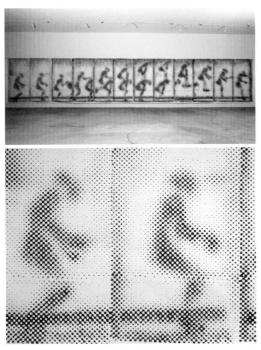

Bridge, 1999
Tempera on paper
108 x 612 (274.3 x 1554.5)
Private collection

A waffle-patterned foam mattress pad, bumpy side covered with black tempera, was laid on the floor paint-side down over a section of white photo backdrop paper. Using a system of ropes and pulleys, I repeatedly lowered myself onto this surface, leaving half-tone body prints that duplicated the figures in an Eadweard Muybridge motion study.

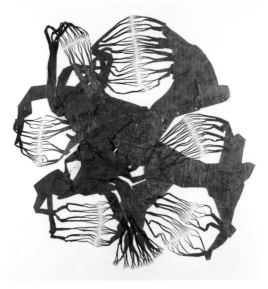

Circ, 1999
Clothing on canvas on panel
60 x 66 (152.4 x 167.6)
Collection of George Lindemann

The legs of the blue pants and the sleeves of the red shirt are frayed down to their individual warp threads, at which point red shirt-threads link up with blue pants-threads.

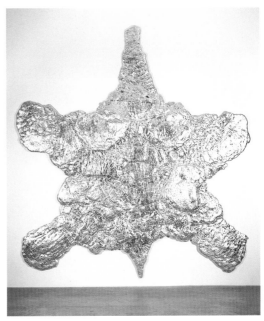

Elephant Skin #2, 1999
Aluminum foil, urethane foam, and felt
130 x 125 x 6 (330.2 x 317.5 x 15.2)
Private collection

Urethane foam, poured in the general configuration of a splayed elephant, was covered with aluminum foil and patterned with incised lines that duplicate the wrinkles of an elephant's skin.

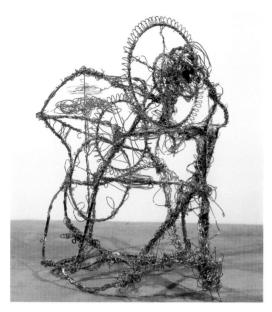

Gin, 1999
Chromed wire
38 x 36 x 28 (96.5 x 91.4 x 71.1)
Collection of Tony and Gail Ganz

Bent, bound, and twisted 12-gauge wire configured into the frame, gears, verge, spring, etc., of an escapement or windup clock motor.

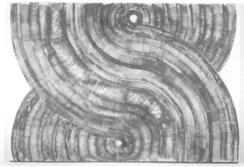

Graph, 1999
Ink on chromed paper

96 x 144 (243.8 x 365.8)
Private collection

Printing rollers were made from a latex impression of my body cut into horizontal bands of varying widths from head to toe. Each roller reproduces the skin pattern of a different cross-section— left index finger's middle knuckle, right knee, mouth, etc. Nostrils can be seen in the repeated double white dot pattern a few rows out from the center of the top spiral.

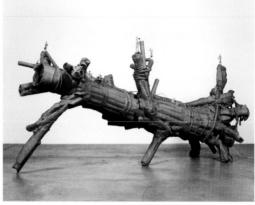

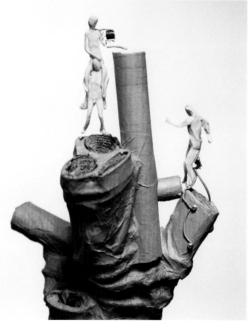

Log (with Homunculi), 1999
Polymer clay, cardboard, papier-mâché, rope, string, solenoids, found computer program, and mechanical components
57 x 116 x 45 (144.8 x 294.6 x 114.3)
Private collection

Bath-generated homunculi from *Drain and Plug*, cast in Sculpey, tap, kick, head-butt, and pound out rhythmic patterns on a log made of cardboard, paper, rope, and string.

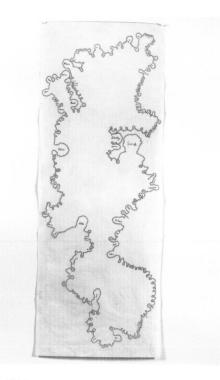

Map, 1999
Ink on paper
63 x 24 (160 x 61)
Collection of Tony and Gay Browne

Silhouettes of alumni were traced from the back pages of a UCLA newsletter. The images were fitted together to become the inlets, coves, peninsulas, lakes, and jetties—named after their sources— that comprise the bounding characteristics of a fictional island.

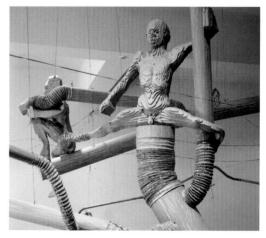

Pentecost, 1999 (detail)
Polyurethane foam, sonotubes, solenoids, found computer program, and mechanical components
Dimensions variable
Andrea Nasher Collection

Twelve figures based on the *Bathtub-Generated Contour Lace* pattern were suspended within the branches of a tree

composed of cardboard tubes covered with wooden-deck rubbings (*Crow's Nest*). Each figure taps with a different part of his body on a branch of the tree. Syncopated, rhythmic patterns are generated by a found computer program.

80 x 60 x 34 (203.2 x 152.4 x 86.4)
Private collection; courtesy Ace Gallery

Cardboard tubes, corrugated cardboard, paper, rope, string, and twine make up bark, trunk growth rings, and roots.

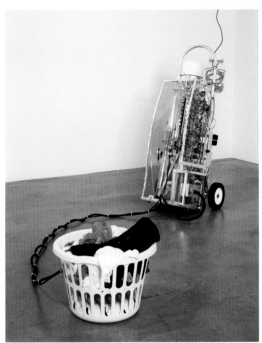

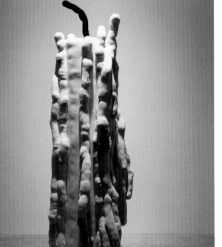

Grid, 2000
Paper, aluminum foil, and foam
53 x 93 x 10 (134.6 x 236.2 x 25.4)
Collection of the artist and Ace Gallery

An expanding and contracting grid of peg-board. Crumpled aluminum foil hooks are scaled up or down according to the pattern in the grid.

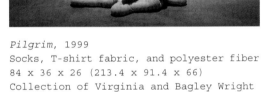

Pilgrim, 1999
Socks, T-shirt fabric, and polyester fiber
84 x 36 x 26 (213.4 x 91.4 x 66)
Collection of Virginia and Bagley Wright

The drips of wax on this candle are socks stuffed with Dacron.

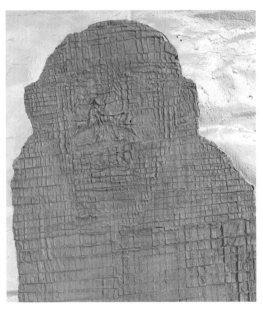

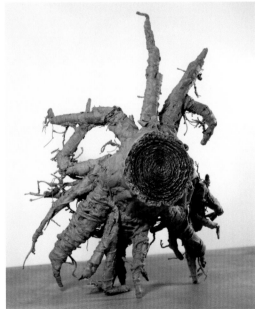

Root Ball, 1999
Paper, cardboard, rope, twine, string, and glue

Life-Size Mirror Self-Portrait, 2000 (detail)
Synthetic polymer and aluminum foil on polyester
80 7/8 x 22 (205.4 x 55.9)
Frederick R. Weisman Art Foundation, Los Angeles

I stood in front of a full-length mirror, nose to nose, and sculpted my reflection onto the glass. Four duplicates of this specter were diced into little squares and spliced together to make a life-size figure.

Spy Clothes, 2000
Clothing, motion detectors, and mechanical components
48 x 23 x 21 (121.9 x 58.4 x 53.3)
Private collection

Buttons found on a pile of clothing dumped in a laundry basket track the viewer's movements like the eyes of an otherwise immobile beached sea creature.

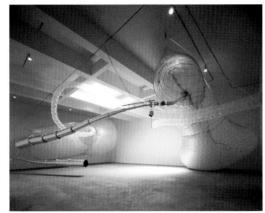

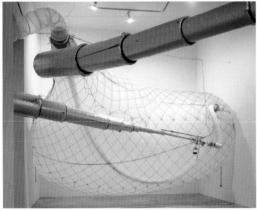

Überorgan, 2000
Twelve woven polyethylene balloons,
nylon, cardboard tubing, mechanical
components, and air
Dimensions variable
Andrea Nasher Collection

Twelve bus-size biomorphic balloons,
each with its horn tuned to a different
note in an octave, make up a walk-in self-
playing organ. A 200-foot-long scroll of
dots and dashes encodes a musical score
of old hymns, pop classics, and improvi-
sational ditties. This score is deci-
phered by the organ's brain—a bank of
light-sensitive switches—and then re-
interpreted by a series of switches and
relays that translate the original pat-
terns into nonrepeating variations of
the score.

Daisy Clock, 2001
Dried flower, glass bottle, and
clock motor
12 x 2 x 2 (30.5 x 5.1 x 5.1)
Private collection; courtesy Ace Gallery

The last two petals of a flower were
mechanized to tell the time of day.

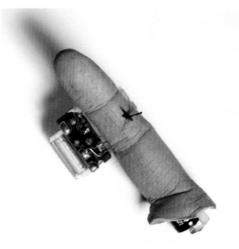

Finger Clock, 2001
Plastic resin and clock motor
3 ¼ x 1 x ¾ (8.3 x 2.5 x 1.9)
Ace Gallery

Stitches tell the time in this plastic
resin cast of my wounded finger.

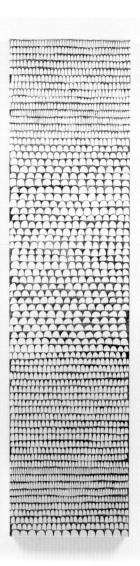

Plot, 2001
Watercolor on rice paper on panel
72 ½ x 18 (184.2 x 45.7)
Collection of Gary Fink

I calculated the circumferences of my
body at 1-inch intervals from head to
toe, then, using a mathematical formula,
translated the numbers into frequencies
or quasi-wavelengths, which are now seen
as an inverted fish-scale pattern or
tombstones in a cemetery.

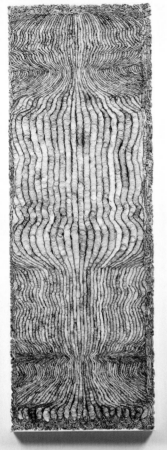

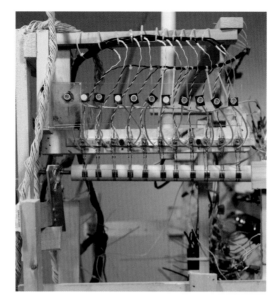

Print: 49 x 36 x 4 (124.5 x 91.4 x 10.2);
stepladder: 27 x 24 x 19 (68.6 x 61 x
48.3); cable: 174 (442) (length)
Andrea Nasher Collection

Patterns of light and dark emanating from
a television set are translated into
signals that control the features of my
face—eyes, ears, nose, mouth—which have
been cut up and hinged together into a
two-dimensional puppet.

Drip, 2002 (detail)
Polyethylene, mechanical component,
and water
Dimensions variable
Collection of Steven Neu

A sort of drumming machine. The spin
frequencies of a train of gears are ran-
domly sampled, mixed, and synchronized
to generate a nonrepeating rhythmic
pattern. The pattern is heard as water
dripping into buckets from the ends
of the tentacle-like structures of a
creature hovering above.

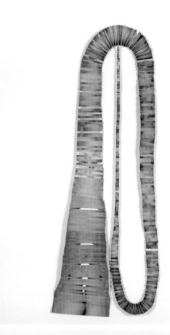

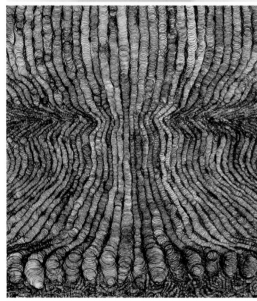

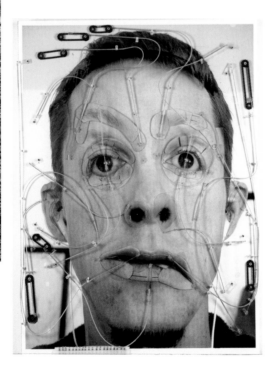

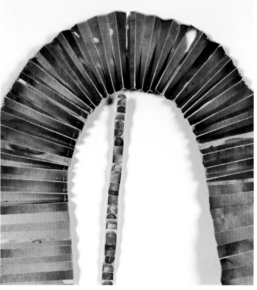

Scribe, 2001
Ink on rag paper mounted on panel
77 x 18 (195.6 x 45.7)
Frederick R. Weisman Art Foundation,
Los Angeles

My circumferences translated into
frequencies are connected dot-to-dot
to create the wormlike forms drawn in
spiraling black ballpoint pen.

Emoter, 2002 (detail)
**Altered ink-jet print on plastic and
foam core on panel, monitor, stepladder,
and mechanical components**

Taper, 2002
Photocollage
67 1/2 x 25 (171.5 x 63.5)
Collection of Michael Danoff

My body photographed in 1/2-inch-wide
horizontal strips and redistributed in a
loop according to width, from the nar-
rowest tip of pinky at the top, to the
widest section of waist at the bottom.

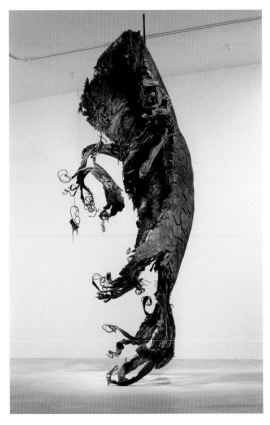

Magdalen, 2003
Paper, wire, string, foam rubber,
and caulking
156 x 64 x 32 (396.2 x 162.6 x 81.3)
Andrea Nasher Collection

A monster-tire blowout made of foam rubber, paper, wire, string, caulking, etc.

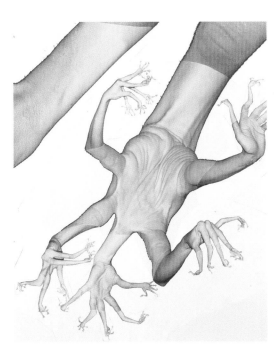

Untitled, 2003 (detail)
Ink-jet prints on foam core on panel

68 x 117 (172.7 x 297.2)
Private collection; courtesy Ace Gallery

Hands, photographed in different positions, sprout from the fingertips of larger hands, which sprout from larger hands, repeating for five generations of hands from fingers.

Bear, 2004–
Eight granite boulders
265 x 216 x 180 (673.1 x 548.6 x 457.2)
The Stuart Collection, University of
California, San Diego

Eight naturally formed granite boulders make a 20-foot-tall bear that weighs approximately 300 tons. To be completed March 2005.

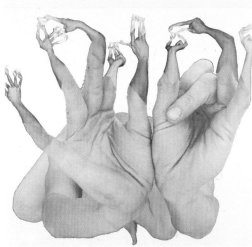

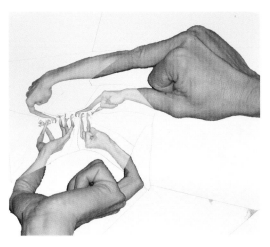

Fruit, 2004 (details)
Ink-jet prints on foam core on panel
96 x 120 x 2 (243.8 x 304.8 x 5.1)
Private collection

The fourth generation of hands sprouting from hands spells out the words *love*, *joy*, *peace*, *patience*, *kindness*, *goodness*, *faithfulness*, *gentleness*, and *self-control*.

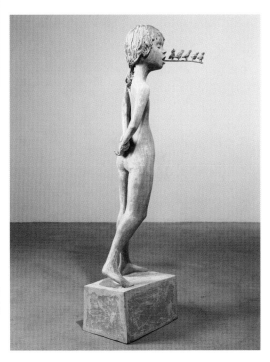

Sweet Tweet, 2004
Fiberglass and polyester resin
55 x 19 x 16 (139.7 x 48.3 x 40.6)
Private collection

Five small birds sing, perched on the girl's tongue.

Chronology

Born 1960 in San Francisco
Lives and works in Los Angeles

EDUCATION

1989
MFA, University of California
at Los Angeles

1984
BFA, San Jose State
University, California

SELECTED EXHIBITION HISTORY

SOLO EXHIBITIONS

2004
Akira Ikeda Gallery, Berlin

2002
Überorgan, Ace Gallery,
New York

2001
Directions, Hirshhorn Museum
and Sculpture Garden,
Washington, D.C. (brochure)

2000
Miyake Design Studio, Tokyo

New Work, White Cube, London
(cat.)

Pentecost, Ace Contemporary
Exhibitions, Los Angeles

The Power Plant Contemporary
Art Gallery, Toronto (cat.)

Überorgan, MASS MoCA, North
Adams, Massachusetts
(brochure)

1999
Ace Gallery, New York

New Works, Akira Ikeda
Gallery, AIG Exhibition/
Taura, Taura, Japan (cat.)

1998
Ace Contemporary Exhibitions,
Los Angeles

Galleria Milleventi, Milan

Pneumatic Quilt (collaboration
with Issey Miyake), Ace
Contemporary Exhibitions,
Los Angeles

1996
Ahi Ikmnnostw, Armory Center
for the Arts, Pasadena (cat.)

*Humongolous: Sculpture and
Other Works by Tim Hawkinson*,
organized by The Contemporary
Arts Center, Cincinnati; trav-
eled to Akron Art Museum, Ohio
(1996); Yerba Buena Center for
the Arts, San Francisco (1996);
The Aronoff Center for the
Arts, Alice F. and Harris K.
Weston Art Gallery, Cincinnati
(concurrent exhibition
with The Contemporary Arts
Center, Cincinnati, 1996–97);
Southeastern Center for
Contemporary Art, Winston-
Salem, North Carolina (1997);
and John Michael Kohler Arts
Center, Sheboygan, Wisconsin
(1997) (cat.)

Secret Sync, Gallery Paule
Anglim, San Francisco;
Ace Contemporary Exhibitions,
Los Angeles (1997)

1995
Ace Gallery, New York

1994
Guggenheim Gallery, Chapman
University, Orange, California
(brochure)

1993
Ace Contemporary Exhibitions,
Los Angeles

1991
Anders Tornberg Gallery, Lund,
Sweden (cat.)

1990
Ace Contemporary Exhibitions,
Los Angeles

1988
Objects, Ace Contemporary
Exhibitions, Los Angeles

1985
Brunswick Gallery, Missoula,
Montana

1984
Gallery 6, San Jose State
University, California

1982
Freight Door Gallery, Santa
Clara University, California

1981
Carlson Tower Gallery, Chicago

SELECTED GROUP EXHIBITIONS

2003
We Are Electric, Deitch
Projects, New York

2002
2002 Biennial Exhibition,
Whitney Museum of American
Art, New York (cat.)

*Fantasy Underfoot: The 47th
Biennial Exhibition*, Corcoran
Gallery of Art, Washington,
D.C. (cat.)

2001
The Americans: New Art,
Barbican Gallery, London
(cat.)

*Chain Reaction: Rube Goldberg
and Contemporary Art*, Williams
College Museum of Art,
Williamstown, Massachusetts,
and The Tang Teaching Museum
and Art Gallery at Skidmore
College, Saratoga Springs,
New York (cat.)

Clenchclutchflinch, Paul
Rodgers/9W, New York (cat.)

Un Art Populaire, Fondation
Cartier pour l'Art
Contemporain, Paris (cat.)

2000
American Bricolage, Sperone
Westwater, New York (cat.)

*Arte Americana; Ultimo
Decennio*, Museo d'Arte della
Citta di Ravenna, Italy

The Greenhouse Effect, The
Serpentine Gallery, London
(cat.)

Sprovieri Gallery, London

1999
48th Venice Biennale, Venice
(cat.)

*Dreaming III: Contemporary
American Art and Old Japanese
Ceramics*, Akira Ikeda Gallery,
New York

*Head to Toe: Impressing the
Body*, University Gallery,
University of Massachusetts
Amherst (cat.)

Los Angeles Municipal Art
Gallery

Persona, Carousel, Paris

*Zero-G: When Gravity Becomes
Form*, Whitney Museum of
American Art at Champion,
Stamford, Connecticut (cat.)

1998
Deep Thought, Basilico Fine
Art, New York

Être Nature, Fondation Cartier
pour l'Art Contemporain, Paris
(cat.)

1997
CA 90001-185, W139, Amsterdam

*Identity Crisis: Self-
Portraiture at the End of the
Century*, Milwaukee Art Museum;
Aspen Art Museum, Colorado
(1997–98) (cat.)

Yard Sale, Special K
Exhibitions, Los Angeles

1996
Be Specific, Rosamund Felsen
Gallery, Santa Monica

The Empowered Object,
Hunsaker/Schlesinger Fine Art,
Santa Monica

First Person, Marc Foxx
Gallery, Santa Monica

*Narcissism: Artists Reflect
Themselves*, California Center
for the Arts Museum, Escondido
(cat.)

The Scream: Borealis 8,
Arken Museum of Modern Art,
Copenhagen (cat.)

*Shirts and Skins: Absence/
Presence in Contemporary Art*,
The Contemporary Museum,
Honolulu

1995
Beyond 15 Minutes, Cheney
Cowles Museum, Spokane,
Washington (cat.)

*California in Three
Dimensions*, California Center
for the Arts Museum, Escondido

In the Black, Irvine Fine Arts
Center, California (cat.)

Veered Science, Huntington
Beach Art Center, California
(cat.)

1994
Current Abstractions, Los
Angeles Municipal Art Gallery,
Barnsdall Artpark

Hooked on a Feeling, Kohn
Turner Gallery, Los Angeles

This Is My Body, Greg Kucera
Gallery, Seattle

1992
Imperfect Order, Irvine Fine
Arts Center, California

1991
Evocative Objects, California
State University, Los Angeles

1990
Michael Kohn Gallery,
Los Angeles

Lead & Wax, Stephen Wirtz
Gallery, San Francisco

1989
Modern Objects,
Richard/Bennett Gallery,
Los Angeles

Self-Evidence, Los Angeles
Contemporary Exhibitions

1988
Excavations, Otis Art
Institute of Parsons School
of Design, Los Angeles

Curt Marcus Gallery, New York

Profound Visions, Ace
Contemporary Exhibitions,
Los Angeles

1987
Livestock, Los Angeles

Vorpal Gallery, San Francisco

Young American Artists V,
Mandeville Gallery, University
of California, San Diego

1986
Abstract Dimensional Painting,
Richmond Art Center, California

*All-California 86: On a Small
Scale*, Laguna Art Museum,
Laguna Beach, California

1985
Coming Attractions, San Jose
Institute of Contemporary Art,
California

New Art in the West, Vorpal
Gallery, San Francisco

Paint in Space, Main Gallery,
San Jose State University,
California

1984
*Painted, Tinted, Tainted
Sculpture*, San Jose Museum of
Art, California

1983
Painted Constructions,
Main Gallery, San Jose State
University, California

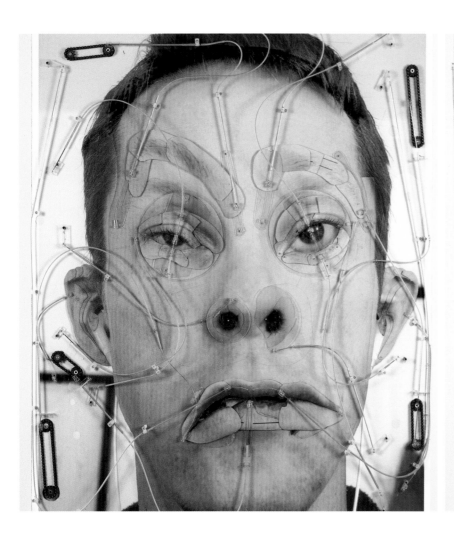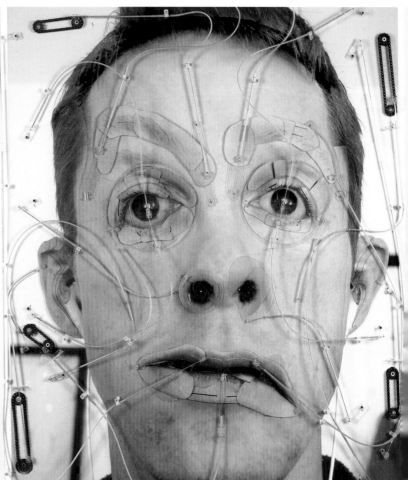

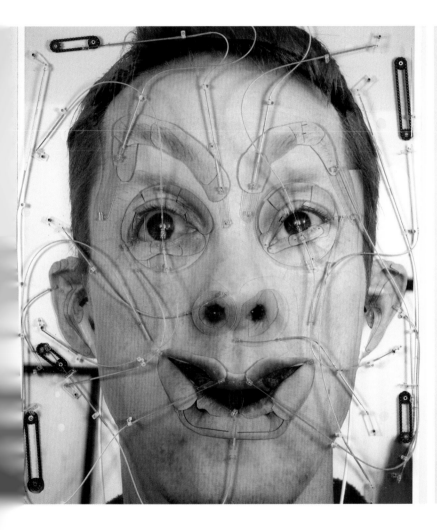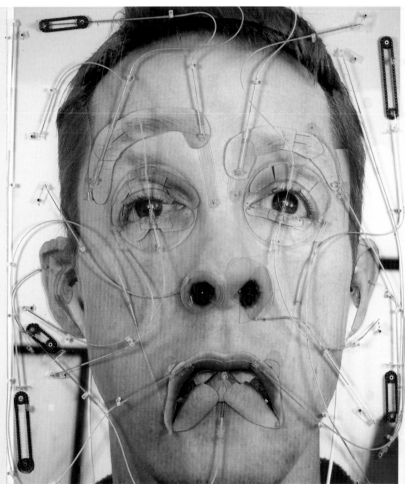

Selected Bibliography

SELECTED BOOKS, EXHIBITION
CATALOGUES, AND BROCHURES

1991
Tim Hawkinson. Lund, Sweden:
Anders Tornberg Gallery.

1994
DiMichele, David. "Finding
Things Out: The Art of
Tim Hawkinson." Orange,
California: Guggenheim
Gallery, Chapman University.

1996
Belloli, Jay. *Ahi Ikmnnostw*.
Pasadena: Armory Center for
the Arts.

Desmarais, Charles.
*Humongolous: Sculpture and
Other Works by Tim Hawkinson*.
Cincinnati: The Contemporary
Arts Center.

1999
Tim Hawkinson: New Works.
Taura, Japan: Akira Ikeda
Gallery, AIG Exhibition/Taura.

2000
Monk, Philip, Laura Steward
Heon, and Doug Harvey.
Tim Hawkinson. Toronto: The
Power Plant Contemporary
Art Gallery.

New Work. London: White Cube.

2001
Fletcher, Valerie. *Directions:
Tim Hawkinson*. Washington,
D.C.: Hirshhorn Museum and
Sculpture Garden.

SELECTED ARTICLES, ESSAYS,
AND REVIEWS

1988
Knight, Christopher.
"Hawkinson Puts Eccentric
Twists in Time." *Los Angeles
Herald Examiner*, June 24, p. 4.

1989
Bunn, David. "Tim Hawkinson."
Art Issues, 3 (April), p. 27.

Drohojowska, Hunter. "Timothy
Hawkinson: Concrete Metaphors."
Art News, 88 (December),
pp. 109-10.

1990
Baron, Todd. "Tim Hawkinson."
Art Issues, 13 (September/
October), p. 34.

Bonetti, David. "Tim
Hawkinson." *San Francisco
Examiner*, September 21, p. C2.

Curtis, Cathy. "Space
Oddities: Tim Hawkinson."
Los Angeles Times, May 1,
calendar section, p. F5.

Selwyn, Marc. "Tim Hawkinson:
Ace Contemporary Exhibitions."
Flash Art, 23 (October),
p. 158.

Snow, Shauna. "Tim Hawkinson—
Manipulating Everyday Objects
and Notions." *Los Angeles
Times*, July 22, p. 96.

1993
DiMichele, David. "More
Questions: Tim Hawkinson at
Ace Contemporary Exhibitions."
Artweek, 24 (August 5), back
cover.

Duncan, Michael. "Tim Hawkinson
at ACE." *Art Issues*, 29
(September/October), p. 44.

Frank, Peter. "Tim Hawkinson:
Domestic Setting." *L.A.
Weekly*, September 17-23.

Pagel, David. "Hawkinson's
Out-of-Body Experiences."
Los Angeles Times, June 10,
p. F12.

Selwyn, Marc. "Tim Hawkinson:
Ace." *Flash Art International*,
26 (November/December),
p. 114.

1994
Curtis, Cathy. "Out of the
Ordinary." *Los Angeles Times*,
March 29, calendar section,
p. 1.

Mallinson, Constance. "Tim
Hawkinson at Ace." *Art
in America*, 82 (January),
pp. 112-13.

1995
Albertini, Rosanna. "Tim
Hawkinson: A Cricket Trills."
Art Press, 199 (February),
pp. 51-53.

Curtis, Cathy. "A Show Mr.
Wizard Would Be Proud Of."
Los Angeles Times, August 15,
calendar section, p. 1.

Friedman, Terri. "Tim
Hawkinson: Ace." *Zingmagazine*,
2 (November), pp. 215-16.

Levin, Kim. "Artificial
Respiration: Tim Hawkinson."
The Village Voice, October 31,
p. 86.

Smith, Roberta. "Art in
Review: Tim Hawkinson." *The
New York Times*, November 3,
p. C21.

Wei, Lilly. "Tim Hawkinson at
Ace." *Art in America*, 83
(November), p. 110.

1996
Auerbach, Lisa Anne. "Nothing
Is Real: Inside Tim Hawkinson's
Fertile Imagination." *Los
Angeles Reader*, 18 (July 19),
p. 14.

Baker, Kenneth. "Hawkinson's
Inventions More Than Hot Air."
San Francisco Chronicle,
September 24, p. E1.

Bonetti, David. "Fascinating
Body of Work." *San Francisco
Examiner*, September 18, p. C4.

Decter, Joshua. "Tim Hawkinson."
Artforum International, 34
(February), p. 85.

Denton, Monroe. "Tim Hawkinson:
The Body in Space." *Art
International*, 28 (March/
April), pp. 176-95.

Drohojowska-Philp, Hunter.
"A Tinkerer's Damnedest."
Los Angeles Times, June 23,
calendar section, pp. 55-56.

Knight, Christopher. "Inventing
an Edgy Carnival of the Human
Condition." *Los Angeles Times*,
July 24, p. F5.

Roth, Charlene. "'Tim
Hawkinson: Ahi Ikmnnostw' at
the Armory Center for the
Arts." *Artweek*, 27
(September), pp. 22-23.

Servetar, Stuart. "Tim
Hawkinson." *New Art Examiner*,
23 (February), p. 48.

Volk, Gregory. "The Cutting
Edge: Tim Hawkinson." *Art
News*, 95 (October), p. 43.

1997
Bumgardner, Ed. "One Man's
Trash." *Winston-Salem Journal*,
January 19, pp. E1-2.

Dougherty, Linda Johnson.
"Tim Hawkinson at Southeastern
Center for Contemporary Art."
Sculpture, 16 (May/June),
pp. 67-69.

Duncan, Michael. "Recycling the Self." *Art in America*, 85 (May), pp. 112-15.

Hammond, Anna. "Tim Hawkinson." *Art News*, 96 (October), p. 171.

Kandel, Susan. "Demonstrating That Time Is Where One Finds It." *Los Angeles Times*, February 7, p. 16.

Patterson, Tom. "Eye on Art." *Winston-Salem Journal*, March 9, p. E4.

Plagens, Peter. "Inflated Reputation." *Newsweek*, February 24, p. 64.

1998
Darling, Michael. "The Unrenowned Soldier: Tim Hawkinson labors on, in comparative obscurity." *L.A. Weekly*, March 6-12.

Gerstler, Amy. "Tim Hawkinson." *Artforum International*, 37 (September), p. 101.

Howell, George. "Tim Hawkinson, Jannis Kounellis." *Sculpture*, 17 (December), pp. 52-54.

Menegoi, Simone. "Tim Hawkinson." *Tema Celeste*, 68 (May/June), p. 90.

Miles, Christopher. "Tim Hawkinson." *Art/Text*, 61 (May/July), p. 80.

Smith, Richard. "Tim Hawkinson at Ace Gallery." *Artweek*, 29 (March), pp. 29-30.

1999
Johnson, Ken. "The Art of the Machine, The Machine as an Art." *The New York Times*, March 19, p. B38.

Kastner, Jeffrey. "Tim Hawkinson: Ace Gallery." *Sculpture*, 18 (July/August), pp. 70-71.

Krauss, Nicole. "Tim Hawkinson at Ace." *Art in America*, 87 (October), pp. 159-60.

McKenna, Kristine. "Irregular Guy: Tim Hawkinson at Play." *L.A. Weekly*, February 19-25, pp. 32-33.

Saltz, Jerry. "Mr. Wizard: Tim Hawkinson." *The Village Voice*, March 16, p. 143.

2000
Fearon, Elizabeth. "Tim Hawkinson." *Vie des Arts*, 44, no. 179 (summer), p. 78.

Gopnik, Blake. "What-if-ery at its purest." *The Globe and Mail* (Toronto), June 22, p. R5.

Lupien, Jocelyne. "Tim Hawkinson: The Body as a Place of Sculpture." *Espace* (Canada), no. 51 (spring), pp. 11-13.

Miles, Christopher. "A Thousand Words: Tim Hawkinson Talks about Überorgan." *Artforum International*, 39 (September), p. 153.

Newhouse, Kristina. "Tim Hawkinson: Mechanical Follies." *Sculpture*, 19 (December), pp. 10-11.

2001
Cooper, Bernard. "Tim Hawkinson: Out on a Limb." *Los Angeles Magazine*, (September), pp. 140-41.

Haymes, Greg. "Überorgan Provides an Experience of Unusual Note." *Chicago Tribune*, February 26, p. 3.

Herbert, Martin. "Body Rhythms: Tim Hawkinson." *Tema Celeste*, 84 (March/April) pp. 76-79.

Howell, George. "Tim Hawkinson: Hirshhorn Museum and Sculpture Garden." *Sculpture*, 20 (December), pp. 67-68.

Miller, Keith. "North Adams, Massachusetts." *Art Papers*, 25 (March/April), p. 45.

O'Sullivan, Michael. "Tim Hawkinson's Body of Work." *The Washington Post*, March 30, p. T55.

Richard, Paul. "Bodily Charm: Tim Hawkinson Really Puts Himself Into His Art." *The Washington Post*, April 15, p. G1.

2002
Smith, Roberta. "As You Live and Breathe, With, Um, a Couple of Adjustments." *The New York Times*, February 8, p. E38.

2004
Howell, George. "As You Spend Time with It: A Conversation with Tim Hawkinson." *Sculpture*, 23 (April), pp. 48-53.

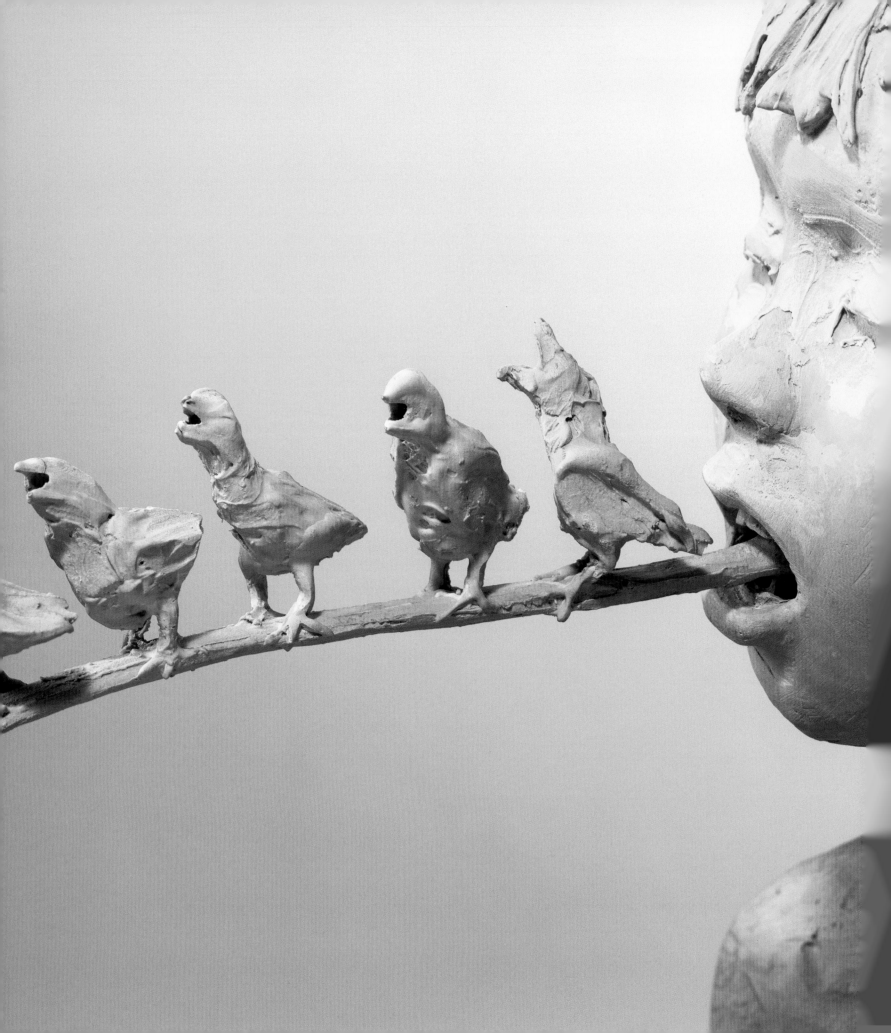

Sweet Tweet, 2004 (detail)

Ann

Joseph

Mary

Brian

Tammy

Garry

Joan

Jens

Bill

David

Gary

Barry

Violet

Helen

Richard

George

Jason

Ren

Michelle

Becca

Peter

John

Peter

Renee

Sammy

Roger

Paul

Bill

Alan

Eba

Jen

Gayla

Gloria

Tiffany

Shelly

Sarah

Harry

Andrea

Charles

Shawn

Allie

Bill

Christopher

Debra

Larry

Hank

Chloë

Charles

Ann

Elaine

Chloe

Whitney Museum
2004-05 National
Committee Members

Mr. and Mrs. Anthony Ames
Mr. Charles E. Balbach
Ms. Laura Lee Brown and Mr. Steve Wilson
Mrs. Melva Bucksbaum
Mr. and Mrs. Paul R. Cassiday
The Honorable Anne Cox Chambers
Ms. Joan Hardy Clark
Mr. and Mrs. Thomas B. Coleman
Dr. and Mrs. David R. Davis
Mr. and Mrs. Peter H. Dominick, Jr.
Mr. Stefan Edlis and Ms. Gael Neeson
Mr. and Mrs. Drew Gibson
Mr. and Mrs. Jerry Grinstein
Mr. and Mrs. Andrew J. Hall
Mr. and Mrs. James Hedges, IV
Ms. Julia Jitkoff
Mr. and Mrs. R. Crosby Kemper, Jr.
Mr. and Mrs. Michael L. Klein
Mr. and Mrs. Leonard A. Lauder
Mr. and Mrs. Jonathan O. Lee
Dr. Bert A. Lies, Jr. and Ms. Rosina Lee Yue
Dr. and Mrs. Robert C. Magoon
Mr. Byron R. Meyer
Mr. Scott D. Miller and Ms. Tina Staley
Mrs. Mary Schiller Myers
Ms. Nancy Brown Negley
Mr. and Mrs. William M. Obering
Ms. Linda M. Pace
Mr. and Mrs. John Pappajohn
Mr. and Mrs. Allen I. Questrom
Mr. and Mrs. Wayne Reynolds
Mr. Leopoldo Rodés
Mr. and Mrs. Paul C. Schorr, III
The Reverend and Mrs. Alfred Shands, III
Mr. and Mrs. Albert H. Small
Mrs. Susan Sosnick
Dr. and Mrs. Norman C. Stone
Mrs. Marion B. Stroud
Mr. and Mrs. Stephen Susman
Mrs. Nellie Taft
Mr. and Mrs. Thurston Twigg-Smith
Mr. and Mrs. Robin Wade
Mr. and Mrs. Robert J. Woods

EX OFFICIO
Mr. Adam D. Weinberg, Alice Pratt Brown Director
 of the Whitney
Mr. Robert J. Hurst, Whitney President

HONORARY LIFETIME MEMBERS
Mr. and Mrs. Sydney F. Biddle
Mrs. Fiona Donovan
Mr. Robert E. Meyerhoff
Mr. and Mrs. James R. Patton
Ms. Jennifer Russell

NATIONAL COMMITTEE COORDINATORS
Ms. Joanne Leonhardt Cassullo, Trustee
Ms. Mary Anne Talotta, Manager of Patron Programs

Map, 1999

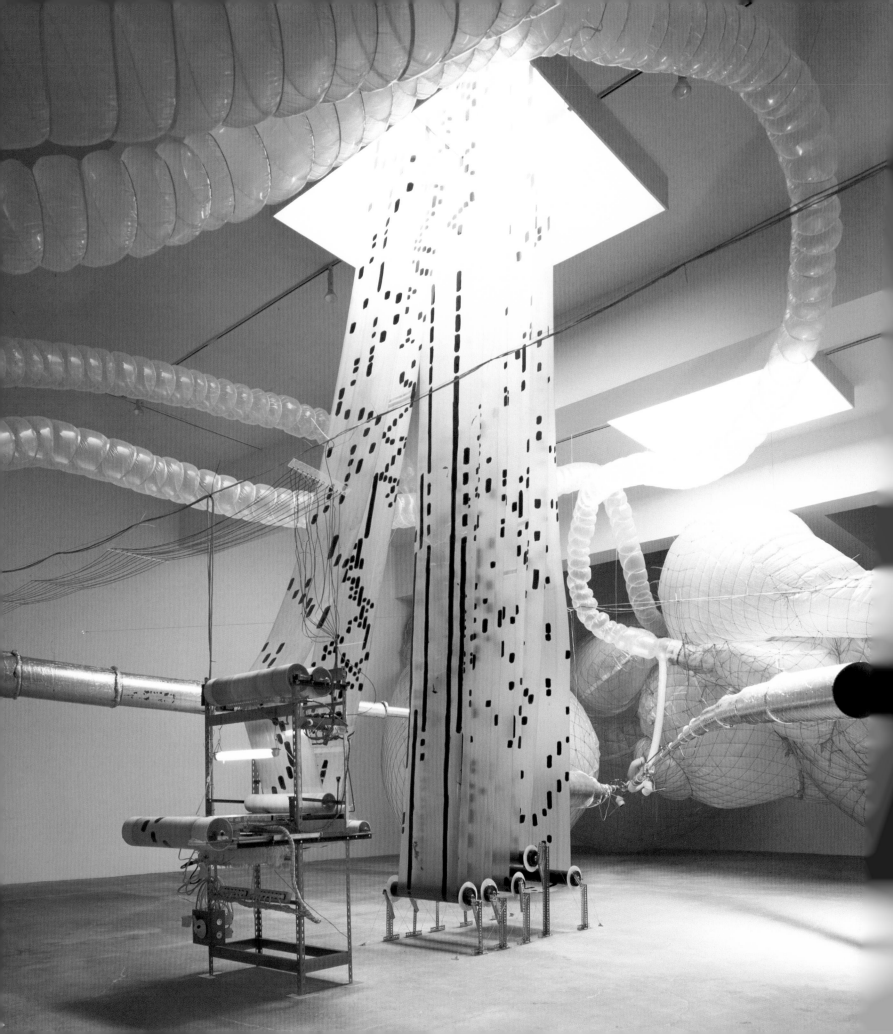

Whitney Museum of American Art
Staff

Jay Abu-Hamda
Randy Alexander
Adrienne Alston
Ronnie Altilo
Martha Alvarez-LaRose
Basem D. Aly
Callie Angell
Xavier Anglada
Marilou U. Aquino
Bernadette Baker
Harry Benjamin
Jeffrey Bergstrom
Lana Bittman
Hillary Blass
Richard Bloes
Julie Brooks
Meghan Bullock
Douglas Burnham
Ron Burrell
Garfield Burton
Carolyn Bush
Pablo Caines
Meg Calvert-Cason
Andrew Cappetta
Gary Carrion-Muriyari
Howie Chen
Julie Chill
Ivy Chokwe
Kurt Christian
Ramon Cintron
Lee Clark
Ron Clark
Maggie Clinton
Melissa Cohen
Deborah Collins
Rhys Conlon
Arthur Conway
Lauren Cornell
Heather Cox
Stevie Craig
Sakura Cusie
Heather Davis
Nathan Davis
Evelyn De La Cruz
Donna De Salvo
Christine DeFonce
Chiara DeLuca
Anthony DeMercurio
Eduardo Diaz
Eva Diaz

Apsara DiQuinzio
Gerald Dodson
Elizabeth Dowd
Anita Duquette
Tara Eckert
Adrienne Edwards
Bridget Elias
Scott Elkins
Alvin Eubanks
Altamont Fairclough
Kenneth Fernandez
Jeanette Fischer
Mayrav Fisher
Rich Flood
Samuel Franks
Murlin Frederick
Annie French
Ted Gamble
Donald Garlington
Arianne Gelardin
Filippo Gentile
Larissa Gentile
Kimberly Goldsteen
Jennifer Goldstein
Lena Goldstein
Mark Gordon
Pia Gottschaller
Elizabeth Grady
Suzana Greene
Patricia Guadagni
Peter Guss
Paola Hago
Joann Harrah
Collin Harris
Barbara Haskell
Todd Hawkins
K. Michael Hays
Barbara Hehman
Dina Helal
Carlos Hernandez
Karen Hernandez
Thea Hetzner
Nicholas S. Holmes
Tracy Hook
Henriette Huldisch
Wycliffe Husbands
Chrissie Iles
Lucy Im
Stephany Irizzary
Carlos Jacobo

Ralph Johnson
Lauren Kash
Chris Ketchie
Wynne Kettell
David Kiehl
Anna Knoell
Tom Kraft
Margaret Krug
Tina Kukielski
Diana Lada
Joelle LaFerrara
Michael Lagios
Raina Lampkins-Fielder
Sang Soo Lee
Monica Leon
Vickie Leung
Lisa Libicki
Kelley Loftus
Jennifer MacNair
Christopher Maddocks
Carol Mancusi-Ungaro
Joel Martinez
Sandra Meadows
Graham Miles
Dana Miller
Shamim M. Momin
Victor Moscoso
Maureen Nash
Chris Neal
Colin Newton
Carlos Noboa
Darlene Oden
Richard O'Hara
Meagan O'Neil
Nelson Ortiz
Carolyn Padwa
Anthony Pasciucco
Christiane Paul
Angelo Pikoulas
Marcelle Polednik
Kathryn Potts
Linda Priest
Vincent Punch
Elise Pustilnik
Christy Putnam
Suzanne Quigley
Michael Raskob
Bette Rice
Kristen Richards
Emanuel Riley

Lawrence Rinder
Felix Rivera
Jeffrey Robinson
Georgianna Rodriguez
Joshua Rosenblatt
Matt Ross
Amy Roth
Jan Rothschild
Jane Royal
Carol Rusk
Doris Sabater
Jeanne Salchli
Angelina Salerno
Warfield Samuels
Stephanie Schumann
Julie Seigel
David Selimoski
Frank Smigiel
G.R. Smith
Stephen Soba
Karen Sorensen
Barbi Spieler
Carrie Springer
Mark Steigelman
Elisabeth Sussman
Mary Anne Talotta
Kean Tan
Tami Thompson-Wood
Phyllis Thorpe
Bonnie To Yee
Joni Todd
Robert Tofolo
James Tomasello
Lindsay Turley
Makiko Ushiba
Ray Vega
Eric Vermilion
Cecil Weekes
Adam D. Weinberg
Monika Weiss
John Williams
Rachel de W. Wixom
Sylvia Wolf
Andrea Wood
Sarah Zilinski

as of October 2, 2004

Überorgan, 2000

TIM HAWKINSON 214/215

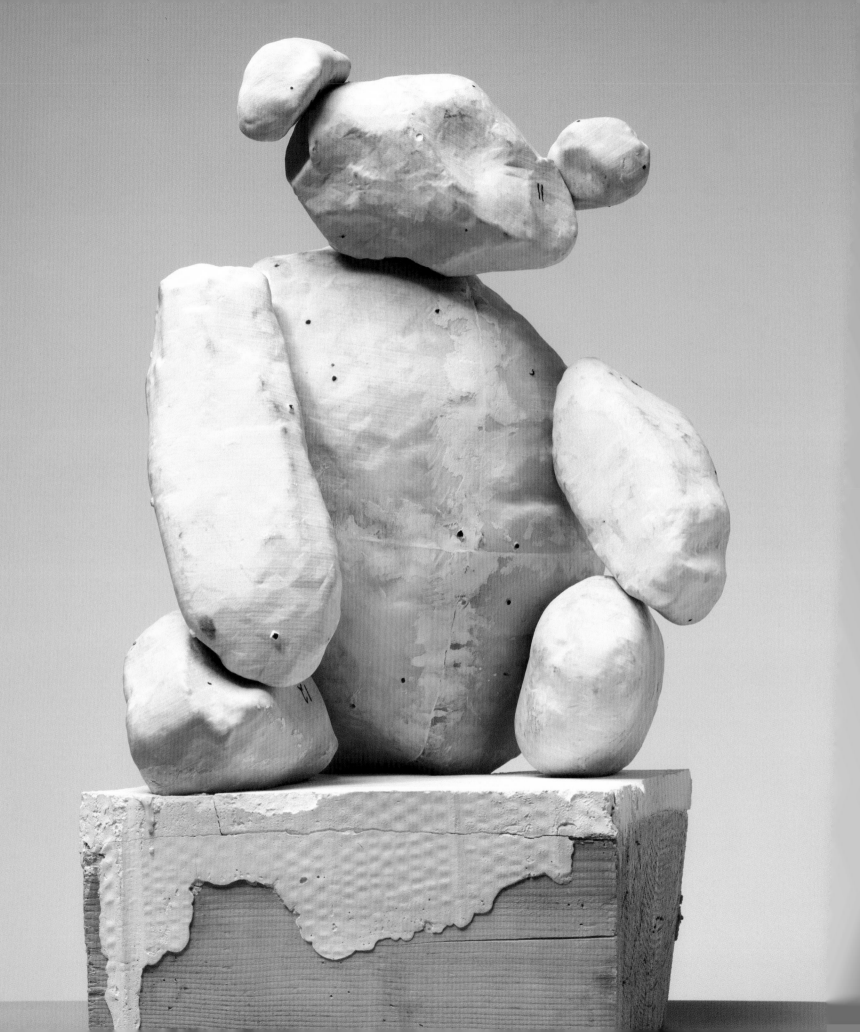

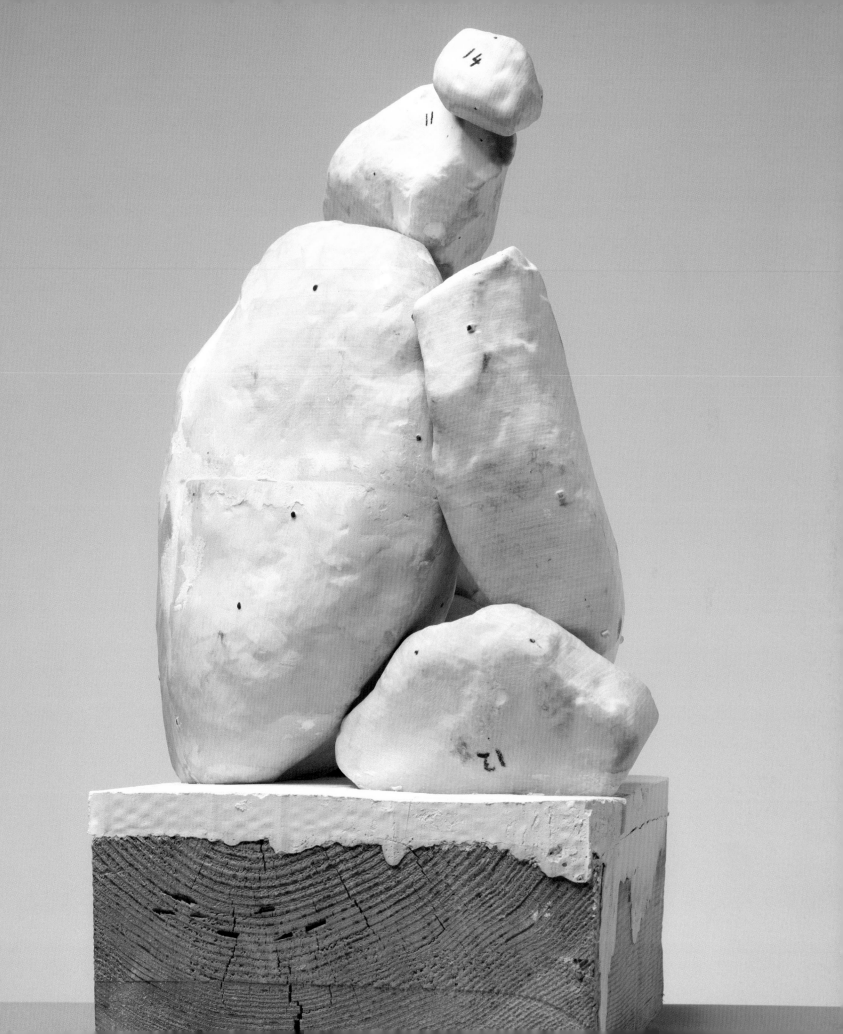

Index

Überorgan, 2000 (detail) (installation view at Ace Gallery)

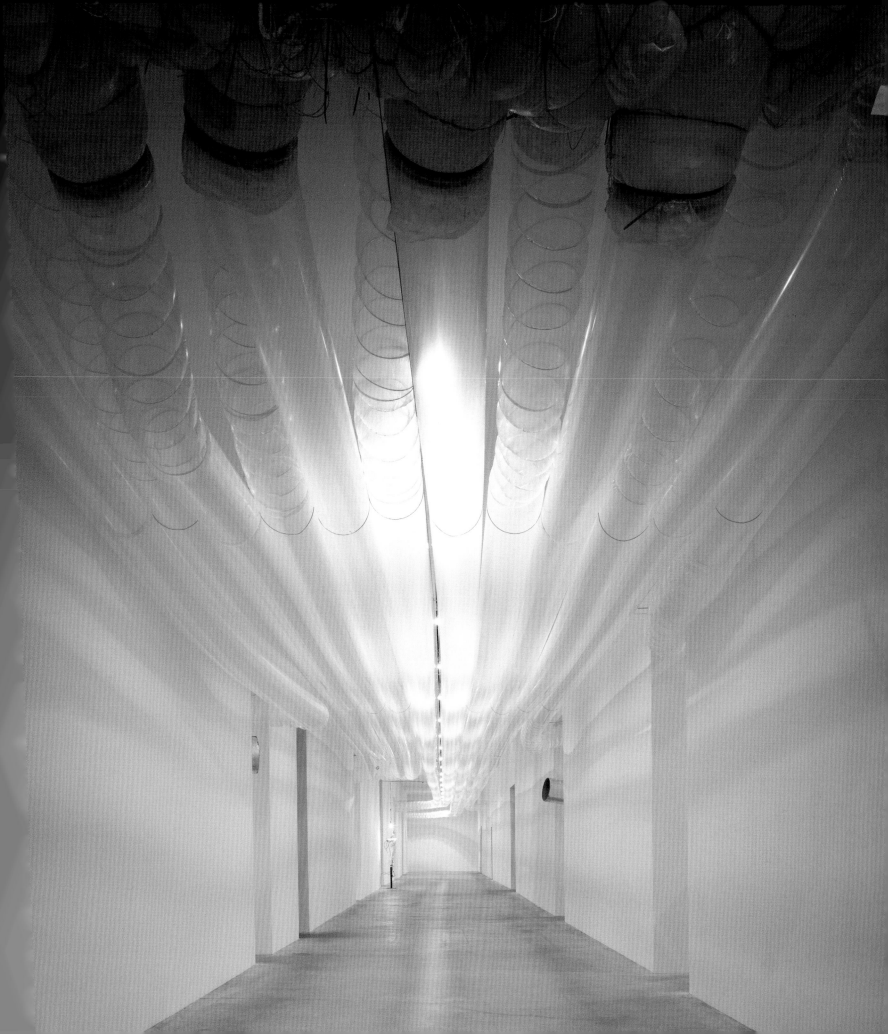

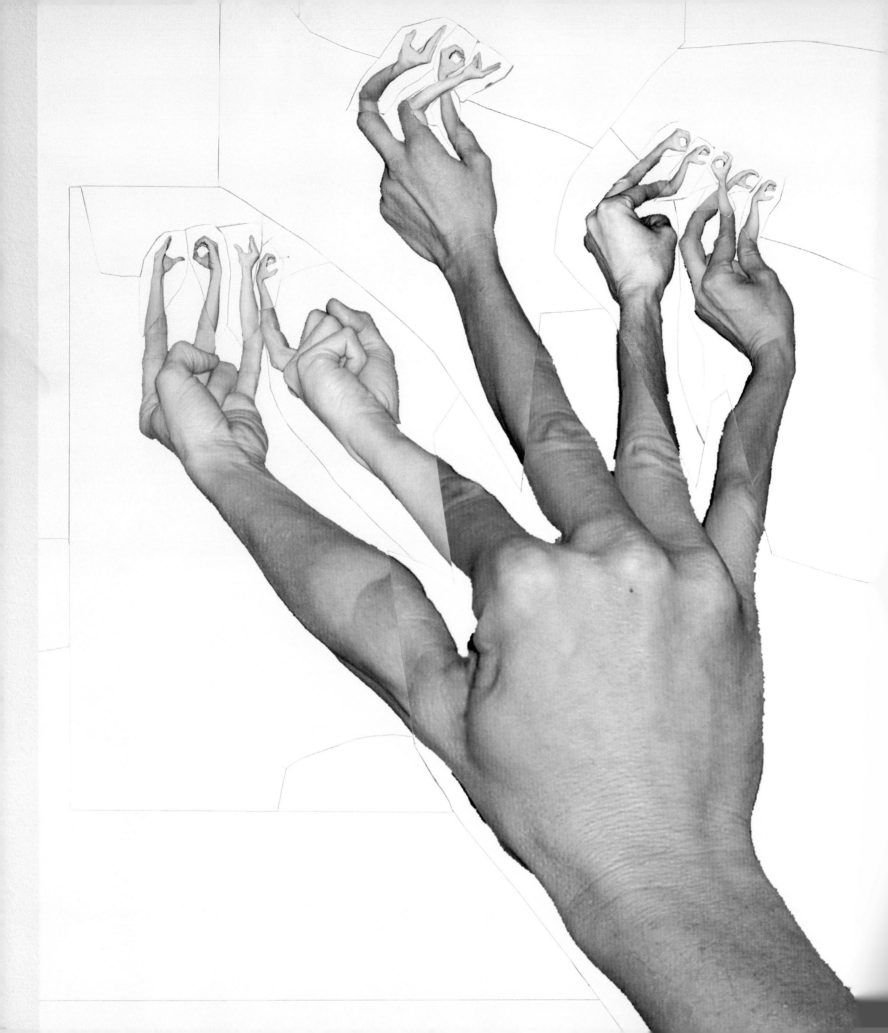

Colophon

Photograph and reproduction credits:
All photographs of work by Tim Hawkinson are courtesy
Ace Gallery.

Geoffrey Clements: 17 (bottom), 18; Sheldan C. Collins: 16
(top, bottom); Erich Lessing, courtesy Art Resource, New York:
25; courtesy Elizabeth Murray and PaceWildenstein, New York:
17 (top); courtesy Regen Projects, Los Angeles: 15 (top);
Sandak, Inc.: 15 (bottom); courtesy Scala/Art Resource, New
York: 19 (bottom)

The images on the following pages are details. 6-7: *Fruit*, 2004;
12-13: *Überorgan*, 2000; 28-29: *Spin Sink (1 Rev./100 Years)*,
1995; 42-43: *Alphabetized Soup*, 1992; 206-07: *Emoter*, 2002

Pages 216-17: model for *Bear*, 2004

This publication was produced by the Publications and New
Media Department at the Whitney Museum of American Art, New
York: Rachel de W. Wixom: head of publications and new media;
Thea Hetzner: associate editor; Jennifer MacNair: associate
editor; Makiko Ushiba: manager, graphic design; Vickie Leung:
production manager; Anita Duquette: manager, rights and
reproductions; Arianne Gelardin: publications assistant.

Editor: Kate Norment
Catalogue Design: Omnivore, Alice Chung and Karen Hsu
Proofreaders: Thea Hetzner and Jennifer MacNair
Indexer: Susan G. Burke

Printing: Dr. Cantz'sche Druckerei, Ostfildern, Germany

Printed and bound in Germany

Fruit, 2004 (detail)